Dog Photography FOR DUMMIES®

by Kim Rodgers and Sarah Sypniewski
Co-founders of Bark Pet Photography

WILEY

John Wiley & Sons, Inc.

Dog Photography For Dummies®
Published by
John Wiley & Sons, Inc.
111 River St.
Hoboken, NJ 07030-5774
www.wiley.com

Copyright © 2012 by John Wiley & Sons, Inc., Indianapolis, Indiana

Published simultaneously in Canada

For general information on our other products and services, please contact our Customer Care Department within the U.S. at 877-762-2974, outside the U.S. at 317-572-3993, or fax 317-572-4002.

For technical support, please visit www.wiley.com/techsupport.

Wiley also publishes its books in a variety of electronic formats and by print-on-demand. Some content that appears in standard print versions of this book may not be available in other formats. For more information about Wiley products, visit us at www.wiley.com.

Library of Congress Control Number: 2011936930

ISBN 978-1-118-07775-7 (pbk); ISBN 978-1-118-17075-5 (ebk); ISBN 978-1-118-17076-2 (ebk); ISBN 978-1-118-17077-9 (ebk)

Manufactured in the United States of America

10 9 8 7 6 5 4 3 2 1

WILEY

About the Authors

Kim Rodgers and **Sarah Sypniewski** co-founded Bark Pet Photography (www.barkpetphotography.com), a Los Angeles-based pet photography business, with a mission of giving back to local animal rescue organizations. In two short years, Bark Pet Photography emerged as an industry leader and was named Los Angeles's best pet photography business of 2011 by the CityVoter Los Angeles *HotList*.

Kim, the photographer behind Bark, graduated from Loyola Marymount University in Los Angeles, California, with a bachelor of arts degree in studio arts. Kim's images are described as modern, bold, and graphic — a style influenced by her years of working as a graphic designer. Her work has been seen in places like the *Wall Street Journal*, PeoplePets.com, LAist.com, TMZ, *People StyleWatch Magazine*, and *Popular Dogs Series* magazines. When she's not photographing her clients' dogs, she's pursuing her first true love: helping to save animals in need with her pro-"bone"-o work. Whether taking professional photos of shelter dogs, flying with them across the country to their forever home, or adopting them herself, Kim tries to help animals in need however she can.

Sarah, the marketing force behind Bark, left her ten-year career in the nonprofit world to pursue writing, consulting, and Bark on a full-time basis. When she's not waxing poetic in the Bark newsletter or churning out website copy for her various consulting clients, she's rescuing animals on a volunteer basis and using the specialized strategy she developed for NinjaDog Concepts (www.ninjadogconcepts.com) to recover lost pets. She writes about all her adventures on her blog, *Sarah Leaps* (www.sarahsypniewski.wordpress.com). Her poem, "Paws Amidst Pain" — about the therapy dogs she worked with after the 9/11 tragedy — has become a tribute used by service animal organizations everywhere. Sarah holds a bachelor of arts degree in psychology from DePaul University, which she calls upon frequently when performing such tasks as writing heartstring-pulling adoption bios for her homeless animal friends, calming dogs and humans alike during photo shoots, and using "I" statements.

Dedication

From Kim: For my parents, who taught me what it means to love and care for a dog as part of the family.

For MeMe, who took in a feral cat despite being a "dog person" her whole life and who taught her grandkids that dogs and cats *can* coexist.

For my current four-legged friends (Kali, Piko, Sammy, and Delilah), who have reminded me throughout this process to pause and take a break every now and then.

And for all the animals I grew up with but never had the chance to photograph as I would today — Teddy, Boz, Norman, Bubba, Kitty, and Duncan.

From Sarah: The hours I spent on this book are dedicated with my deepest adoration and gratitude to all the dogs in my life — especially Sophie, Kali, Piko, Sammy, and Delilah. It is to them that I co-wrote this 320-page love letter.

From both: A *huge* wet kiss and tail wag go to all the animal rescuers out there who devote their lives to making a difference, one animal at a time. You spend countless hours and sleepless nights being the voice for the voiceless, and you inspire us to keep going. This book really is for you. May it help you find many homes for many deserving dogs.

Authors' Acknowledgments

We feel extremely lucky to have been able to write this together — there's no way we could've done it alone. Thank you to our Wiley team of cheerleaders and smarties, who let us do this as a duo and made this whole experience a great one: our acquisitions editor, Tracy Boggier, for finding and believing in us all the way through; our project editor, Vicki Adang, for moving the pieces around to maximize clarity, for allowing our creativity to run wild, and for laughing at our jokes; our copy editor, Todd Lothery, for refining our words and catching our errors; and our tech editor, Jenny Denton of Red Hydrant Pet Photography, for making sure our techniques and recommended settings were spot on.

We want to give a big, juicy bone to all our furry clients who lent their cute mugs to these pages and to all the human pals who helped us pick images, promote the book, and just generally supported us every step of the way.

I (Sarah) also want to thank my family — most of all, Mom and Dad — not only for loving dogs as celebrated members of the brood but also for not freaking out (at least externally) when I told you I was ditching my career and paycheck to chase my dreams of becoming a writer. It's because of you that this book was even possible. A special thanks to Katie, who always was one of my biggest fans. I hope you can see this from where you sit.

A tip o' the cap also to my muse, for knowing I was a writer before I did and for always giving me a reason to put down words.

Publisher's Acknowledgments

We're proud of this book; please send us your comments at http://dummies.custhelp.com. For other comments, please contact our Customer Care Department within the U.S. at 877-762-2974, outside the U.S. at 317-572-3993, or fax 317-572-4002.

Some of the people who helped bring this book to market include the following:

Acquisitions, Editorial, and Vertical Websites

Project Editor: Victoria M. Adang

Acquisitions Editor: Tracy Boggier

Copy Editor: Todd Lothery

Assistant Editor: David Lutton

Editorial Program Coordinator: Joe Niesen

Technical Editor: Jenny Stierch Denton

Editorial Manager: Michelle Hacker

Editorial Assistants: Rachelle S. Amick, Alexa Koschier

Cover Photos: Kim Rodgers, Sarah Sypniewski

Cartoons: Rich Tennant (www.the5thwave.com)

Composition Services

Project Coordinator: Nikki Gee

Layout and Graphics: Claudia Bell, Heather Pope, Christin Swinford

Proofreaders: Betty Kish, Dwight Ramsey

Indexer: Sherry Massey

Publishing and Editorial for Consumer Dummies

 Kathleen Nebenhaus, Vice President and Executive Publisher

 Kristin Ferguson-Wagstaffe, Product Development Director

 Ensley Eikenburg, Associate Publisher, Travel

 Kelly Regan, Editorial Director, Travel

Publishing for Technology Dummies

 Andy Cummings, Vice President and Publisher

Composition Services

 Debbie Stailey, Director of Composition Services

Contents at a Glance

Table of Contents

Introduction

*T*hey're just like humans — no two are the same. Some constantly wag their tails, happy just to be alive in their blissful oblivion. Others are curmudgeonly and reserved; they prefer to chew a bone in peaceful solitude, not caring to be bothered with playtime. And then there are those who hear the jangle of their leash and come scrambling across the house, excited to go on a new adventure to parts (and smells) unknown.

Dogs.

They're complex and simple, funny and serious, hyperactive and sloth-like. But among them all, one common thread runs strong and true: We love them. Whether because of or in spite of these quirks, we love the specific things that make our dog *ours*.

This book is actually a tribute to them. It's an ode to those who curl up at our feet, plop themselves onto our laps, lick our tears away, crack us up with their four-legged antics, get us out of the house for walks, teach us new tricks, and school us on what it means to truly care for someone.

Dog Photography For Dummies is a celebration of these beautiful creatures that take up residence in our hearts and share a lifetime of moments with us. Though we can't make them live forever, with a few photography skills and lots of patience, we *can* capture the belly rubs, dirty paws, and slobbery kisses forever, before they fade away all too soon.

About This Book

Although they come with their own challenges, dogs make very obvious and interesting photography subjects, and a lot of books are devoted to this topic. But where other dog photography books stop at giving you composition ideas or pages of the author's own photos as examples to replicate without really telling you *how* to take them, we start at the beginning and end with a final photo suitable for framing and hanging in a place of honor in your home.

Just like our subject, *Dog Photography For Dummies* does a lot of sniffing and digging. If you're a beginner, you'll find some basic information about equipment and how to use it so you're ready when your dog does something cute. If you already have some photography experience, you'll still benefit from chapters that describe different types of dog-specific shots in a fun, step-by-step way to ensure that you capture the moment. And if you already know

that dog photography's your thing and you want to break into the business, we have a full how-to on that, too.

We start with a general photography refresher for anyone who needs it, and then we point out how to take every doggie photograph you want (and even some you don't yet know you want). We continue on with what to do after you take your photos to get them to look all polished and pretty, and then we tell you what to do if you want to join the ranks of the professionals.

The great thing about *Dog Photography For Dummies* is that we, your humble authors, are just like you — dog lovers and photography enthusiasts. And we remember a time when we weren't professionals. With this book, we hope to offer you an entertaining, easy-to-follow adventure through the ever-expanding world of dog photography. We're glad you're here and hope you enjoy choosing your own path through these pages.

Conventions Used in This Book

We use the following conventions throughout the text to make things consistent and easy to understand:

- New terms appear in *italic* and are closely followed by an easy-to-understand definition.
- We use **bold** text to highlight keywords in bulleted lists and the action parts of numbered steps.
- All web addresses appear in `monofont`.
- Each photo in this book is followed by information in small print that looks something like this: *50mm, 1/500 sec., f/2.8, 100.* These are the camera settings used to take the photo. The first number is the focal length, the second is the shutter speed, the third is the aperture, and the fourth is the ISO. (Don't worry if you don't know what any of that means; we explain each of those settings in Chapter 4.)

Oh, and one more photography thing regarding those digital cameras that you can slip in your pocket or purse — we don't call them *point-and-shoot cameras* here; we call them *compact digital cameras* (CDCs), which is in line with the current industry standard.

As for how we talk about dogs in this book, we always refer to them as "he," "she," or by a proper name (thanks to our clients and fans for letting us "borrow" those names). Also, we don't use the term *owner,* but rather, we refer to a person as a dog's *human* or *guardian.*

What You're Not to Read

No matter how much you love dogs, photography, and reading, we realize that parts of this book matter less to some of you than they do to others. Even though we poured our *hearts and souls* into writing this just for *you,* we understand that you may not want to read every word. Really. We get that you may have better things to do than dive into every page. No, no — it's okay. We're fine. Those aren't tears running down our faces; that's just, er, water.

Seriously, though, we get that you have dogs to photograph, so if you need to skip over some parts so you can pull your nose out of this book, we support that. Here's what you can gloss over:

- ✔ **Text in sidebars:** *Sidebars* are shaded boxes that usually give detailed examples or provide some information about an advanced technique on the topic at hand.

- ✔ **The stuff about us at the front of the book:** This book isn't about us. It's about *you.* And your dog.

Foolish Assumptions

Yeah, yeah, we know what they say about assuming. Nonetheless, keeping this book under a thousand pages is good for all of us, so we had to narrow our audience just a tad. Here's what we went with:

- ✔ You love dogs and have at least basic experience with them.

- ✔ You aren't afraid of handling cameras and photography equipment.

- ✔ Your knowledge of dog photography is anywhere from zilch to advanced.

- ✔ You *may* want to open your own dog photography business.

- ✔ You're up for getting down on the floor, getting dirty, and occasionally getting slobbered on.

- ✔ You may not be a pro, but you want to take photographs like one.

- ✔ You have a computer and are willing to use it for the sake of your photos.

Though we debated about what kind of camera you, our readers, are using, in the end, we decided to gear this book toward digital SLR users. If you use a compact digital camera, never fear. We haven't left you out, fair friends. Most

of the guidelines in this book apply to you, and where they don't (or when we offer additional information specific to compact digital camera users), we note that with a special "Quick Click" icon (see the later section about icons for more details).

How This Book Is Organized

To aid your mission of carving your own path through this book, we divide it up into nice, manageable pieces for you to navigate. We start with parts, which are broad areas of interest. We break the parts down into chapters. Use the table of contents as your map and the index as your compass, and enjoy the journey.

Part 1: Heel! The Basics of Dog Photography

This is the place where we go over all the foundational information you need. We cover how to use both digital SLRs and compact digital cameras (and if you don't have a camera yet, we even outline what to look for in a new one) and what to keep on hand when you photograph dogs. We even throw in a couple of psychology lessons (both canine and human). Start with this part if you want to catch up (or brush up) on your fundamentals.

Part 11: Fetch! Go Get That Perfect Photo

This is where the rubber meets the road — er, the camera meets the canine. We give you lots of example photos and tell you *exactly* how you can achieve similar results. We go through indoor and outdoor shots, posed shots, action shots, and even detail and group shots. If you already know your way around cameras and dogs and you're ready to start photographing, this is the part for you.

Part 111: Sit! What to Do after the Photo Shoot

In this part, we go over everything you need to do to take your photos through their final stages. We usher you through downloading the files off of your camera and onto your computer, editing them, and even uploading them onto your website and other media. We also devote a whole chapter to making a business out of dog photography.

Part IV: The Part of Tens

This part covers a range of helpful topics distilled into informative lists. Here, we dish it all — making photo shoots fun, overcoming common challenges, giving back to the animal rescue world, and drumming up business.

Icons Used in This Book

To make this book easier to read and simpler to use, we include some icons that can help you find and fathom key ideas and information.

This icon is meant to draw your attention to a little something extra we think you'll find helpful.

This icon points out something that you may already know or that we've stated before, but it's important enough to reiterate by setting it apart from everything else.

This icon signals that the information listed here can save you from potential disaster, whether that's harm to your dog, damage to your equipment, or injury to yourself.

This icon marks information that is specific to compact digital camera users, so if you use one, pay close attention!

Where to Go from Here

This book is designed so you can start anywhere, end anywhere, and go anywhere! Need a little direction? If you want a nice photo for your holiday cards this year, head over to Chapter 7. If you want a family portrait, jump to Chapter 10. If you want to know how to set up a dog photography business, your destination is Chapter 14.

If you still don't really know, just start at the very beginning (it's a very good place to start). Part I gives you a full introduction to dog photography and can give you an idea of where to head to next.

Part I
Heel!
The Basics of
Dog Photography

The 5th Wave By Rich Tennant

DOG PHOTOGRAPHY

In this part . . .

Y ou have a lot to get in order before you start photographing your favorite pooch, and in this part, we cover it all. We detail the tools and skills you need to master so you and Fido can make it all look effortless. The chapters in this part comprise a framework that's both sturdy and welcoming, whether you're a novice or an advanced photographer. We take you through all the prerequisites you need — be they camera or canine competencies — to succeed in this fun, furry adventure.

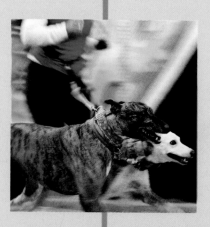

The Big Picture of Dog Photography

People are showing a growing interest in pet photography of all kinds, especially dog photography (exhibit A: you're reading this book). At the hobbyist as well as professional level, dog photographers are popping up all over. This interest makes perfect sense — we share our lives with our wonderful dogs, but the time we spend together is simply much too short. Those of us who love dogs seem to be on a quest to immortalize our canine friends, to somehow hang on to these moments we share together forever. That's where dog photography comes in.

In this chapter, we reveal how snapping pictures of your (or someone else's) dog can change your life, and perhaps even the dog's life. But before you grab your camera, you should know something about the skills that can make you successful, so we also cover those. And just as your dog has his favorite tricks, you'll come to have your favorite ways to take photos of your pup. We outline your options at the end of the chapter.

The Scope of Dog Photography

People have different motivations for wanting great photos of their dogs, so your first task is to figure out what that motivation is so you can take the right photo, whether for yourself or someone else. Do you want to capture images of Hercules playing his favorite game? Maybe you want just one nice

photo of Hogan you can use for your holiday cards this year. Or perhaps Quimby's starting to slow down a little and you want to make sure you have photos of him as you two go about your shared daily routine that you'll one day miss.

Whatever the motivation is, the goal of dog photography is pretty basic: catch those real moments of a beloved dog's life. The scope of what it takes to achieve that goal is, admittedly, a hearty challenge. You have to understand how dogs think and behave, be willing to get down and dirty with them, be just as clever with the dog's humans, and employ every drop of patience, flexibility, and tranquility you have. Just like Jesse's obedience lessons, dog photography takes hard work and practice, but in the end, there's nothing but tail wags all around.

Capturing moments and stories that are fleeting

The true goal of dog photography (as with any other photography) is to freeze time — to capture those precious moments in a dog's life for all eternity. When you reflect upon your dog and the relationship you share with her, what stands out? What do you always want to remember about her? When you want to show the "real" Millie in photographs, forgo the commands. Much of dog photography is just about being quick with a shutter button. In Figure 1-1, we caught an unplanned moment in which Henry decided it was time to play tug with his leash, perfectly capturing this little joker's personality.

One of the unique aspects about photographing dogs is that you can't really tell them exactly how to pose, and while that *can* be an obstacle, you also end up capturing some seriously genuine moments. Dogs can't really fake it; what you see is what you get. Sure, you can tell Jackie Brown to "sit," but you can't instruct him to "back up 3 yards and then come running toward me with a happy grin on your face." If you want that to happen, you have to follow Jackie around with a camera until he spontaneously does what you're looking for. Of course, there are a ton of tips, tricks, and strategies to encourage your fuzzy pal to do something cute or fun (and we tell you all about those in this book), but being quick on the draw results in your being able to freeze in time some very real-life moments.

Understanding how dogs are like children to their humans

Obviously, you know what your own dog means to you, so remember that feeling when you photograph other people's dogs. Always respect the humans' directions (as long as the dog isn't in danger) and defer to them. You wouldn't tell others how to parent their human children, nor should you do so with canine kids.

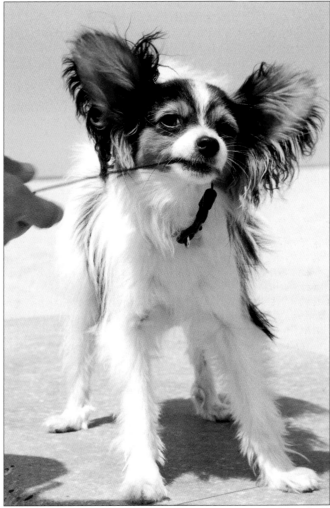

50mm, 1/160 sec., f/11, 125

Figure 1-1: Keep an eye out for unplanned moments like this.

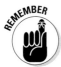

The heart of the matter really is a matter of the heart. People love their dogs, just like you love yours. And that's probably why they're letting you take photos of them in the first place. Most times, you fall just as in love with them as their humans have, but sometimes, a dog may try your every last nerve. Just remember: That dog is someone's child. No matter how Max tests you, don't get angry and don't give up. Take a break if you must, but always strive to see Max through loving eyes, just as if he were your own dog (or child). And create images that truly bring out the parent-child bond that many humans share with their dogs.

Keeping your canine subject at ease

Dogs are energy experts. They can read it, they can give it off, and they can detect the most subtle changes in it. Energy is one of their main languages, which means that if you're stressed, dogs sense it. If you're calm, they know it. More than that, they mirror your energy.

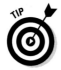

When you're photographing dogs, get yourself into a peaceful state of mind and stay there until you're done. If you get all crazy and hyper (or even demanding and angry), you can expect the dog to do the same. Ever notice how those TV shows about improving pet behavior start with a clip of humans demonstrating a dog's horrible behavior as they yell at the dog in vain, but then the expert steps in, and suddenly, the dog is heeling, sitting, and ignoring the cat? It's not magic; it's energy. And to be successful with your dog photography, yours has to be good.

Different dogs respond differently, of course, so it's up to you to meet the dog where the dog is. In other words, a big Lab mix may not mind you bending down to give him a big greeting and a solid pat on the back, whereas a small Chihuahua probably doesn't feel comfortable with someone hovering over her. Your canine subjects need a lot of space, especially at the beginning. Remember that being the star of a photo shoot is probably a brand-new experience for them, so to keep them comfortable and calm while photographing, give them plenty of mental and physical space.

More important, keep the process *fun!* The more you can turn it into a game, the better your results will be.

Using dog photography in rescue work

Shelters and rescues across the United States (and throughout the world) house millions of homeless dogs just waiting to be adopted. Now more than ever, a good photo of a shelter dog has the power to literally save his life. Websites, social media, smart phones, and e-mail all contribute to the ability to send photos out over state and country lines and even overseas. When people hit the Internet to find their next canine companion, a compelling photo catches their eye and causes them to click a link to find out more.

Overworked shelter employees often don't have the time or equipment to take good photos of each of the hundreds of dogs in their shelter. Often, the only chance a dog has rests on a grainy snapshot taken while the dog was at his most fearful or injured. The animals waiting for adoption can benefit greatly from your skills as a dog photographer. Your high quality equipment, photography skills, and kind rapport with dogs can save lives when you produce photos that get dogs noticed.

In Figure 1-2, you can see the before and after photos of Sugar, a pit bull who had been abused and then dumped at the shelter. The photo on the top was taken on a cellphone the day she was found, and the photo on the bottom was professionally done. Using the cellphone photos didn't yield much interest in Sugar; the photos were small and grainy and simply emphasized her scar. The professional photos showed Sugar in a new light, garnering her much attention and support from countless individuals, as well as Molly's Mutts & Meows, an amazing rescue group that took Sugar under its wing and stood by her through thick and thin.

There's no better feeling than when someone who's just adopted a rescue dog says, "Oh, I saw the photo you took of him and just *knew* he was mine."

Skills You Need to Excel

Just like any new activity, dog photography takes practice. As long as you're willing to spend the time learning techniques and trying them out, you can excel. Of course, having a few of these skills helps you produce even better photos:

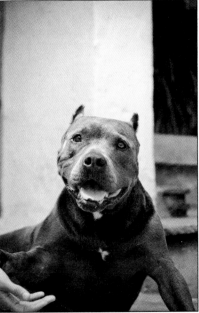

50 mm, 1/500 sec., f/2.8, 125

Figure 1-2: One good photo of an adoptable dog can make a huge difference in how they're perceived.

- ✔ **Creativity:** Photography is an art, but dog photography is art with four legs and lots of slobber. Not only do you have to get creative with perspective, style, composition, color, and all that stuff you learn about in art school, you also get to work with subjects that don't really understand English, which makes things *really* interesting. From how you get a dog's attention (see Chapter 2) to how

to coax a shy dog to pose (check out Chapter 7) to how you do your final edits (flip to Chapter 12), dog photography really requires out-of-the-box thinking!

✔ **Dog handling skills/basic understanding of dog psychology:** There's lots to know about how dogs think and how to best work with them. If you want to photograph them, you have to understand them and be willing to communicate with them in their language. You need to be comfortable with how dogs interact with one another and with people, and you need to be able to direct them to some degree — at least enough to keep them safe and happy during your session. (We give you the skinny on dog psychology in Chapter 2.) Of course, the better you are at understanding and interacting with your canine friends, the better your photos will most likely be.

✔ **Proficiency with cameras, lenses, and more:** Obviously, you need a lot of technical knowledge and skills to be good at dog photography. You need to understand how the different parts of a camera work together to create the photograph you want. This is especially important with dog photography because the subjects move so fast. If Luca suddenly starts doing something really cute but you're occupied with fiddling around with your settings, chances are you'll miss the shot. Knowing where to set your aperture, what lens to use, and how much light you need for any given shot should be second nature. Practice until it is! (Chapter 3 covers photography equipment, and Chapter 4 provides basic information about camera settings and photography techniques.)

✔ **Business acumen:** If you want to make a business out of dog photography, a love of dogs is a good starting point, but you need much more than that. You have to be a good researcher, manager, marketer, salesperson, planner, accountant, and about a dozen other things. If you truly want to succeed, you have to work hard to develop all these areas. (If this sounds like the perfect career for you, check out Chapter 14.)

Picking the Perfect Approach

Photography is all about options. You can choose how much light to use, where to shoot, what to do, and which colors to use. All these choices contribute to the overall look and style of your photo. One of the biggest choices to make when it comes to dog photography is your approach. You can aim for truly candid moments, candid-looking (but planned) shots, or totally posed portraits. Each approach is different and yields different (but equally delightful) results. As we discuss different settings and ideas throughout this book, keep in mind these different approaches and choose which one works best for you.

Capturing candid moments

Candid shots are all about capturing and conveying what sets Libby apart from, say, Butch. These are the spur-of-the-moment, unplanned pictures that capture life as it unfolds. You don't need to use many commands or tell the dog what to do (well, not *too* much, anyway). You should let Libby do whatever it is she wants to do and just shoot. Anything goes! Portraits are nice, but the true joy of photographing dogs is getting those images that instantly say something about *your* specific dog. You want to be able to look at these photos and exclaim, "Oh my gosh! I captured Charm's ear thing perfectly!" or, "Aw! That's totally Sundance's dinnertime look!" You get bonus points if you make tears of recognition well up in your own eyes upon viewing the final images. Getting these images, though, takes equal parts persistence, patience, foxlike cunning, and just pure luck.

The first rule in capturing candids is to *always* have your camera, and *always* be ready to point it at your dog when the moment strikes, no matter what time it is. Most humans would probably punch you if you tried to stick a lens in their face before they've had their coffee. Luckily, dogs don't drink coffee, so you have more options when it comes to breaking out the camera. But that doesn't mean all hours are created equal.

Think about what your dog is like at different times of day and what you want to capture. If he's sleepy during the day and you want to get some shots of him curled up on his favorite bed or lounging around in his favorite sunny spot in the yard, try the afternoon. If you'd rather get shots of him playing fetch or running around, choose a time when he's most energetic — perhaps right when he wakes up. The key to getting the most genuine images is to follow your dog's natural daily routine.

Candid shots are great because they can happen anytime, so long as your camera is within reach! These shots aren't posed, so it's just a matter of keeping your eyes open for the right moments. Maybe you're with your dog at your favorite corner hangout when you notice how amazing the lighting is. Or maybe you discover him napping in the funniest position while you're cleaning the house. Figure 1-3 is a candid moment we captured at the end of our photo shoot with Flora. As we were packing up, we saw Flora plop down on the carpet and begin burying her tired eyes in her paws, so Kim quickly got down at her level and continued shooting. When shooting candid photos, quickly and accurately choosing your camera settings is important, so make sure you do your homework (see Chapter 4 for details about camera settings)!

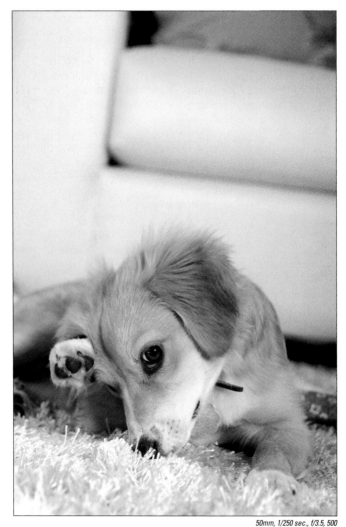

50mm, 1/250 sec., f/3.5, 500

Figure 1-3: Candid moments can happen at any time!

Planning candid-looking images

Don't think you have to wait around for something to happen, though. You have some not-so-candid ways of *making* things happen that still result in a candid-looking moment. This is a good approach to use with dogs that like to play games and listen fairly well.

To pull this off, the first thing you need to do is set the scene. Because the photo is candid-*looking* but not really candid, you can take your time to make

sure the lighting and background is how you want it to be. After you set that up, the real fun begins — getting the dog to do what you want her to do.

Take Figure 1-4, for instance. You may think that Kim was serendipitously in the right place at the right time to capture this perfectly composed photo of Mac traipsing across the patio. Mac looks natural and is in his own world, paying no attention to the photographer, but what you can't see is one of Mac's humans standing to the right of the frame, calling his name so he runs to her. You also can't tell that this one photo took 20 minutes of Mac essentially playing "monkey in the middle" and cruising back and forth between members of his family.

What can we say? Sometimes the best candids aren't so candid after all!

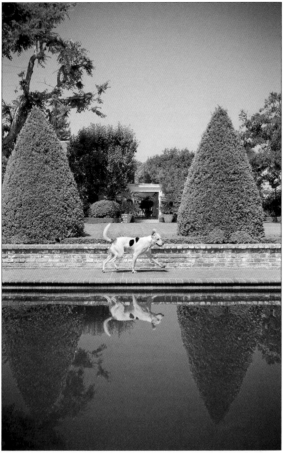

25mm, 1/640 sec., f/3.5, 100

Figure 1-4: With an extra person or two and a little bit of persistence, you can plan shots that look totally spontaneous, even when they're not!

Posing for perfection

Sometimes you just want a nice, posed photo of Violet in all her regal glory. Maybe you want that nice holiday card or something you can hang above your mantle. Or maybe you want to enter Violet into a cutest dog contest.

When you go this route, you should do so at a time when Violet has low enough energy that she's likely to listen to your commands but not so little energy that she sleeps through the session! (For more about doggie portrait sessions, head to Chapter 7.)

This approach typically takes a lot of mental energy for both the dog and you, so be prepared to take it all in stride. If your dog's obedience class rank is anything like our dogs', you have to use a lot of treats to persuade him to keep his position. Others, like Mya in Figure 1-5, are natural-born models.

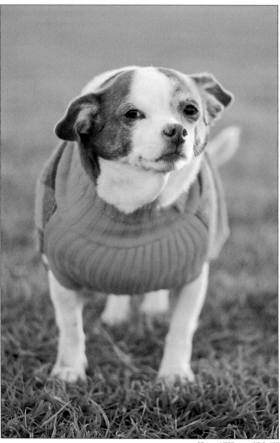

25mm, 1/200 sec., f/2.0, 125

Figure 1-5: Mya strikes a pose.

Dog Photography: It's Like No Other Animal!

If you're reading this book, you've probably had lots of amazing moments with your dog that you want to capture with your camera. Either that or you're getting sick of having to ooh and aah over everyone else's baby photos and you want to silence them once and for all with the beauty that is Shorty! Or maybe you've already attempted to photograph some favorite activities only to discover that the otherwise clingy and underfoot Lakota heads for the hills when he sees a camera. Whether you want to capture spontaneous images, create profound artistic statements that will impress your baby-toting friends, or just stop chasing Bear around the house with your camera, you must first master the ins and outs of working with your canine friend.

Remembering That Fido Isn't Human

As much as you may feel like he is, your dog isn't human. As dog lovers and guardians ourselves, we know that notion is pretty hard to buy into sometimes. Our dogs are complete members of the family, with all the privileges and rights thereto: They eat their dinner as we eat ours, hang out on the couch and watch TV with us, and even

hog the bed once in awhile. Yes, we admit it — we treat them like people. And treating them like people actually works out just fine for the most part, unless you count Kali's clever trick of barking her face off when we're not fast enough with the treats (who's training whom here?). These kinds of moments have a way of reminding us that we actually are a different species and that sometimes we have to interact with a dog like, well, a dog.

This is an important little nugget to remember as you embark on your dog photography journey because photographing your dog is very different from photographing your family picnic. Little Oliver can't say "cheese" or turn a little to the right and look off into the distance wistfully. In order for your endeavor into photography of the canine persuasion to be successful, you have to remember that it's a dog's world.

Dog Psychology 101: Figuring out the canine mind-set

In general, dogs are social, externally motivated sponges. They want to be part of the group (or *pack* in dogspeak), follow your lead, and please you. They like to have their minds and bodies challenged, and they have an amazing capacity to learn new skills when given the chance. All these characteristics make them a good match for photography if you know how to use them!

A smart approach is to turn a photo session into a game that you and your dog play together. Games really appeal to your dog's natural tendencies, so the first rule of dog photography is *always make it fun for your dog to achieve something!* Dogs are similar to human children in that they push your limits as they learn what's okay and what's not, and a photo session is no exception. Because dogs respond well to positive reinforcement, be sure you incorporate plenty of it into your photo session, whether it's treats, hugs, or toys. Keep in mind that this is a very general peek into a dog's mind, but it comes in handy when you break out the camera.

Dogs *want* to learn and achieve, so all you have to do is be patient and consistent, kind yet firm. For example, if you want Rudy to sit and look at you so you can snap a photo, hold a treat near your camera until he looks. But don't give him the treat for free or you'll lose your leverage. And on the flip side, reward him as soon as you get the behavior you want; don't delay it. Say you put Rudy in your favorite leather chair and give him a sit-stay command. He does it like a champ, but you realize you have to fiddle with your camera for a few minutes. Don't wait until after you're done adjusting your camera to treat him. You must reward him right away so he can learn what you want from him. If you don't, he'll get confused and frustrated and won't want to work with you.

Sensitive or fearful dogs may not take to this new activity right away. In fact, the camera can be downright scary to some dogs. With lots of patience on your part, your dog can overcome his fear of the camera. We talk more about camera fear in Chapter 4, but for now, just remember to keep things fun with lots of rewards! The bottom line is that you are your dog's companion, and he wants to be with you, feel safe, and be rewarded.

Understanding how dogs communicate

Even though dogs can't talk, they have plenty to tell you, as long as you know how to listen. They're keen observers, interpreters, and givers of nonverbal cues. They know how to read energy, and they say a lot with their faces and body posture. Knowing your pooch's cues is invaluable to your efforts in photographing him. Ignore his cues and one (or both) of you can end up hurt. Even if he's never so much as growled at you before, be humble and cautious. Sticking a camera in his face for the first time can prompt aggressive behavior to surface (like growling or biting) that you've never seen before. To keep both of you happy and safe, read his body language so you know when to stop before things escalate to a dangerous level.

- ✔ **Ears:** Ears that are perky signal that your dog is relaxed or interested. If your dog's ears are flattened against his head, that probably means he's scared or stressed out. If you see flattened ears during your photo session, stop what you're doing and take a break.

- ✔ **Eyes:** Dogs naturally see eye contact as threatening, but eye contact is a little different with your own dog because you've built up years of trust, and he understands that you aren't challenging him with innocent eye contact. Still, try not to hold his gaze for minutes on end as you adjust every little setting on your camera to get exactly the right shot. Try looking at his nose when you're giving him commands and getting him to hold his pose. If he won't look at you straight-on at all, that could be a sign of fear or discomfort. That sideways glance when you see the whites of his eye is dubbed the *whale eye* and usually signals insecurity, so you may want to take a few steps back until he's more comfortable with the camera.

- ✔ **Mouth:** The mouth is where a lot of action happens. You'll most likely use a lot of treats to reward your pal when you take photos of him, so be on the lookout for signs of thirst, like panting and the slow licking of the chops. Be sure to have plenty of water on hand. The photo of Mac in Figure 2-1 was taken on a hot summer's day, which is pretty obvious from the looks of his tongue! Repetitive and excessive lip licking is a sign of discomfort and stress. This differs from hunger or thirst lip licking in that it's a quick, almost lizard-like licking. Also, if your dog exhibits any growling, snarling, or snapping, take it as a sign that you're moving too fast. If your dog isn't typically touchy, you probably don't have to worry much about this, but this *is* a new situation, so don't take anything for granted.

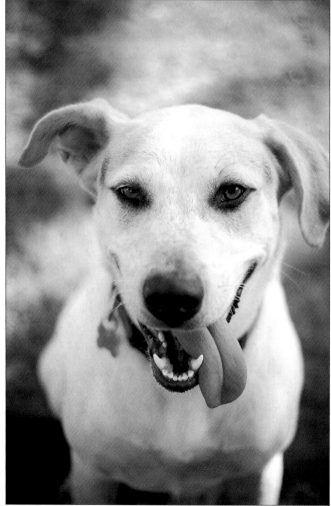

50mm, 1/1600 sec., f/1.8, 100

Figure 2-1: After this shot, Mac took five for a drink!

- ✔ **Tail:** Hopefully, your dog's tail is wagging a lot. A wagging tail makes for a happy dog. A nice, relaxed tail that's just hanging out is a good sign as well. You know there's trouble if your dog tucks his tail between his legs. If this happens, he's not digging the situation, so call it a day.

- ✔ **Fur:** Similar to the mouth, the fur gets a lot of rewards by way of pets and scratches. It's also a good fear indicator; the fur on your dog's neck and back can stand on end when something alarms him. If you see this, stop and figure out what's making him upset. It could be the weird-looking

camera, a strange position you're in to get the shot, or something (or someone) else nearby.

✔ **Nose:** The only thing you have to know about your dog's nose is that his sense of smell is amazing (as if you didn't know that already), so sometimes, just the smell of a treat is enough to draw his attention. Other times, the smell of a treat is enough to send a treat-crazed dog into a tizzy, so be sure you know where your pooch's nose sits on the smell-o-meter and plan your strategy accordingly.

Although every dog communicates a little differently, these body language cues are basic ones to be on the lookout for. As you become more in tune with your own dog's communication habits, your photo sessions will gradually become easier.

Working with Your Best Friend

Everybody knows that office romances can get a little precarious. Working with a loved one can also get complicated, especially if one of you is calling the shots. Well, when you're taking photos of Spike, you want to leave complications (and drama) out of it. This should be a happy and fun experience for both of you. You're equal partners in making this happen. The same loving relationship you have during your regular lives should carry over into your photo time.

Dog photography can get stressful, but this chapter provides you with a lot of advice about what to expect so you don't take any frustrations out on Spike. After all, he doesn't know what that camera is or what you're about to do with it. But he *does* understand love, encouragement, fun, and patience. Use the natural, already-established commands and language you use every day. Give him clear, simple, consistent direction and reward him well so he can learn what you want him to do (not too different from your average human employee, eh?). And don't forget to take lots of breaks! Dogs have a much shorter attention span than humans. Getting them to focus on following commands and sitting still for an hour or more takes a lot out of them, so be prepared to work at Spike's pace. All you have to do is set out to accomplish a goal together, stay calm, and not punish him if he doesn't sit just right or won't do that one awesome trick. After all, you don't want him running to HR to file a hostile work environment complaint, do you?

Boning up on your four-legged subject

You've lived with your dog 24/7 for the past five years, and you say you know everything there is to know about ol' Baxter. That may be true, but how

conscious of his traits are you? And do you know how each trait may impact the photographs you take of him? From color and size to energy level and motivation, the particulars about Baxter give you vital information about how you can get the best shots of him. Before you even get out your camera, get to know your subject in a whole new light.

Taking inventory of basic info: Breed, color, size, and age

First off, what kind of dog is Baxter, and do you want to highlight his breed in your photos? Is Baxter a working dog, like a German Shepherd, known for their ability to complete certain tasks? Is he a toy poodle who likes being toted around in his own bag? Or maybe he's a mutt you adopted from a local shelter. Thinking about his breed is a good way to come up with ideas for photos.

What color is Baxter? Color is an important consideration because you need to use backgrounds that show off his coloring well, not backgrounds that compete with his color or wash it out. For dark dogs, you want to use light backgrounds, and for light dogs, you want to use dark backgrounds. Pure black and pure white dogs have special concerns, which we outline in Chapter 16.

How big is Baxter? Obviously, you need to be conscious of his size so you can choose settings and angles that convey that size. Keeping his size in mind is especially important if he's extra large or extra tiny. Try to think of ways you can set up a shot to communicate his size to the viewer. In Figure 2-2, Kim photographed this Mastiff from below in order to exaggerate his already enormous paws.

How old is Baxter? Is he a puppy? A senior? A gangly adolescent? This little tidbit helps you decide not only where to shoot but also how much of an attention span he has. If he's a puppy, he probably doesn't know commands or boundaries yet, so keeping him in a small, secure location with few distractions works best. If he's an energetic adolescent

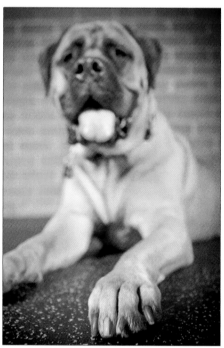

24mm, 1/200 sec., f/2.8, 500

Figure 2-2: Choose angles that accentuate a very large or very small dog's size.

or adult, he probably has the stamina to go on a hike or frolic through a meadow. A senior dog most likely has reduced mobility and maybe even poor eyesight and hearing, so flat territory that's quiet and familiar is the best setting for him.

Knowing what motivates your subject

Does Chauncey come running every time he hears the crinkle of his treat bag? Is a ball the best thing in the world to Gryffin? Maybe all Zuma needs is a pat on the head and a "good girl" to keep doing tricks. Knowing what keeps your dog wanting to listen and perform is what you should use as a reward during your photo sessions. We keep saying it, but it's really true: Lots of fun and rewards ensure success. Here's a rundown of how to use different motivators:

- ✔ **Treats:** If your dog goes gaga over treats like Brooke in Figure 2-3, cut, break, or tear up a bunch of them into little pieces before your photo session because you'll go through them fast. If you have one of those pouches made especially for treats during dog training, use it. If you don't, think about getting one. They're durable, they have a drawstring to protect against sneak attacks, and they clip easily onto your belt, waistband, or pocket. They're easier to access than your pockets or a plastic baggie.

 Be careful though: If you reward your dog too much, he may end up with that treat-crazed look in his eyes. Find a balance that's right for your dog. Treats are a great way to get your dog's attention, but if you go overboard, he may become fixated on the food and unreachable for the rest of the session.

- ✔ **Squeakers/noisemakers:** If a squeaker is what sets your dog's heart aflutter, have one or two in your pocket. It's best to use only the squeakers instead of the whole toy it comes with. You can purchase replacement squeakers at your local pet supply store that are perfect for the task.

- ✔ **Toys and play:** A favorite toy can be a perfect reward. Make sure to hide it until you need to use it; otherwise, you may have a hard time getting your dog's attention! After he's done what you've asked, hand over the toy as a reward and have a mini play session if he likes that (just don't get him too riled up) before moving on to the next shot.

- ✔ **Praise:** Some dogs don't even need an object; all they need is your approval. Make sure to heap on the praise if that's what motivates your dog. After he does what you want him to, take a few seconds to tell him what a good boy he is and scratch his tummy or give a good scritch of the ears.

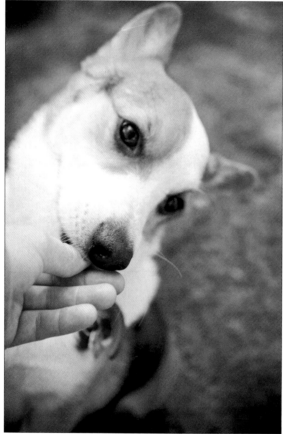

24mm, 1/500 sec., f/2.8, 160

Figure 2-3: Brooke, a normally shy dog, came out of her shell for some treats.

Following commands

Does Huck know basic commands? If so, use them, and give him treats appropriately. If he doesn't, don't. This isn't the time to start training him. Repeatedly yelling at him to *sit!* if he doesn't already know how to only stresses him (and you) out, and you'll both be miserable. The last thing you want is a bunch of photos of a totally stressed dog. If he listens well without needing treats, that's the best situation and what you should always start with. Break out the treats only if you need them.

Assessing your dog's energy level

What's your dog's energy level like in general? Does it change throughout the day? Use this key piece of info to help you choose the right time for and type of photos you want to capture. If you want to get some shots of Emmie playing Frisbee, select a time when she has a lot of energy. If you want to get shots of her sitting or lying down, or you just want her to be extra attentive, choose a time when she's a little low on energy. If she's a high-energy dog in general, a long session probably won't work, so you should keep your sessions short. Consider a bunch of super-short sessions (like five to ten minutes or so, depending on your pooch) over a week or more's time.

Walk, run, or play with your high-energy pooch to tire her out a little before you start photographing her.

Controlling the dog

Keeping in line with the goal of this being a fun experience, try to follow your dog's lead as much as possible. Ideally, having your dog off-leash in a secure and familiar environment (like your home) and using commands (if he knows any) is the way to go. If that won't work, try these tips and tricks to ensure Milo hits his mark:

- ✔ **Choose your leash wisely.** If you're in a session with an uncooperative dog (or if you're outside in a nonsecure environment), break out a retractable leash to hold him where you want him. Editing out a retractable leash during postprocessing is easier than editing out a thicker nylon leash. Always use caution when using a retractable leash though; know how to lock the leash so you can stop him if something triggers him to take off.

- ✔ **Use a wrangler or two.** Having an extra person or two during a photo session really helps. After all, someone needs to hold the leash while you're behind the camera. If you have two extra people, one can hold the leash while the other stands behind you with a squeaker or treat to get the dog to look at you.

- ✔ **Use treats creatively.** We usually use this technique when we're working on a studio setup, but it can be useful in any setting if you have a fearful or stubborn dog on your hands. Sometimes, dogs refuse to come onto our backdrop paper because it scares them, so we toss treats from afar onto the paper and allow them to find the treats at their own pace. We don't drag or force them onto the paper; it's much better if they're allowed to approach it on their own terms. Desensitizing them can take a while, but when they finally come around, it's well worth the effort!

If you find that you're still having a hard time after trying all these ideas, don't force the situation. Move on to another activity and come back to the photo session later. Remember to keep the fun factor high and the frustration factor low!

Always treat your dog with love and respect. It's not just the right thing to do; if you don't, you'll probably find yourself on the sharp end of the golden rule.

- ✔ *Never* hit, yell, or otherwise punish a dog during a photo shoot (you should never hit at any time).
- ✔ Don't approach a dog from behind; you may startle him.
- ✔ Don't take a treat or bone from a dog (unless you're working with your own dog and you've trained him to release his items to you when asked).

Keeping Fido safe

Your first priority in general should always be to keep your dog safe, and that applies when you're taking photos of him as well. If you don't want to have him on a leash (otherwise known as having him "off-leash"), use a secure, enclosed area (like your house or yard). Otherwise, make sure he's on a strong leash and never let go, even for a second. And if you're taking photos in a public place, never leave your dog unattended. Another good idea is to have someone help you by doing the handling or wrangling (see the preceding section to understand the benefits of using a wrangler). Because you're photographing him, you're not able to devote 100 percent of your attention to his safety.

Nothing is more important than the safety of you and your dog. *Nothing.* That goes for emotional and mental safety, too. If your dog feels threatened, you won't be able to work with him to get good photos. Be conscious of things that are particularly spooky to your dog — loud noises, tall people, other dogs — and make sure to avoid them. You want your dog to feel relaxed during your photo shoot, and that won't happen if he's too worried that the big guy over by the tree is coming to get him.

Don't take chances with your dog's safety just for a cool photo. It only takes a second or an inch for something to go wrong.

3

Mutts and Bolts: Photography Equipment

In This Chapter

▶ Figuring out the right camera for the job

▶ Selecting the lens you want to use

▶ Choosing your file format

▶ Taking lighting into account

▶ Stocking up your gear bag with doggie essentials

Dog Photography 101 doesn't have too many prerequisites, but having access to a dog and some basic photography equipment are definite musts! Whether you're a beginner or a seasoned shutterbug, you'll need some essential photography gear along the way. If you're new to photography altogether, this chapter gives you a nice overview of what you need to get started, from your camera to chew toys, lenses to leashes, and everything in between. Read on for the dog photography camera bag essentials!

Where It All Begins: Your Camera

Aside from your creativity and a downright infatuation with your dog, the most important thing you need to take pictures of your pooch is a camera. You have thousands of camera choices, and they all have pros and cons and different bells and whistles. Just make sure you choose a camera that you're comfortable with and that you know its capabilities and limitations. Spend time researching which camera is the best type for what you want to achieve. You may not even know what you want to achieve right now, and that's okay. By the end of this book, you'll have a much better sense of your desires and goals.

And if you don't have the luxury of purchasing a brand-new toy, don't fret. Even an old hand-me-down can yield some wonderful images if you know how to use it. The key is to get to know your camera and love it, to practice and experiment.

Digital versus film

Years ago, expensive digital photography equipment yielded results that barely stacked up to film photography. As the price of digital equipment dropped and the technology advanced, slowly but surely, a shift from film to digital cameras began. And as the digital camera became more sophisticated, the quality gap between film and digital photos became indiscernible to the human eye.

Sure, some people are die-hard film lovers, and you may even be one of them, but when it comes to dog photography, using a digital camera is simply the practical way to go. Digital cameras have many benefits over film cameras when you're photographing dogs. Not only can you see your results immediately (and delete the bad stuff) but you can also experiment with different techniques and become a skilled dog photographer *much* faster. Film versus digital is kind of like studying alone for a test and being quizzed a week later as opposed to completing a workbook with a tutor. With instant feedback, connecting the dots and getting the results you're looking for is a lot easier.

In the long run, shooting digitally is also much more affordable. During our own hour-long photo sessions, we snap anywhere from three to four *hundred* photos. Imagine having to purchase and develop ten rolls of film every time you want to get a decent photo of MacKenzie. No thank you!

Compact digital camera (CDC) versus digital SLR

Okay, we hope we've convinced you that digital photography is your best bet. Unfortunately, the decisions don't quite stop there. The digital photography world has two main types of cameras: small, affordable, point-and-shoot type compact digital cameras (CDCs) and larger, somewhat pricier single-lens reflex (digital SLR) cameras. Figure 3-1 compares these two camera types.

In today's market, the price of a CDC ranges anywhere from $100 to $500 depending on its features, whereas the price of a digital SLR starts at about $400 to $500 for a prosumer-level (the level between amateur and professional) camera and goes up to thousands of dollars for a professional camera. The technologies these two types of cameras use are vastly different, resulting in varying degrees of quality and flexibility:

✔ **Compact digital cameras:** These are the everyday, carry-in-your-pocket cameras that you probably already own. They usually have built-in zoom lenses that you can't change out and small pop-up flashes for low-light situations. CDCs are great for toting around because of their compact

size and ease of use, but their small stature also means that they sport a small *sensor* — the piece of technology that actually captures your photo! The smaller sensor translates into inferior image quality when compared to the larger sensors of digital SLRs.

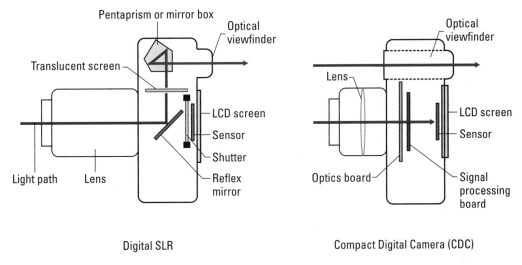

Digital SLR

Compact Digital Camera (CDC)

Figure 3-1: A digital SLR camera (left) compared to a compact digital camera (right).

CDCs offer a substantial amount of automatic modes (like portrait, landscape, night scene, and so on) so the user doesn't have to think too much about *how* to get the shot. Unfortunately, all those bells and whistles can sometimes be detrimental if you don't know how to work around them. Most CDCs also offer some manual exposure options, but they're often buried within the camera's menu, making them a pain to quickly access. If you're not really interested in learning the ins and outs of photography and you want to simply pick up a camera and start shooting right away, a CDC may be right for you. You can absolutely take great photos of your dog; you just won't have as much flexibility as a digital SLR user.

✔ **Digital SLR cameras:** Single-lens reflex cameras sport a much larger sensor than CDCs, resulting in superior image quality overall. They offer more flexibility and manual control over your images, with multiple controls actually built into the camera body itself. Instead of having to sift through the camera's menu to change your aperture or shutter speed, you simply spin a wheel or press the button that controls your exposure. Digital SLRs also afford you the ability to work with different types of lenses and external flashes so you're not stuck with one range of view or bound to using a pop-up flash.

They do come with a higher price tag, but if you're serious about getting the best images possible of your dog, a digital SLR is the way to go. Entry-level digital SLRs still come with many auto functions as well, so don't feel like you need to be a photography pro to pick up one of these. You can always start with auto settings and ease into the manual controls as you become more familiar with them!

One last feature to note about digital SLRs is their ability to shoot using the RAW file format (for the lowdown on this format, see the section "When to choose RAW" later in the chapter). Trust us, if you're looking for perfection and planning on postprocessing your photos, RAW should be your file format of choice. Seriously, once you try it, you may even feel like you're cheating — it's *that* good!

If you're deciding between a CDC and a digital SLR, don't get too caught up in the race for *megapixels*. A digital photo is made up of millions of tiny pixels, and every camera has a different amount translated into a megapixel number prominently marked on the side of the camera. Although the megapixel number was an important factor when digital cameras first came out, any camera you buy today is going to have more than enough megapixels for the job at hand, so try not to worry too much about it. Some of the most affordable CDCs on the market today boast upwards of 12 megapixels, but a digital SLR *always* beats out a CDC when it comes to image quality, simply because its sensor is so much bigger — even if the digital SLR only has a specification of 10 megapixels!

Factoring in your camera's sensor size (crop factor)

If you're a proud owner of a digital SLR camera, you may already be aware of your camera's *crop factor,* and if you're not, you should be.

Although all digital SLRs have larger sensors than CDCs, not all digital SLRs have the same exact sensor size, and most have a sensor size that's physically smaller than 35mm film. The lenses that are used in digital photography are the exact same lenses that were created to be used with 35mm film, so when you pair these lenses with a new technology (digital photography) that sports a smaller-than-35mm-film sensor, it only records the middle part of the image coming through the lens that overlaps the sensor. The overflow that runs off of the sensor (but that would have fit on 35mm film) is essentially cropped out — hence the term *crop factor.* The crop factor of your digital SLR (1.3x, 1.5x, 1.6x, and so on) is the multiplier that represents the ratio of how large the camera's sensor is compared to the size of 35mm film. For any given lens you purchase, the *focal length* (or angle of view that the lens is capable of) is perceived as being magnified when it's paired with a cropped-sensor digital SLR camera because the sensor is only seeing *part* of the image. Basically, all you need to know is that unless you buy a top-of-the-line, full-frame digital SLR

camera with a price point upwards of $2,500, your digital SLR has a crop factor that you should always consider when buying a new lens.

Take Figure 3-2, for example, which was photographed with a full-frame camera at a focal length of 17mm. If you take that same exact lens and put it on a camera with a 1.5x crop factor, the field of view in the final photo is narrowed to what you see within the pink dashed line. Essentially, this means that wide-angle lenses aren't as wide as you may think on your cropped-sensor camera. At a focal length of 17mm, your image looks as if it were shot at 25.5mm ($17 \times 1.5 = 25.5$).

Having a cropped-sensor digital SLR isn't a *bad* thing by any means; it's just something to be aware of if you start purchasing various lenses.

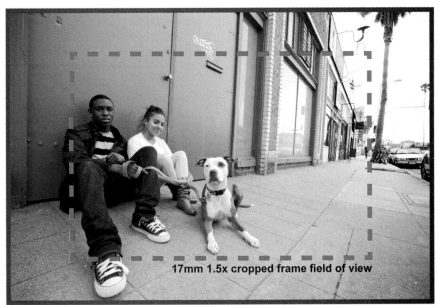

17mm 1.5x cropped frame field of view

17mm full frame field of view

17mm, 1/100 sec., f/10, 1000

Figure 3-2: The size of your digital SLR's sensor determines the ultimate field of view in your final image.

 Although CDCs technically have very large crop factors, CDC users don't need to be concerned with them. CDCs don't come with interchangeable lenses for starters, so whatever lens is paired with your CDC is what you're stuck with. These lenses also already compensate for their extreme crop factors and are usually translated into 35mm-equivalent focal lengths so you're not left doing the math.

Choosing the right memory card

No matter what type of camera you choose, it's pretty useless without a memory card inside of it. A *memory card* is a small, portable storage device that slips into your camera and records the photos you take. You can think of the memory card as the film of the digital age, but unlike film, you can reformat it and use it over and over!

Many different types of memory cards exist, and the kind of camera you have ultimately dictates which type you can use. Most CDCs use SD (secure digital) memory cards, whereas most digital SLRs use CF (compact flash) memory cards. And to make things even more confusing, Sony has its own proprietary type of memory card, which it dubs a *memory stick.* To determine what type of memory card media your own camera accepts, be sure to check your user manual.

When you start shopping for a memory card, you may be alarmed by the huge discrepancy in pricing, which can literally span from ten bucks to hundreds of dollars. Two main factors affect the cost of a memory card:

- ✔ **Rate speed:** The speed of a memory card (expressed in megabytes/second) indicates how quickly the card can save a photo and be ready to receive the next one. When photographing dogs (especially dogs in action; see Chapter 8 for more specifics), a memory card's rate speed is of particular importance, but you don't need to go overboard, either. Our memory cards have a rate speed of 30MB/second, which we've found to be sufficient. The rate speed directly correlates to the price tag; the faster the card, the more expensive it is.

- ✔ **Storage capacity:** The storage capacity of a memory card indicates the amount of space it has. The number of photos a memory card can store is dictated by how large your camera files typically are. You can do your own rough calculations by turning the GB (gigabyte) number into MBs (megabytes). Simply multiply the memory card's GB number by 1,000 and divide by your camera's typical file size. Refer to your camera manual if you're unsure of your camera's typical file size. This number varies widely depending on your chosen file format. For example, the size of a photo taken in the RAW file format is much larger than the size of a photo taken in the JPEG file format. (For more on this topic, see the section "Choosing the Best In-Camera File Format" later in the chapter.) If your camera produces photos of 8MB in size, then a 4GB memory card will hold approximately 500 photos ($4 \times 1,000 = 4,000 \div 8 = 500$), whereas an 8GB memory card will hold approximately 1,000 photos. Just as rate speed correlates to the price of the memory card, so too does storage capacity; the larger the storage size, the more expensive the card.

When you transfer photos to your computer (see Chapter 11 for transferring), you should format the memory card before you use it again. *Formatting* a memory card permanently deletes *all* the data that was previously on it, so you start out again with a clean state. Formatting your memory cards is a good habit to get into, as opposed to simply deleting images one by one or in batches, because when you merely delete an image from your memory card, you run the risk of leaving small bits of data behind that eventually clog up your memory card. The process of formatting a memory card is camera-dependent, but the option usually lies within your camera's tools menu.

Looking at Lenses

Your camera's lens is your camera's eye. Whether you're a CDC or digital SLR user, your lens is the gateway between real life and those precious moments forever immortalized in a photo. In a nutshell, the lens funnels light and focuses it onto your camera's sensor, where it can then be saved to your memory card for eternity.

If you're using a digital SLR to take photographs of your beloved pet, keep reading to get the skinny on the different types of lenses and what to look for when you purchase a new one. If you're using a CDC to take pictures of your pup, you can skip this section.

Getting up to speed on lenses

When you purchase a camera lens, consider its focal length and speed (in addition to the crop factor we discuss earlier). The focal length determines the field of view or amount of the scene you can see through the lens. The speed of a camera lens refers to how wide its *aperture* (the hole that lets light through) can open up. Aperture is measured in increments called f-stops, and the wider your aperture gets, the more light it lets in, allowing you to have a faster shutter speed, which is important for dog photography. Also, the wider your aperture gets, the lower its f-number is. A *fast* lens is capable of very *low* f-numbers, like f/2.8 and below. See Chapter 4 for an in-depth discussion of aperture and f-stop.

If you're looking for the perfect lens to use for dog photography, buy the fastest lens you can afford if you plan on using shallow depth of field to really make your subject pop off the background. A fast lens also comes in handy on cloudy days when you need more light or during action shoots when you want to use a very fast shutter speed. Also look for a zoom lens with various focal lengths so you can quickly adjust your field of view as your dog moves about without having to physically get closer or back up. A zoom lens gives you much more flexibility than the prime lenses we discuss later. The lens we turn to most is our 24–70mm f/2.8.

Focusing on how lenses work

Having a camera with a light-sensitive surface (that is, your camera sensor or film) is only half the battle when it comes to capturing photographs. You also need the ability to focus, and control the intensity of, the light waves that reach your camera sensor. This is exactly where your camera lens comes in! Without a camera lens, you'd be left with some pretty blurry, nondescript images that would hark back to the days of the rudimentary pinhole camera.

Just as your eye has an outer protective cornea and an inner convex lens that join forces to bend light waves, your camera lens is made up of one (and often multiple) individual optical lens that functions to transmit a sharp image to your camera sensor. When your cornea bends light waves, they squeeze through your pupil, which controls the amount of light that ultimately hits your retina. Have you ever walked out of a movie theater during the middle of a super-sunshiny day? As you're hit with bright midday light, your pupils desperately readjust to the size of a pinhole. Conversely, if you walk back into the dark theater, it takes a minute for your pupils to widen and allow in *more* light, which compensates for the darkness of the room. The aperture inside your camera lens does the same exact thing; it controls the amount of light that's allowed to hit the camera sensor.

Don't be confused by the term *fast* when it's used to describe a camera lens. It actually has nothing to do with the speed at which the camera focuses, saves the image, or anything like that. Camera lenses that are capable of opening up to very wide apertures (f/2.8 and below) are considered fast because you can get away with using very fast shutter speeds. For instance, if you use an extremely fast shutter speed, like 1/5000 second, you also let very little light into the camera. To compensate for the lack of light coming through the shutter, you may need to use a larger aperture.

Zooming in on lens types

If you shoot with a digital SLR, a camera lens is an essential piece of the photography puzzle. Often, you can find digital SLR cameras sold as bundled packages that already include an everyday zoom lens. You have a huge amount of lens options to choose from, but typically, a lens falls into one of these three categories:

- ✔ **Fixed focal length lenses:** A fixed focal length lens (also referred to as a *prime lens*) has only one focal length. For instance, a 50mm f/1.8 is considered a prime lens. These lenses are typically small and light because they don't have a lot of moving parts. They also tend to take slightly crisper photos compared to zoom lenses, and they boast fast speeds (that is, low f-stop numbers) at an affordable price. The one downside to a prime lens is that you have to physically move if you want to increase

or decrease your field of view, which can be tough when you're dealing with dogs that are constantly on the move already!

✔ **Zoom lenses:** A zoom lens covers a range of focal lengths. For instance, a 24mm–70mm f/2.8 is considered a zoom lens. These lenses are typically larger in size and weigh considerably more than prime lenses, but they're great for photographing dogs because you can quickly change your angle of view by simply zooming in or out. Zoom lenses are generally more expensive than prime lenses. Although you can find affordable zoom lenses, know that you'll sacrifice speed (a less expensive zoom lens may be capable of opening up to only f/4.0).

✔ **Wide-angle lenses:** A wide-angle lens is any lens with a focal length below 35mm (after factoring in your camera's crop factor). For example, a 16mm–35mm f/2.8 is considered a wide-angle lens if it's used on a full-frame camera, but if your camera has a 1.6x crop factor, you'd need an even wider lens, like a 10mm–22mm f/3.5, to truly shoot at a wide angle.

These lenses are usually used for capturing great, big, flowing landscapes, but don't underestimate the power of getting up close to your subject with a wide-angle lens, especially in dog photography! Wide-angle lenses are great for bigheaded puppy shots, like the one in Figure 3-3, because they have a certain way of exaggerating the perceived distance between things that are close to the camera and things that are farther away. Although little Piko is barely pushing 12 inches in height and 6 pounds in weight, the wide angle that Kim used, combined with focusing the camera just inches from his snout, makes his head and ears appear huge.

Choosing the Best In-Camera File Format

With your camera and lens in tow, it's time to get your camera ready for your first photo session! Most digital cameras, digital SLRs and CDCs alike, offer countless in-camera file format options, most of which serve different purposes, in the hopes of making your life a little easier. The two major file formats to consider are JPEG and RAW. You usually find file format options in your camera's tools menu. Knowing what you plan on doing with your photo after you take it largely determines which file format to use.

When to choose JPEG

The JPEG file format is a compressed digital image file that's usually on the smaller end of the size spectrum. After you snap a photo with your camera set to the JPEG file format, your camera's software quickly grabs the information from your image sensor and processes it into an image file. The major advantage to working with JPEG files is that you can save *many* more files to your memory card before you fill it up.

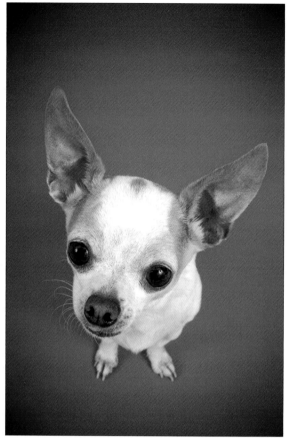

24mm, 1/250 sec., f/11, 125

Figure 3-3: Using a wide-angle lens at close proximity can exaggerate certain traits.

The JPEG format is great for people who take a lot of photos but don't necessarily edit them after the fact. Perhaps you snap off a few quick photos of Benji, download them to your computer, and quickly post them online or send them off to Grandma. The JPEG format is fantastic for this type of workflow because you don't need to convert any files, and just about anyone should be able to open up and view a JPEG file!

The downside to working with JPEG is that, because it's a compressed file format, there *is* some degradation in quality — you're probably not getting the best possible image you could be getting. To be honest, though, most people won't notice the difference, so if you're looking for ease and efficiency, JPEG is the way to go.

When to choose RAW

The RAW file format is an uncompressed digital file that's usually much larger than JPEG in size. For example, a JPEG photo that's 2MB could be 8MB when taken as a RAW file, so if you use the RAW file format, be sure to have a decent sized memory card on hand! After you snap a photo with your camera set to the RAW file format, your camera saves the information from your image sensor directly to your memory card. This means that your computer, not the software inside your camera, processes the data into an image file. Because computers are more powerful than internal camera software, they always do a better job of processing image data. Plus, you have the advantage of being able to manipulate that image data *before* you even process it into an image file!

The major advantage to using the RAW file format reveals itself in postprocessing. Because RAW is a *lossless* file format, you can actually make exposure adjustments *after* you take the photo. It's as if you had made those adjustments in-camera at the moment you took the photo. You're literally working with the raw data of your photo. It's kind of like the difference between having an original document on your computer screen versus a photocopied one in your hand. With a JPEG file, you have only so much leniency with postprocessing and you see a degradation in quality *much* faster than with a RAW file.

Another aspect of the RAW file workflow to consider is that these are *not* actually image files that are viewable or printable right from the camera. In this way, a RAW file is akin to a film negative; it's a step away from the final product (the print). Before you can work with your RAW files, you need to bring them into a special program like Adobe Lightroom (more on that in Chapter 11) to make your edits and then process them into a digital image file, whether that be a TIFF, JPEG, or any other file format you can think of.

If you don't plan on editing your photos, stay away from RAW, because the format can actually produce somewhat dull results if the photos aren't postprocessed at all.

Don't let us scare you off though. If you're really serious about taking the best photos possible, choosing the RAW file format is always your best bet. After you try RAW for yourself and see the final results, you may be reluctant to ever go back to JPEG. Don't say we didn't warn ya!

For the Love of Lighting

Second only to your dog and your camera, lighting is often the make-it-or-break-it component of any photo. Every single thing around you is reflecting light; even a dark-colored dog at dusk has *some* sort of light reflecting off of

him. As a photographer, your job is to assess and harness the available light around you and, if need be, supplement it.

The entire science of photography is based on using light waves to permanently record an image with the help of a light-sensitive material (a digital image sensor or film). Without light, you have no photo, so we want to be frank here — light is important. In fact, it's beyond important — it's a necessity. Whether you use natural daylight or artificial light, you should get familiar with the full spectrum of lighting possibilities so that when you're faced with an unexpected indoor photo session or a cloudy day, you're prepared to roll with the punches! More often than not, the art of lighting boils down to experimenting and learning from your results, so use the following details as jumping-off points only.

A bright idea: Using natural light

Light takes on many different forms in its natural state, from extremely bright midday sun to the soft rays of dawn and everything in between. In dog photography, natural outdoor light is your best friend. That is, if you know how to catch it at its best.

Natural light comes from the sun, that giant light bulb in the sky. It's constantly changing and adjusting throughout the day and seasons. Unfortunately, not all natural light is created equally. For example, the light at noon on a clear day is distinctly different from the sunset on that same day. The color temperature of light shifts, depending on the season. And the amount of natural light present on a cloudy or hazy day changes drastically.

Here are a few rules to live by when making use of natural light:

✔ First and foremost, stay away from midday sun. It shines down from directly overhead, creating harsh shadows and overly bright highlights. If you *must* shoot at high noon, scout out an area that's well-shaded so you can work with a more dispersed and less direct light source.

✔ Whenever possible, shoot during early morning or late afternoon, right around when the sun is rising or setting. Photographers dub these special times "the golden hour" because of the warm hues that bathe their subject. Because the sun also hangs lower in the sky at these times, you won't suffer from overly strong shadows and highlights. Figure 3-4 was taken at sunset and shows Dino soaking up the last golden rays of the day.

✔ Don't write off a cloudy day! Thinking that you can't get good photos on a cloudy or overcast day is a misconception. In fact, this is sometimes the *best* kind of light you could hope for, especially if you're photographing a black dog (more on that in Chapter 16). Clouds can act as a giant softbox that filters the sun to an even and dispersed state, so take advantage of those clouds and forget about the earlier high-noon rule if it's a cloudy day.

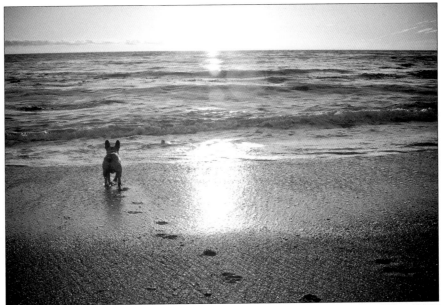

24mm, 1/400 sec., f/9.0, 250

Figure 3-4: The quality of light at sunrise and sunset is perfect for outdoor photographs.

✔ Don't feel stuck with what nature has provided. Invest in some natural light modifiers to gain some control over the direction and intensity of your light. Natural light modifiers include everything from portable reflectors that conveniently fold up into a small pouch to a simple white piece of foam core from your local art supply store. Use these devices to bounce (and conveniently redirect) the sun's light waves. They take some practice in positioning because the light needs to hit them at just the right angle, but they can really be a lifesaver if you're looking for a little extra light on a cloudy day! They're also great for softening those harsh midday shadows if you find yourself in a position with no other choice but to shoot then.

Taking control: Using artificial light

You'll likely take a lot of your photos indoors under man-made light sources. When you're inside, you have more control over the light, which is good because indoor light isn't always quality light. Though you probably won't notice it while you're behind the camera, traditional fluorescent lights and CFL light bulbs can cast an odd color in a room; you may realize this when you start to color-correct your photos during the postprocessing phase. However, thanks to (or maybe in spite of) Thomas Edison, you have many ways to correct for poor or inadequate light indoors.

Built-in flash

Most digital SLR cameras, as well as CDCs, come with a small built-in flash that pops up from the camera when you don't have enough light. Unfortunately, these built-in flashes leave a lot to be desired. One problem is that they blast light at your subject from directly above the lens, which happens to be a very unnatural angle for light to come from and leaves your subject looking pretty unflattering. Another drawback is that sometimes the lens gets in the way of the flash, which casts a horribly ugly shadow (or cloaks your entire subject in darkness).

Figure 3-5 is a good example of what happens when you use your pop-up flash. Suddenly, your cute dog develops glowing alien eyes. When shooting in low light, avoid using your built-in flash at all costs, and if you have no way around it, at least check out Chapter 5 for tips on how to get better results with your built-in flash.

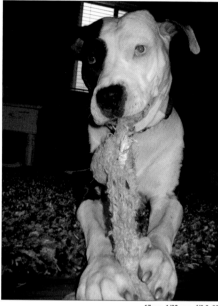

17mm, 1/60 sec., f/8.0, 80

Figure 3-5: A built-in flash yields unflattering results in dog photography.

External flash

An external flash is a separate, battery-operated unit that connects to the *hot shoe* (that little metal connector that sits above your viewfinder) on your digital SLR camera. If you're shooting with a CDC, you're out of luck in this department. The main advantage of an external flash is the ability to control the direction and intensity of the flash. Here's a brief introduction to two external flash techniques (for more on working with an external flash, see Chapter 5).

- **Bouncing your flash:** Even with an external flash on your camera, you still shouldn't point it directly at your subject. Often, photographers use an external flash as a bounce flash to create a soft and dispersed light.

 To create a bounce flash, simply point your flash head at the ceiling instead of directly at your subject. When the flash is triggered, it shoots straight up, hits the ceiling, and reflects back down onto your subject. You can also bounce your flash off of a wall if the ceilings are too high; just remember to find a white wall or ceiling so you don't end up with a strange color cast in your photo.

✔ **Using fill flash:** Your external flash can be a surprisingly great tool for outdoor photography as well, especially if shooting in direct midday sunlight is the only option. Adding a small amount of fill flash to your photo can lighten up the contrast of a midday shot. You may feel funny at first throwing on a big external flash on a perfectly sunny day, but the result speaks for itself. The trick to using fill flash is finding the right balance: Use too little and it doesn't do anything; use too much and the artificial light becomes too obvious. Experiment with your external flash at different angles. Start at 45 degrees so the flash shoots slightly up and away from your subject. If your subject is still too shadowy, try pointing the flash directly at your subject, but be sure to dial back its intensity. Just like the power of a regular flashlight is less intense in bright daylight than in a dark room, so too is your external flash, so when using it outdoors, it's sometimes okay to point it directly at your subject.

Studio strobes

Studio strobes, shown in Figure 3-6, are powerful, off-camera flashes that you typically see in a portrait photographer's studio. Essentially, they're external flash units on steroids. Some flash heads connect to a separate power pack, whereas monolights have power built right into the flash heads. They offer an even wider range of control than external flash units, but they aren't the most portable type of artificial light options. They're also more expensive than an external flash unit.

If you're looking for a studio-style portrait of Buck on a solid-colored background, studio strobes may be for you, but remember that they *are* an investment! We provide more details about working with studio strobe lights in Chapter 7.

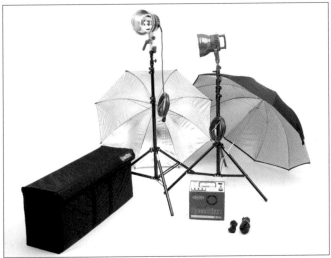

Photo courtesy of Speedotron

Figure 3-6: A typical studio lighting setup from Speedotron.

Other Helpful Things to Have on Hand

Now that the basics are out of the way, you're almost ready to conduct a full-on photo session with your pooch. Before you get sucked into this newfound obsession of doggie cuteness overload, you want to have a few more things on hand. Don't worry though — the major equipment is out of the way! These suggestions won't break the bank, and we hope they make your time with Scout even more enjoyable!

For the dog

Come on now, you know Elvis has about 18 different sweaters to choose from on any given day. What makes you think he shouldn't have his own supply of gear in your camera bag? They may not seem like necessities at the moment, but having these little tricks up your sleeve may just pay off at the end of the day.

- **Treats:** These little snacks are the holy grail of any dog photographer's camera bag. Take note of what your dog responds to — whether it's dehydrated chicken or liver snaps doesn't really matter, as long as he goes gaga over them. Whichever kind of treat you decide on, be sure to break them up into *tiny* pieces — we wouldn't want Elvis getting too pudgy now!

- **Water:** Even if you're doing only a quick photo session, having some good ol' H_2O on hand is always a good idea. Those treats, after all, may get your pooch searching for a swig sooner than you think.

- **Toys:** Some dogs love 'em, some dogs couldn't care less about 'em. If your dog falls into the first category, remember to pack his favorite plushy. You can use this to get him to look at the camera (er, the toy sitting on top of your lens) or as a reward if he isn't exactly food-motivated.

- **Noisemakers:** Be it your mouth, a kazoo, a squeaker, or an iPhone app, unusual and distinct noises are a perfect way to get that inquisitive, cocked-to-the-side head tilt, like in Figure 3-7.

- **Commands:** Practice makes perfect when it comes to basic obedience commands like sit, stay, and down. If your pup already has these down, you're one step ahead of the game!

- **Retractable leash:** If you're conducting a photo session in a public area, you should always use a leash, but if you know beforehand that you want to remove your dog's leash in postprocessing, consider purchasing a thin, retractable one. Always test out a new retractable leash before the photo shoot so you know how to lock it off. A retractable leash isn't any good if you can't actually stop it before Ethel Mae hits the end of the rope.

24mm, 1/250 sec., f/5.6, 100

Figure 3-7: Atticus gives an inquisitive head tilt at the sound of a squeaker.

> ✔ **Slobber rag:** Some dogs are especially slobberrific, and if yours is one of them, try to have a rag ready for the occasion. After treating your pooch about ten thousand times in 20 minutes, your hands will thank you as well.

For the photog

With the doggie accouterments out of the way, it's time to focus on *your* accessories. Again, these aren't requirements at all, but they may come in handy along the way.

✔ **Air blower:** An air blower is a handy little device with a plastic bulb on one end that shoots out air when it's compressed. It's a great tool to clear away dust (or dog hair) from your camera lens! Never use compressed cans of air on your photography equipment though, because every once in a while, they have a habit of releasing liquid, which you don't want to get on your gear.

✔ **Lens cloth:** When photographing dogs, you're bound to get a wet nose to the camera lens eventually. A lens cloth is a specially designed piece of fabric that won't scratch that expensive glass.

✔ **Lens filter:** To protect an expensive camera lens from scratches, consider purchasing a clear filter that screws on to the front of your camera lens. It's *way* cheaper to replace a scratched filter than a scratched camera lens.

✔ **Extra batteries:** Most digital cameras come with batteries that last many hours before needing to be recharged. If you plan on shooting for an entire day, though, have a charged backup battery in your camera bag.

✔ **Clothes to get dirty in:** Choosing an outfit you don't mind rolling around on the ground in is especially important if you're photographing outdoors. You may find yourself having to lie face first in the grass to get certain angles of your pooch.

✔ **Patience:** Patience may not be a tangible accessory you can fit in your camera bag, but patience is one of the single most important traits a dog photographer can possess. This is especially true if your dog happens to be an obedience school dropout. What can we say, school's not for everyone!

✔ **Assistant (wrangler/treat dangler):** Having a friend or family member available to help out during a photo session makes your experience more enjoyable and allows you to spend more time focusing on your photography than on whether Gottlieb is sitting still.

4

Paws-ing for the Basics: Camera Settings and Techniques

*Y*ou know it. Your mom knows it. And anyone who has the pleasure of seeing your smart phone's photo gallery knows it. Your dog is a model — *obviously.* It's only a matter of time before little Gidget is discovered and gets booked on a national ad campaign. Soon, her cute, fuzzy face will adorn every bag of your favorite dog food! But — *hello* — models can't be expected to do *all* the work; it takes a skilled photographer to show-case Gidget's natural-born talent in all its glory.

No matter how cute and photogenic your dog may be, getting that perfect photo without some basic photography know-how under your belt is tough. The more you understand these concepts and explore the "why" behind the "how," the more quickly you'll improve upon your dog photography skills.

In this chapter, you discover the critical settings that make your camera work and how they interact to give you control over the look and feel of your image. At first, your camera may seem like a complicated piece of equipment, but after you understand the basics, we promise you'll have a newfound confidence behind the lens. Save the dog treats for later, pull out that camera, and become its best friend (well, second to Mimi).

Get the most out of this chapter by having your camera and camera manual nearby while you read it. Because every camera is slightly different, you may want to see where certain controls are on yours as we discuss them.

Explaining Photography Fundamentals

Three important camera settings in photography interact to produce your final photo: ISO (also called *film speed*), aperture, and shutter speed. Whether you're shooting with a *digital single lens reflex camera* (digital SLR) or a *compact digital camera* (CDC), you must consider these technical elements before taking your photo. Although they're each separate elements unto themselves, they work together to establish proper exposure.

A digital SLR camera gives you more control than a CDC over these settings. Some CDCs purposely mask these settings and replace them with user-friendly modes like "portrait," "landscape," and "sport." Regardless, having a good understanding of camera setting basics goes a long way toward figuring out what mode your CDC should be set to. Now it's time to dive into the details of the basic settings.

Investigating ISO

Your *ISO setting* is a number that represents how sensitive to light you need your camera's sensor to be. The amount of available light you have is the major determining factor here. If you have a lot of light, your camera doesn't need to be very sensitive, so you can set your ISO to a low number (for example, a typical ISO setting for daylight shooting is 100). If, on the other hand, you don't have much light, your camera needs to be really sensitive. For example, if you're indoors, you need to bump up your ISO to a higher setting. The amount of light available indoors varies greatly depending on how much artificial light you have and whether any windows let in natural light. If you find yourself in a fairly bright indoor space with lots of natural light flooding in, you may have to increase your ISO only minimally (to 320, for instance). If you're in a very dark space, you need to increase your ISO much more drastically (to 600, for example). Take a moment to look at your own camera and scroll through your available ISO settings so you know what you have to work with. ISO settings vary from camera to camera, but a standard range of ISO settings in full-stop increments is 100, 200, 400, 800, and 1600. Further ISO options may be available if your camera works in half-stop increments or smaller. For example, your camera's ISO settings may be 100, 125, 160, 200, 250, 320, 400, 500, 640, 800, 1000, 1250, and 1600.

You want to always keep your ISO as low as possible because the higher you push your ISO number, the more grain you see in your final photo, which can result in poor image quality (see Figure 4-1). The better your camera is, the less you have to worry about this, but pushing the ISO too far is a concern that should always be in the back of your mind.

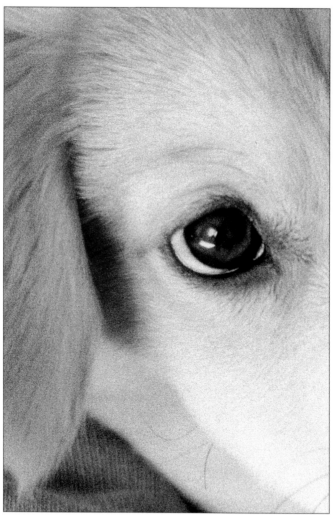

50mm, 1/500 sec., f/1.8, 800

Figure 4-1: This detail depicts the grain (and subsequent degradation of quality) that occurs at high ISO settings.

Appreciating aperture

Simply put, your *aperture* (or *f-stop*) setting dictates exactly how much light passes through the camera lens. The aperture setting can be a confusing topic because your aperture's physical size (the hole that light passes through) corresponds to a number that seems to have been created on "opposite day." The larger the aperture opening, the *smaller* the f-stop; you can see what we mean in Figure 4-2. If you set your f-stop to a low number, your aperture opens widely. If you set your f-stop to a high number, your aperture opens only slightly.

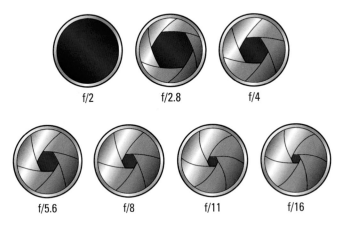

f/2 f/2.8 f/4

f/5.6 f/8 f/11 f/16

Figure 4-2: The larger the physical opening of your aperture, the smaller the corresponding f-stop number is, and vice versa.

When we refer to aperture settings as "large" and "small," we're describing the actual physical size of the opening, not the f-stop number that represents it. For example, you can think of your "large" f/1.8 aperture as the size of a quarter and your "small" f/22 aperture as less than the size of a dime.

Not only does the aperture setting tell the camera how much light to let in; it also dictates the amount of *depth of field* present in your image (that is, how much of your foreground and background appear sharp). Manipulating your depth of field is a fantastic way to choose exactly what you want (or don't want) to draw the viewer's eyes to. Aperture settings vary from camera to camera — some use quarter stop increments while others use half- or third-stop increments — but a full range of aperture settings in whole-stop increments looks like this: 2.8, 4, 5.6, 8, 11, 16, and 22.

Focal length, as well as ISO and shutter speed, also affects the depth of field in your final photo. *Focal length* is the distance (measured in millimeters) between the center of the camera's middle lens and the point at which everything is in focus. It essentially represents how much magnification a lens

gives an image. If you look at your own lens, you'll see a range indicating how much your lens can magnify an image.

At any given f-stop, the longer your focal length is, the less depth of field you have. This means that an image taken at a focal length of 100mm and at an aperture setting of f/8 appears to have much more *bokeh* (a blurred background) than the same image taken at 24mm.

Noticing a pattern? Most elements of photography are dependent on, and affected by, other elements, which is exactly why photography is such an artistic expression. Two people who photograph the exact same thing can theoretically end up with extremely different photos, depending on the individual settings and factors (like focal length) they choose.

Soaking up shutter speed

Your *shutter speed* dictates how long your shutter stays open and allows light to hit the camera's sensor, or "exposes" the shot. Shutter speeds are measured in fractions of seconds, like 1/125 second, 1/250 second, and 1/500 second. The faster your shutter speed, the faster the exposure takes place, meaning that less light is allowed to penetrate the camera's sensor as the shutter speed setting increases. Your shutter speed also affects whether you're able to freeze the motion of a fast-moving subject. A faster shutter speed — like 1/1000 second — is a good starting point for freezing a fast-moving subject. A slower shutter speed — like 1/125 second — is fine for a photo of your dog sitting still, but as soon as Teddy takes off, you need to quickly increase your shutter speed and compensate your f-stop or ISO accordingly. Otherwise, you're left with nothing but blur.

Just as your lens's focal length affects aperture, it affects shutter speed as well. Longer focal lengths inherently require a faster shutter speed in order to avoid blur from hand-held camera shake. The general rule of thumb is to always use, at a minimum, a shutter speed equivalent to your focal length. For example, if your focal length is 60mm, choose a shutter speed faster than 1/60 second, and if your focal length is 200mm, choose a shutter speed faster than 1/200 second, even if you're shooting a fairly static subject.

Working with Your Camera Settings

Now that you have an understanding of the basic elements that go into getting that perfect shot, you may be wondering how to control them. All digital SLR cameras (and some CDCs) come with a few standard modes and settings you should become familiar with. Today's cameras literally have thousands of different setting combinations and custom function capabilities that can quickly become overwhelming. You don't need to memorize that phone book-sized manual that came with your camera (extra points if you do!), but you

should familiarize yourself with the following settings and techniques that we reference throughout the book.

If you're working with a CDC, now's the time to check whether your camera has aperture-priority (AV) and shutter-priority (TV) modes. Having the ability to work in AV mode means you can manually set your f-stop as you'd like while your camera automatically chooses your shutter speed. Conversely, having the ability to work in TV mode means you can manually set your shutter speed as you'd like while your camera automatically chooses your f-stop. If your CDC doesn't have AV or TV modes, make sure to read the "Maximizing Your Compact Digital Camera" section later in this chapter.

Focusing on autofocus

One of the most critical things you do when you take a photo is focus on your subject, and if you're reading this book, your subject is most likely a quick-moving dog! Unless you set up for a shot of Riley sleeping, we highly suggest using your camera in autofocus mode. Using autofocus allows for much quicker focusing and all-around better results. Today's cameras are so sophisticated that we can almost guarantee your camera lens has better vision than you! Your *focus mode switch* is actually on the side of your lens, not on the camera body itself. You'll see two options — AF (for *autofocus*) and MF (for *manual focus*). Make sure your switch is set to AF (as shown in Figure 4-3) because that's the mode we assume you're in throughout this book.

Figure 4-3: Look for your focus mode switch on the side of your lens.

You can access some additional AF options through settings on your camera body: *AF mode* (different from the focus mode switch) and *AF point selection*. Here we explain what these AF options do; later in the chapter, we explain how to use them in your photography.

AF mode

Within your AF mode setting, you have three options:

- ✔ **One shot:** In this mode, when you press the shutter release halfway, your camera locks focus *once*. This is typically your camera's default setting and works wonderfully for still photos like portraits.

- ✔ **AI servo:** In this mode, when you press the shutter release halfway, your camera *continuously* focuses on your subject. This setting is typically used when photographing action.

 Not all camera terminology is created equal. If you're having a hard time finding AI servo, look for words like *tracking AF, predictive autofocus,* or *focus tracking.*

- ✔ **AI focus:** In this mode, your camera is set to one shot but automatically switches to AI servo if your subject starts to move.

One of the biggest complaints we hear time and time again goes something like this: "My dog is too fast! Even at the fastest shutter speed, I just can't get a sharp photo!" People get very emotional about this issue, but don't worry — we're here to help. Take a deep breath, stay calm, and know that it's all going to be okay.

Nine times out of ten, the culprit is the AF mode. When you're dealing with a fast-moving subject, getting a crisp photo can be nearly impossible because, between the moment your camera locks focus (at the halfway mark of pressing the shutter release) and the moment you actually release the shutter, your speed-demon dog is still moving. However, your camera is focused on the position your dog was in a millisecond ago. To combat this issue, simply change your AF mode to AI servo so that your camera continues to adjust focus on your moving subject up until the moment you take the image.

AF point selection

Your AF point selection setting tells your camera exactly which AF point to use. To choose a specific AF point, do the following:

1. **Find the AF point selection button on your camera body and press it.**

2. **Look through your viewfinder (or at the LCD panel) to see all the AF points lit up.**

3. **Slowly spin the dial near your shutter release button to see the AF points light up one by one.**

4. **Simply stop spinning the dial when you land on the AF point you want to use**.

By default, your camera is set to "automatic AF point selection." You know this because when you look through your viewfinder and press the shutter release halfway, you see *all* the AF points light up. In this mode, you're at the mercy of whatever your camera decides is most important to focus on (like the tip of Quincy's nose instead of her eye). Remember to take back auto-focus control by choosing one specific AF point instead!

If you're using a single AF point in AI servo mode, move your camera with the subject (see Chapter 8 for more on tracking your subject), making sure that your AF point overlays your subject. Otherwise, your camera will focus on whatever that AF point hits and *not* on your dog.

Experimenting with depth of field in aperture-priority mode

Manipulating your depth of field is a fantastic way to home in on specific details of your image and draw the viewer's eye exactly where you want it. In Figure 4-4, you see the same image side by side, but each image tells a very different story. The photo on the left was taken with a very small aperture (f/18) and would likely be described as a woman and her dog enjoying a view of the distant city. This photo has great depth of field, which keeps the sub-jects and the distant view all in focus. Equal weight is given to the subjects and the background; neither really stands out from the other. Conversely, the photo on the right was taken with a very wide aperture (f/2.8) and would likely be described as a woman and her dog bonding. This photo has very shallow depth of field, which keeps the subjects in focus but blurs the view of the city. The effect that your aperture has on your final image is dramatic, to say the least!

When working with a very small aperture, you let in very little light, which may result in you needing an extremely slow shutter speed. The image on the left in Figure 4-4 was photographed using a tripod because it called for such a slow (0.4 second) shutter speed. Because the photo's subjects were sitting still, a slow shutter speed was okay to use.

Use aperture-priority (AV) mode when you want to make deliberate decisions about the depth of field in your final image. To work in AV mode, simply set the mode dial on your digital SLR to AV. Then you can freely flip through your f-stop settings until you land on the f-stop you want. The exact dial or button you use to change your f-stop varies from camera to camera, so check your manual if you're unsure of how to do this.

When working in AV mode and shooting with a shallow depth of field (a smaller f-stop number), try to accurately focus on the exact area that you want in focus because much of the shot consists of bokeh, the purposely out-of-focus areas that are rendered as a soft, creamy blur.

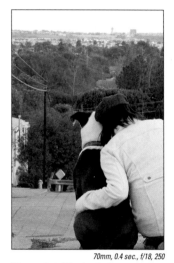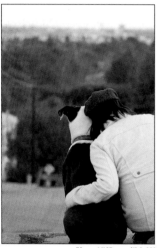

70mm, 0.4 sec., f/18, 250 70mm, 1/125 sec., f/2.8, 250

Figure 4-4: Manipulating your aperture from one photo to the next can yield dramatically different results.

Sifting through shutter speed in shutter-priority mode

If you're more concerned with capturing action than managing the amount of bokeh in your shot, *shutter-priority mode* (TV) is the way to go! When working in shutter-priority mode, you can set your desired shutter speed, and your camera chooses the appropriate aperture based on the amount of available light and your ISO setting. Setting your shutter speed accurately can be the difference between ending up with a white streak across the middle of your image and a crisp, frozen shot of Brecken in mid-air.

Shutter-priority mode is most important to use when you're dealing with a subject in motion. To work in TV mode, simply set the mode dial on your digital SLR to TV and then you can freely flip through your shutter speeds until you land on the shutter speed you want. The exact dial or button you use to change your shutter speed varies from camera to camera, so check your manual if you're unsure of how to do this.

Exposing exposure

Your aperture, shutter speed, and ISO each serve a very specific function, but more important than their individual jobs is the relationship among them that allows you to take a properly exposed photo. *Exposure* is the amount of light it takes to develop your image. You may be familiar with the terms *underexposed* and *overexposed,* but in reality, exposure is more of an artistic preference than a steadfast rule. What looks good to you may, in fact, look overexposed to another photographer and vice versa. Instead of spending

time understanding "proper" exposure (which, in our opinion, doesn't even exist), read on to familiarize yourself with the unique inverse relationship that aperture, shutter speed, and ISO possess.

Much like shutter speed and f-stop, exactly how you set your ISO depends on your individual camera, so check your manual if you're unsure. Many digital SLR cameras have an easily accessible ISO button on the camera body, while most CDCs have this setting buried within the camera's menus.

Exposure is measured in units called *stops,* and every time you adjust your exposure by a stop, you either double or halve the light that reaches your camera's sensor. For example, if you're shooting at 1/250 second at f/5.6 on a setting of ISO 200 and you change your ISO to 100, you effectively decrease your exposure by one stop. For your image to remain at the same exposure, another setting needs to compensate (either aperture or shutter speed) in the *opposite* direction. In photography lingo, this is called *reciprocity.* Now that your camera is set at ISO 100 and is essentially letting less light in, you can choose a larger aperture opening by changing your aperture setting to f/4, or you can choose a slower shutter speed by changing your shutter setting to 1/125 second. Either of these compensations accomplishes the same thing — allowing in more light to compensate for the reduction of light that occurred when you "stopped down" your ISO.

This compensation is exactly what your camera automatically does for you in AV and TV modes. At this point you may be wondering why you should waste precious space in your brain for this information if your camera can take care of your settings automatically. The answer? You have *way* more options when you choose your own settings! Consider this situation: You're outside on a sunny day and you're trying to photograph Missy zipping back and forth through a large field. You set yourself up in TV mode, choose a shutter speed of 800, an ISO of 100 (it is sunny, after all), and begin to snap away. Problem is, at these settings, your camera automatically chooses a very wide aperture, like f/4.5. Because Missy is so far away, your camera probably doesn't have the depth of field that you need (despite how perfect your shot is, Missy still seems a tad fuzzy). You want to shoot at a smaller aperture — like f/8 — but your camera tells you that it's not possible! Consider the rule of reciprocity and do the following:

1. **While remaining in TV mode, decrease your shutter speed one stop at a time as you count how many increments you have to go until your camera chooses f/8 for the aperture.**

 As an example, say you have to change your shutter speed five increments (to 1/250 second) before your camera automatically chooses f/8. Because 1/250 second is far too slow to capture Missy in action, you need to use the rule of reciprocity so that your camera is set at *both* the f-stop and shutter speed you want!

2. **Bump up your ISO setting five increments.**

 In this example, that puts you at ISO 320.

3. **While still in TV mode, change your shutter speed back to 1/800 second.**

 Now, when you look through your lens you see that your camera is magically choosing f/8, your desired f-stop!

4. **Compose your photo and snap away!**

Overwhelmed yet? Try not to fret! This concept can take some time to fully understand. It didn't totally click for Kim until she paired the concept with a phrase she knew she'd always remember. Now, whenever she needs to jog her memory on the topic of reciprocal exposure, she thinks back to the famous Newton law that states, "For every action there is an equal and opposite reaction." And voilà . . . reciprocity in a nutshell!

Distinguishing between drive modes

Another important camera setting is your *drive mode.* Typically, your drive mode is set to *single shooting,* meaning that every time you press the shutter release, your camera takes one (and only one) shot. When shooting quick action, switching this setting to *continuous shooting mode* (also called *high speed burst*) can be helpful. Now when you hold down the shutter release, your camera snaps off as many frames as it can in one burst. This mode is especially useful for action photos, but it's not a bad idea to always have your camera set to this when photographing difficult subjects like dogs to better your chances of getting that money shot!

Exploring Common Techniques

After you have all these fancy camera settings under your belt, you can use a few tricks of the trade to make the most of them. With *selective focusing,* you take control of exactly what's in focus, regardless of which AF point you use. By *panning,* you can add a sense of motion to your background elements without compromising the action.

Practicing selective focusing

If you're using a single AF point for more focus control, understanding how to use selective focusing is imperative. Without this technique, you have to quickly change your selected AF point every time you want to move the subject within your frame. Instead of constantly rotating AF points, follow these steps for selective focusing:

1. **Press the AF point selection button and choose a single AF point to work with.**

2. **Align your chosen AF point (the only one that's red when you look through the viewfinder) with the exact area you want to be in focus, be it your dog's eye, nose, or ear.**

3. **Press your shutter release halfway to lock focus.**

 Don't worry about your composition yet; just make sure your AF point overlaps the area you want in focus.

4. **While keeping the shutter release pressed halfway, recompose your shot until you have the composition you want.**

5. **Continue pressing the shutter release all the way down to take the picture.**

 Remember, you're not releasing from the halfway point and then fully pressing the shutter release; you're going directly from halfway-pressed to fully-pressed — capiche?

When choosing your AF point, try to choose one that's relatively close to the point you're focusing on. For example, if your dog's eyes appear in the top half of the frame, don't choose AF points from the bottom half of the frame. If you have to drastically recompose your shot after locking focus, your focus may not be as accurate.

Selective focusing is one of those techniques you'll use in just about any situation, but it's especially important when shooting close-ups or details with shallow depth of field. Chapter 9 provides plenty of ideas for practicing your selective focusing skills.

Panning for motion blur

Panning is a technique that photographers use for some very unique-looking action shots, but panning takes a lot of practice. Even the most skilled photographers have to take lots of panned shots before getting a decent one. To create motion blur, track your subject while shooting at a slower-than-normal shutter speed for an effect in which the background is blurred but your subject remains fairly focused (Chapter 8 has more details on taking action photos). In order to achieve this look, do the following:

1. **Press the AF point selection button and choose the center point.**

2. **Put your camera in AI servo mode.**

3. **Set your camera to continuous shooting mode.**

4. **Change your shutter speed to 1/60 second.**

5. **Align your AF point on your dog, press your shutter release halfway, and have him run straight in front of you while continuously tracking him with your AF point.**

6. **Press and hold down the shutter release while you continue to track your dog.**

7. **Let go of the shutter release while you continue to track your dog.**

8. **Check out your photos and repeat until you've nailed it!**

Your success with this technique is largely determined by your ability to smoothly pan at the same speed at which your dog is moving. Pick a spot (like his eye or collar) as a marker to focus your AF point on. Also, keep in mind that your subject doesn't always have to be totally crystal-clear; experiment with what looks good to you!

For Figure 4-5, Kim spent well over an hour specifically shooting panned action photos. More than 200 frames later, she ended up with only a few keepers, but the dramatic sense of motion in the image was worth the effort.

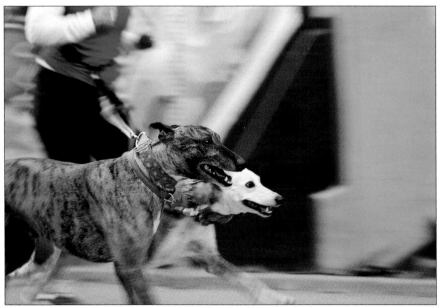

55mm, 1/60 sec., f/2.8, 200

Figure 4-5: Use panning to add an exaggerated sense of speed to your images.

Maximizing Your Compact Digital Camera

You don't need a digital SLR for dog photography, but if you're working with a compact digital camera, it's still important to understand camera basics if you want to make the most of your camera. In today's market, some CDCs even come with higher-end settings like aperture-priority mode, shutter-priority mode, and even AI servo functionality. If yours does, follow the guidelines we provide in this chapter. If not, start by familiarizing yourself with your CDC and take note of all the different settings (or "scenes") it offers.

CDCs are meant to be very user-friendly and to make sense to even the most novice photographer out there. Unfortunately, this design can sometimes mean that the process is so automated that you lose all control over how your images look. However, with a solid understanding of the various modes offered on your camera, you can easily take back that control by choosing your modes wisely. Most CDCs come with the following modes:

- ✔ **Portrait:** In *portrait mode,* your camera automatically chooses a wide aperture (that is, a small f-stop number like f/4), giving you shallow depth of field. When you're shooting a portrait, your subject is generally the focal point of the image, so creating an out-of-focus background makes the subject stand out even more. If your camera doesn't offer AV mode, consider using portrait mode whenever you need shallow depth of field in your dog photos.

- ✔ **Landscape:** In *landscape mode,* your camera automatically chooses a very small aperture (that is, a larger f-stop number like f/16), giving you great depth of field so that even distant objects are still in focus. Even if your subject isn't a distant landscape, use this mode when you're in need of a larger f-stop number. But remember that you likely need a lot of light for this mode (or a higher ISO setting). Because your camera is forcing such a small aperture and letting in very little light, it has to compensate by choosing slower shutter speeds.

- ✔ **Sport** (some cameras refer to this mode as *kids and pets*): In *sport mode,* your camera automatically chooses a very fast shutter speed to freeze your subject in motion. Choose this mode for action photos of your dog running or playing. If you want to experiment with the panning technique we discuss in the "Panning for motion blur" section earlier in the chapter, try using portrait mode instead of sport mode for that motion-blurred background effect.

- ✔ **Night:** In *night mode,* your camera chooses a slower shutter speed and also fires your flash for low-light situations. When it comes to dog photography, you probably want to stay away from this mode unless you're looking for those irresistible glowing alien eyes.

✔ **Macro:** In *macro mode,* your camera not only chooses a very wide aperture (that is, a small f-stop number) but also allows you to focus on a subject extremely close to your lens. This setting is usually reserved for photographing still subjects (like flowers) in detail, but don't let the little flower icon fool you; this can be a very useful setting in dog photography as well! If you find that portrait mode doesn't give you a blurry enough background for your liking, experiment with macro mode. Just remember that you have to get in very close to your subject, so consider photographing Bubu asleep as opposed to darting around the yard.

Although many CDCs come with prepackaged settings and fancy bells and whistles, these modes aren't fail-safe. Be sure to test out all the different modes and don't be afraid to stray from the suggested settings if you find better results in a different setting. On some cameras, we've found the AI servo setting to be very helpful, but it makes matters worse on other cameras.

One of the best ways to master your camera modes is to keep a journal of what mode you're in for each shot. It may be a little tedious, but after one or two journaling sessions, you'll have your settings down.

As you can see from the various modes that your CDC offers, many of them are related to your camera's aperture setting. Although you may not be able to fine-tune your settings to the point that a digital SLR user can, you still have a lot of control over your camera's settings!

Developing an Artistic Eye: Composition

You know the scenario. Lucky starts doing something cute or amazing, prompting you to get your camera and start clicking away. After a feverish few minutes, you look at the LCD with disappointment. "*That* doesn't look like what I imagined it would! What went wrong?" Well, a fascinating subject does not a great photograph make. Having the basic technical knowledge is helpful, but it's not everything. Anyone can hold a camera, aim it in a general direction, and press the button. But the true art of photography starts with understanding composition.

Composition is all about looking at a subject in an environment, figuring out what story you want to tell, and knowing how to manipulate yourself and your camera to create that specific image. You can photograph Lucky in a given situation in hundreds of ways, and each little variation alters the final product. Composition is how you set up the relationship among the elements in your photograph so that your photo portrays *your* personal interpretation and perception of the scene. We could spend many pages discussing composition, but for now, we start you off with a few hearty basics. (For a more in-depth look at composition, pick up *Digital Photography Composition For Dummies,* by Tom Clark, published by John Wiley & Sons, Inc.)

Following the rule of thirds

When lining up a shot, it's practically instinct for beginning photographers to put the subject of their photo right smack in the middle of their frame, but other options often make the photograph more interesting.

The *rule of thirds* is a concept that suggests dividing your frame into thirds, as shown in Figure 4-6. Imagine drawing two vertical lines through your frame, one a third of the way from the left side of the frame and the other a third of the way from the right. Then imagine drawing two horizontal lines, one a third of the way from the top of the frame and the other a third of the way from the bottom. (It would look like a tic-tac-toe board.) Your goal is to keep your subject and other key elements out of the center area, and instead, aim to put them in the frame's thirds (that's either the top or bottom or one of the sides). Doing so can often result in a much more dynamic and interesting photo to look at and is the first step toward building your story about Lucky.

To add extra power to your subject in the English-speaking world, line Lucky up in the left-hand third (because we read left to right).

Eyeing your background and perspective

Your subject should always remain the star of the show. A big part of that is making sure your background is just that — the background. The background shouldn't pull attention from the key elements in the photograph but rather support them in a meaningful and tasteful way.

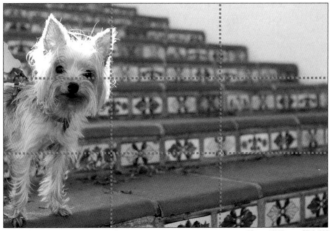

38mm, 1/125 sec., f/3.2, 200

Figure 4-6: This portrait exemplifies the rule of thirds.

Say you and Lucky are at the park after a rousing game of fetch, and you want to capture her post-play bliss. Before you even plop down, do a quick scan of the area to find the best, least-distracting background. Choose a grassy patch out of the way instead of that bench right in front of the basketball court. Having a blanket of green behind Lucky allows her to shine as the subject while still telling a story about where she is (as riveting as it is, you don't want the shirts versus skins throwdown pulling attention away from Lucky). After you're in your spot, look through your lens so you can home in even further on the exact scene your camera is capturing. Pay attention to distractions like litter, sticks, or dirt patches. Some distractions are okay, but try to keep them to a minimum.

You determine *perspective* by where and how you place your camera in relation to the subject and other key elements you're photographing, and perspective determines a lot about the story you tell. Decide which element is most important and highlight that.

Say you're still in the park with Lucky and you want to communicate how much she loves playing fetch. You could put her mangled ball in front of her and focus on that while she lies behind it. The viewer would see the details of the ball — doggie slobber, teeth marks, and bits of grass — and would also see Lucky in the background, gazing lovingly at it. Such an image conveys how much she plays without her even needing to be in action.

Alternatively, you could leave the ball out of the picture and instead focus on the details of Lucky's face, like her lolling tongue and smiling eyes. Position your camera lower than Lucky and photograph upwards to capture the full feeling of triumph Lucky has after conquering the ball. Viewers don't need to have the ball in the photo to understand the feeling Lucky has; the angle takes care of it.

In general, if you want to celebrate your subject, you can use the technique of positioning your camera low and photographing upwards. Getting above her and photographing downwards helps you incorporate environmental elements. Try from the side and see what happens. Let your imagination run wild!

Framing the subject

A viewer has a lot of places to look within a photograph. When you want to put some extra power behind drawing your viewer to your subject, you can use a technique called *compositional framing*. It's kind of like superimposing a gigantic, flashing neon arrow onto your photo (but a lot more clever and way less totally 80s). Here's how it works: You find something that's in your environment, whether you're indoors or out, to act as a frame for your subject. Placing the subject inside a natural frame adds weight to the subject and draws the viewer's eyes right to it.

In Figure 4-7, Kim was photographing Emma and her mom standing in a gazebo and used the railings to perfectly frame them both. Inside, you can use things like doorways (also known as door*frames*), fireplaces, and staircases. You can use tree branches and leaves to frame outdoor scenes.

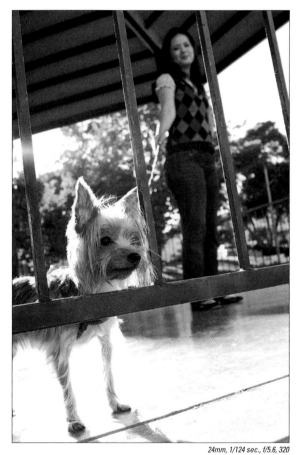

24mm, 1/124 sec., f/5.6, 320

Figure 4-7: Framing your subjects emphasizes their importance.

Choosing what to leave in and what to leave out

You don't always have to include all of the scene or subject in your image. Sometimes you can create a much more interesting image by leaving things out. When photographing your dog, cropping creatively can really bring certain details to light. For example, instead of photographing Lucky head

on standing in the grass with her ball, try getting a shot of just her back end from the side so you can capture her wagging tail. Or maybe zoom in just to get a detail of her dirty paws, leaving the viewer to guess how she got them.

You can also leave an area around your subject that's completely void of any elements and is only one color. When you do, you're using *negative space*. You can use this technique when you have distracting elements in your frame or you simply want to add extra emphasis to the subject. You can position your camera so that you have your subject in one of your thirds with negative space filling up the rest of the frame.

The opposite of using negative space is *filling the frame*. You use this technique to create an up-close and personal sense of "being there." If you want your subject to really shine, consider eliminating the background elements altogether and zooming in close for a more intimate photo.

Establishing balance

Visually speaking, balance is bliss. When you're photographing, your goal is to create images that keep your viewer's attention for as long as possible. Having good balance encourages that. In basic terms, balance means that, from top to bottom and/or left to right, your image possesses elements of equal weight, otherwise known as *symmetry*. Sometimes, you're not able (or don't want) to achieve symmetry, so you can use the *informal balance technique*. In this technique, you find something just as interesting (even though it's not the same size or shape) to place on the opposite side of your subject.

Figure 4-8 of Mac running alongside the pool uses symmetry to the max. Not only do the two trees on his left and right balance the scene, but the pool reflection adds even more balance to the top and bottom of the image.

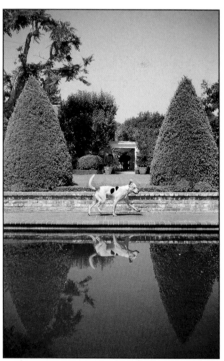

25mm, 1/640 sec., f/3.5, 100

Figure 4-8: Create a sense of balance by adding symmetry to your images.

Creating Images in Color versus Black and White

All digital cameras record color photographs by default, but most have a *monochrome mode* for black-and-white photography. It's up to you which mode you prefer to shoot in, but we suggest always shooting in color for more flexibility. You can always change a photo to black and white in post-processing, but you can't change a photo originally taken in black and white back to color. Changing your photographs to black and white is an artistic decision that dramatically affects how viewers perceive your final image. For more on postprocessing, see Chapter 12.

Using color strategically

Just because your camera shoots in color doesn't mean that everything you create has to be in color, but you should use color strategically. When shooting in color, be aware of what's surrounding your subject and try to complement it. For instance, if your dog is a dark color, position him on a light-colored carpet or couch. Conversely, if your dog is white, don't photograph him against a white wall that he blends in with. Keep the following tips in mind whenever you shoot in color:

✔ Look for bold colors you can use as a background, like a bright red couch, a turquoise building, a yellow garage door, or even a brightly colored wall of graffiti.

✔ Choose props, like toys, based on their colors. If your dog is sitting pretty on a bright orange couch, like Alamo in Figure 4-9, go for the blue toy as opposed to something that would clash, like red.

✔ Consider the psychological effects that colors have and use this effect to evoke a feeling from your viewers. Cool tones like blue and gray aren't as cheery as warmer tones like orange and red. If you're setting the tone for a quiet, serious moment, stay away from the bright and happy spectrum of the color wheel.

✔ Change your point of view for even more options. If you're outdoors on a clear day and you photograph from below, like Kim did in Figure 4-10, you may have a gorgeous blue background at your disposal.

34mm, 1/250 sec., f/8, 250

Figure 4-9: Make use of colors that complement each other when choosing backgrounds and props such as toys.

50mm, 1/200 sec., f/2.8, 125

Figure 4-10: Use a blue sky as a background by photographing from below.

Setting a mood with black and white

For us, black-and-white photography is all about setting a mood. Because you're stripping out all the color from your photograph, it becomes *just* about your subject, composition, and story. You may feel like you're removing an important part of your image by converting it to black and white, but if used judiciously, taking away color can actually *add* to the strength of your image.

Consider Gus in Figure 4-11. The color image on the left depicts a cute puppy posing for the camera on what appears to be a gloomy day. The grass he's sitting on isn't uniform in color and creates a somewhat distracting pattern that pulls attention away from Gus. In contrast, the black-and-white image on the right removes the distracting background color, which gives more weight to Gus's expressive eyes — exactly where Kim wanted to draw the viewer.

You Don't Have to Be a Pro to Shoot Like One!

Dog photography is a booming industry filled with professionals who are talented at capturing amazing images of dogs. They've mastered the skills mentioned in this book, but you don't have to be a professional to try this stuff out for yourself! You can learn and practice everything here no matter what level you're at! A few skills go a long way. Even just locking in one skill improves your photos. Being an amateur doesn't mean you can't employ a few professional yet simple techniques that make it seem like you belong with the big dogs!

50mm, 1/500 sec., f/1.8, 100 *50mm, 1/500 sec., f/1.8, 100*

Figure 4-11: Converting your color photos to black and white can completely change the mood of your image.

Before the photo shoot

A photo shoot starts before you even take your camera out of the bag! Thinking through your session and mentally preparing for what's ahead helps ensure that everything runs as smoothly as possible. When working with dogs, don't underestimate the importance of the pregame!

The first thing you want to do is make a game plan. Doing so is especially important if you're photographing someone else's pooch, but thinking through your plan even when you're working with your own dog can help make your experience a successful one. Figure out ahead of time how things are going to work. Think about your dog specifically and what sort of flow makes the most sense. You can even draw up an outline, noting specific shots you don't want to miss. Keeping some structure helps and adds a level of calmness to the shoot. You may not have total control over your dog, but you do have control over your own actions. Don't forget to think through contingency and alternative plans (for example, what happens if the park you thought was going to be empty isn't, or your dog suddenly doesn't like the treats that you've stuffed in your pockets?).

After you have a plan, familiarize yourself with the photo shoot's location. You'll probably use a location you already know, like your own house or yard, but if you want to use a public place, make a trip there ahead of time without your dog. Pay attention to the quality of light, available backgrounds, and amount of traffic. Spend some time scouting out different angles (don't

forget to get low, because that's where the dog is). Know where things are and what's allowed (we don't want anyone getting arrested here!). If you can't make a special trip, spend a few minutes before you start photographing to get oriented to the lay of the land.

Even if you're in your own home, looking around the house through the eyes of a photographer (sounds fancy, doesn't it?) is a good idea. You'll probably be surprised at the ideas that come to you or the things you notice that you hadn't noticed before. (And if anyone starts asking why you're crawling around from room to room on all fours, tell them to "stop interrupting your creative process" and keep going.)

During the photo shoot

Anything can happen during a photo shoot. No matter how much you plan, photographing dogs can quickly turn chaotic and frustrating. Having a few techniques up your sleeve to deal with the unexpected is definitely helpful.

Slow and steady: Introducing the camera

For some dogs, new things are exciting and interesting, but for others, they can be scary. Even if your dog is on the confident side, get down on the ground and let the dog sniff your camera and equipment before you start — maybe even days ahead of time, if your pooch is on the extra timid side. As he's checking everything out, make sure to praise him and tell him what a good boy he is. You can even offer a treat if you need some extra positive reinforcement.

After your dog seems at ease around the camera, you can try raising it and pointing it in his direction. Again, take it slowly; don't make any sudden movements. Keep praising him for doing such a good job. Then try clicking off a frame to see how he reacts to the sound. Again, reward him when the camera goes off so the experience becomes positive. The goal is to make the camera as nonthreatening as possible in your dog's eyes before you pick it up and start rapid firing.

Staying calm

Dogs read energy as one of their main sources of information and often respond to people like little mirrors. If you're happy, your dog is happy. If you're angry, your dog tenses up. No matter what happens during your photo shoot, you must act like it was supposed to happen. Stay as calm and non-reactive as possible. When you stay calm, you make better decisions and you can creatively solve problems as they come up. Your dog also feels more at ease when he knows you're calm, cool, and collected.

Treating, squeaking, and drawing attention

To get those shots where your dog is looking right at the camera, you have to draw his attention to the camera with something he likes. For a lot of dogs, this means treats; for others, it means a squeaker or a toy. Place objects as close to the lens as possible (sitting right above or below or to the side . . . or even touching it sometimes) to get the dog to look right at you, and snap away!

Drawing out a camera-shy dog

Patience is the key with a camera-shy dog. Because the dog is experiencing fear, the goal is to help him build up confidence and to feel secure around the camera. Doing so takes a while, but it's totally possible. If your dog exhibits signs of fear around your camera, follow these steps to desensitize her:

1. **Sit on the floor with your camera in your lap and allow your dog to approach at her own pace.**

 Talk in a high-pitched "happy" (but soothing) voice and praise her as she starts to move toward you.

2. **Provide treats when she gets close enough to you and allow her to sniff your camera while it remains in your lap.**

3. **After she sniffs the camera, be sure to provide more treats.**

4. **Raise the camera a few inches off of your lap very slowly while watching how your dog responds to this action.**

 If she backs up in fear, you've probably raised the camera too high or too fast on your first try, so work in smaller increments. Each time you raise the camera and your dog stays near or moves closer to investigate, praise and treat her.

5. **Continue to raise your camera in very slow increments while rewarding her at each stage, until the camera is high enough to look through the viewfinder.**

6. **When you're able to raise your camera without Trudy running for the hills, press your shutter release, give her a treat, and then rest.**

 Pet and reassure her, and then repeat. Keep it slow, and stay tuned to how Trudy reacts because she'll always let you know if you're moving too fast.

Never force a dog when she's scared. The goal here is to build up trust and confidence. If you start forcing her to do something she's afraid of, she'll lose trust in the activity and possibly lose trust in you in general. If she's not ready for something, your job is to wait.

Desensitizing a scared dog to the camera may take some time, but with enough patience, they always seem to come around. It's all about making this a positive, fun experience, so reward every bit of progress, no matter how small! Keep your voice calm, and try not to raise it too loud, even when you're praising. Any jump in tone or volume can sometimes alarm a timid dog. If you find yourself getting frustrated, take a break and try again later!

Dealing with a vocal dog

Dogs bark for all sorts of reasons. Sometimes they're scared, sometimes they're demanding, and sometimes they're just being needy. If your dog's barking starts up during your photo session, you can try a change of scenery or change what you're asking him to do. If it's still a no-go, get creative. He can't bark if his mouth is occupied by something else, so try giving him a toy, bone, or treat. Snap a few off when his mouth is busy (but don't underestimate the power of a photo of him mid-bark either!).

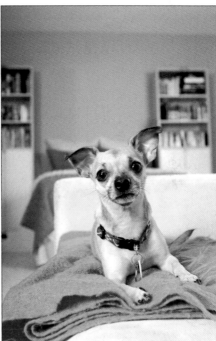

27mm, 1/250 sec., f/4.0, 125

Figure 4-12: Randall looking pretty between barks.

It happens very rarely, but if you happen to encounter a pooch that simply won't give up on the barking no matter what, you can still get some decent closed-mouth photos. One of our all-time favorite clients, Randall, happens to be quite the barker, so we devised a technique during our shoot that enabled us to get some photos of him *not* barking. We found that every time Randall ate a treat, he'd stop barking to eat it, and we'd have about two seconds of bark-free time while he swallowed and caught his breath. Figure 4-12 was captured during those precious two seconds in which Randall was in between barks!

Part II

Fetch! Go Get That Perfect Photo

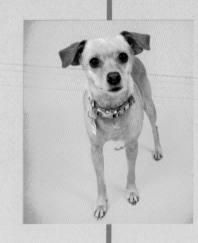

In this part . . .

We hope you're hungry, because this part is the book's real meat and potatoes (or tofu and veggies, for you fellow vegetarians). We break down dozens of ideas for shots into easy-to-digest bites. We let the creativity fly as we take you through different settings, lighting, and even seasons and weather! No matter what kind of photo you want, the examples and instructions in this part help you achieve it!

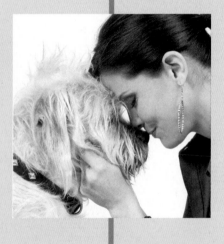

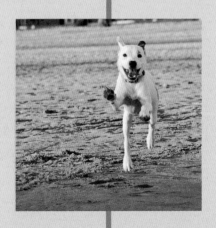

5

Photographing Indoors

▶ Maximizing natural indoor light to get the best photos

▶ Using a built-in or external flash successfully

▶ Choosing unique settings for photographing your dog

*Y*our house is just a house until you fill it with your loved ones, and if you're anything like us, your dog is very much included in the group that makes your house your home and makes your life worth living. The moments that matter the most aren't necessarily pretty, inspiring, award-winning, amazing, or noteworthy. Nope, the moments that matter the most to you are probably those regular, daily routines you share together. You know, the kind where you find Charlie sitting patiently in the kitchen at 8:32 when you're two minutes late putting out breakfast. Or the kind that come after dinner every night when you always play a game of tug. Or maybe Charlie's one of the lucky ones who gets to come to the office with you during the week, and every day, he settles into his bed beneath your desk while you work.

Whether Charlie gets full run of the place or he's relegated to a couple of rooms, whether he's an office dog or he lounges the day away on his favorite chair while he waits for you to come home, the time he spends inside probably makes up the majority of his life. These are the moments and settings that, when stitched together, tell the real story of the life you share.

Because your dog spends so much of his time inside, knowing how to photograph indoors serves you well in your mission to capture your pooch's real-life moments. In this chapter, we cover all the specific points you need to know about indoor photography, and we show you how to make the most of the different places your dog spends his time!

Allowing Light to Determine When You Shoot

Take a second to ponder all the moments of your pooch's life that you want to try to capture. That's the first step to deciding when to pull out your camera. Do you want to photograph mealtime? Playtime? Naptime? Drop-a-stink-bomb-but-blame-it-on-the-cat time? A little mental inventory can go a long way in achieving photographic success!

After you decide which moments you want to catch, you have to take into account the main determining factor of indoor photography: lighting. When photographing indoors, lighting is a big deal.

Different rooms in your house get different light at different times. Make sure the room you use as a backdrop is at its brightest when you photograph in it. If your kitchen gets bright morning light, capture mealtime photos during the breakfast hour. If late afternoon sunbeams pour through the living room windows, take advantage of the richness by taking some shots on the carpet or the couch around 3 or 4 p.m. When we book photo shoots for clients, we always ask them when their home gets the best light, and we plan around that. Figure 5-1 of Jill and her human makes use of the abundant natural light that was flooding into their kitchen through floor-to-ceiling sliding glass doors.

Also, take into account the weather. That may seem weird, given that you're inside, but shooting on a bright, sunny day gives you a lot more light to work with than shooting on a cloudy day. Because most of the natural light outside is blocked by walls (unless you're lucky enough to have floor-to-ceiling windows), you should capitalize on the extra brightness of a sunny day.

42mm, 1/250 sec., f/4.5, 100

Figure 5-1: This image of Jill lying on the floor with her human was taken in the kitchen because it was the room with the most light.

Venturing out to non-home locales

Don't forget about your pooch's favorite places outside of your home! Pack up your camera and Baron and head out on the town to snap some photos of him in places like his favorite doggie boutique, doggie day care, or even Grandma's house. A day on the town together is fun and can yield great images if you do a little prep work:

✔ Go on a scouting trip. Think about the places your dog already knows and loves and pay a little visit to get some ideas.

✔ If you want to take photos in a public place, ask the manager or owner for permission ahead of time.

✔ Choose a time of day that's quiet but also has enough light. You can enlist the manager's help here. For the following shot of Piko, we worked with our friends and owners at Fitdog Sports Club to plan a Sunday morning shopping trip.

✔ Venturing away from home and into public places is an activity best suited to inter-mediate or advanced photographers. You have to manage a lot of elements, and con-ditions can change quickly, so you need to be adept at simultaneously handling your pooch and adjusting your settings on the fly.

✔ Remember to stick with places your dog *likes*. You may think your vet's the cool-est around, but chances are that your pooch doesn't think so. Same thing for your groomer. If your dog does like them, by all means take a trip there. Otherwise, skip it. He'll just get stressed out, and the photos will show it.

24mm, 1/100 sec., f/4.0, 320

Even though the level of light determines what *room* you use as your back-drop, your dog's energy level is what determines *how* he poses. Being in the bedroom doesn't mean you have to make him lie down. If he's ready to play, go with it and get some shots of him bouncing around in the pillows. Or if he'd rather lie on the cool floor of the kitchen than eat his kibble there, be a dear and oblige. Forcing a dog to do something he doesn't want to will be a miserable experience, and your photos will reflect it. Always follow your dog's natural lead.

Photographing Your Dog in His Favorite Places

Time for more mental inventory-taking. Think about the different rooms in your house. Take a little tour, even. That may sound silly, given that you *live* there and all, but taking a spin around the house to figure out what makes a nice backdrop is quite helpful. And remember that although you need a lot of light, you don't need a lot of background. You just need something that's clean enough not to distract from the dog's cute canine mug, such as a painted accent wall, colored couch fabric, or a hardwood floor. Just remember to try and complement your dog's coat as opposed to camouflaging it.

For instance, if you're photographing a white dog, opt for a darker background that he'll stand out from. If you're photographing a black dog, choose lighter background colors instead. Finding a good background to work with is all about having an eye for what shows off the dog the best! Choose places in your home that the dog already likes to spend time in, and position him with your chosen background in mind. Use as much natural window light as possible, but don't position yourself so the windows become the background unless you want to show the dog as a silhouette.

Special Considerations for Indoor Photos: It's All about the Light

Taking photos inside can be a dreadful experience if you don't have the right lighting skills under your belt. Shedding the right amount of light on the situation can make or break your photo. In addition to being adept at the photo basics we outline in Chapters 3 and 4, paying special attention to the amount of light available (or lack thereof) goes a long way toward dialing in the right exposure. More often than not, a seemingly bright room can yield lower-than-expected shutter speeds, forcing you to use your flash just to get a photo. And if you're reading this book, you probably already know one thing: flashes + dogs = glowing alien eyes. To overcome this and other canine conundrums, read on!

Making the most of natural light

Sometimes, you can photograph indoors with natural light if you're careful about choosing the right time of day and the appropriate room to get the job done, sans alien eyes. Capitalize on available light by giving your nosy neighbors a thrill and opening every last shade in your house to determine which room is the brightest. Still not sure? Set your camera to aperture-priority mode, point it toward your desired location, look through the viewfinder, and press the shutter release halfway. Take note of the shutter speed your camera selects and repeat this in your other rooms. The room that has more light yields a faster shutter speed. Now you can be sure you're in the brightest place in the house.

Next you need to determine whether your shutter speed is fast enough to successfully take a sharp image. Even if you're in the brightest room on the brightest day, your shutter may still have to stay open for awhile to achieve proper exposure without a flash. The longer your shutter is open, the more likely it is that you'll end up with a blurry photo, especially if you're holding your camera in your hands as opposed to using a tripod. Personally, the slowest shutter speed we're comfortable using with a hand-held camera is 1/80 second (assuming the dog is sitting still). A better starting point is 1/100 second or 1/125 second, but if you're on the cusp of making the almighty flash-or-no-flash decision, sometimes opting for a slightly slower shutter speed wins out. If you opt for a slower shutter speed, see Chapter 4 for info on avoiding hand-held camera shake, or use a tripod if your dog is maintaining a static pose. A tripod combats hand-held camera shake issues, but it won't do you any good if your subject is moving around.

If you're in the brightest area of your house and your camera still sets a slow shutter speed, you can force it to select a faster shutter speed one of two ways:

- ✔ **Choose a wider aperture.** If you're at f/5.6 and your camera is capable of wider f-stops (like f/4.0 or f/2.8), open up your aperture to let in more light. To compensate for the additional light, your camera chooses a faster shutter speed.

- ✔ **Choose a higher ISO rating.** If you're still having trouble getting to a fast enough shutter speed, bump up your ISO setting. This makes your camera's sensor more sensitive to light, so you don't need as much light to achieve higher shutter speeds.

Bear in mind that you should only increase your ISO to a setting that you're comfortable with. Go too high and your photo starts to look grainy in the shadowy areas. The only way to know what's too high for your own camera is to experiment with your ISO settings and view the results on your computer. Know what your maximum acceptable ISO setting is and try not to surpass it.

If you're working with a compact digital camera (CDC) and don't have the ability to change your aperture, choose a mode like portrait that's likely to default to a wider aperture and increase your ISO setting to avoid triggering that built-in flash. Flip back to Chapter 4 for more on how to maximize the modes offered on your CDC.

Using your built-in flash

When all else fails and you simply can't achieve a fast enough shutter speed with only the available natural light, it's time to turn to your flash for some supplemental light. If that statement induced a cringe, you're certainly not

alone. Flash photography can be one of the trickiest aspects of photographing indoors, but getting that indoor shot of Rocky sans demon eyes *is* possible if you know how to control your flash.

Most digital SLR cameras come equipped with a built-in (or pop-up) flash, as well as a small metal adapter that sits right behind the built-in flash called a *hot shoe*. You use the hot shoe to connect an external flash (more on that later). If you ever shoot in automatic mode, you're probably well aware of your camera's built-in flash, which flings open anytime your camera senses that you don't have enough light. You're also probably aware of the painfully harsh results that the little fireball produces — washed-out skin tones, red-eye in people, demon-eye in pets, and ugly shadows to top it all off! Seriously, who invented this thing?

Okay, so enough complaining about the built-in flash. It's time to find out how to better control it with a simple accessory you can purchase for under $30 — a *far* cheaper option than buying an external flash, which we talk about in the next section. Built-in flashes produce an unnatural effect because they blast light directly onto your subject. The solution is to redirect the light and bounce it off the ceiling to evenly disperse the light and have it hit your subject from a more natural angle — slightly above instead of head-on. The best tool we've found to redirect your built-in flash is Professor Kobré's Lightscoop, which is shown in Figure 5-2. This device snaps into your camera's hot shoe and uses a mirrored surface to redirect the flash up and away to the ceiling. From there, the flash bounces off the ceiling and back down to your subject, creating a soft, dispersed light.

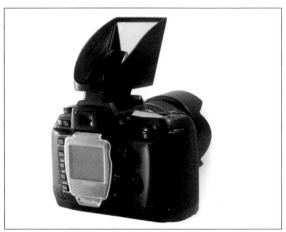

Professor Kobré's Lightscoop

Figure 5-2: An affordable accessory like Professor Kobré's Lightscoop snaps into your digital SLR's hot shoe and diffuses the light from your built-in flash.

In Figure 5-3, you can see for yourself the difference between a photo taken with only the built-in flash and the same photo taken using the Lightscoop. Neither of these photos has been touched up, but the one on the right clearly has softer, much more flattering light. Also, notice the lack of glowing demon eyes!

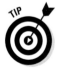

Professor Kobré's Lightscoop works best when you use its suggested optimal settings, which you can find on the how-to page of the product's website (`www.lightscoop.com`) and in the literature that comes with the product.

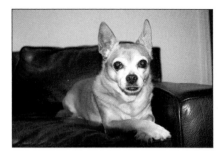 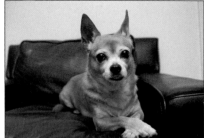

24mm, 1/125 sec, f/2.8, 250

Figure 5-3: An example of using a built-in flash (left) as compared to using a built-in flash with an attached diffuser (right).

Dialing in your external flash power

Another option for adding supplemental light to your photo is to use an *external flash unit*. These are battery-operated units that connect to your camera's hot shoe and provide much more flexibility than a built-in flash does. This flexibility does, of course, come with a downside: price. An external flash unit runs you anywhere from $140 for a low-end, less-powerful unit to $500 for a higher-end, more-powerful unit.

The concept behind an external flash is similar to the concept we discuss in the preceding section — bouncing light. Ultimately, you can rotate, pivot, and swivel the flash head as you please so you can bounce the flash off of a ceiling, wall, or anything else. This indirect light eliminates (you guessed it) the dreaded demon-eye look.

Another advantage to an external flash unit is that you can also use it off-camera by simply connecting a wireless transmitter to your hot shoe and a receiver to the actual external flash unit that connects to a light stand. This means that your light doesn't *always* have to come directly from your camera; you can position your external flash unit wherever you'd like and even experiment with light modifiers like umbrellas and soft boxes.

Some dogs find flashes frightening. If yours is among them, don't force the issue. Like most things, getting your dog used to the flash takes patience, time, and positive reinforcement. Go slowly at first; fire the flash once and then reward him. If he runs away, just wait for him to come back; don't drag him back. Gradually increase the number of times you fire the flash before rewarding him. For more tips on photographing shy or fearful dogs, visit Chapter 2.

Dear Diary: Recording Day-to-Day Activities and Hangouts

You don't have to live in a mansion or go in search of the most breathtaking landmark in the city to get beautiful photographs. Aiming your camera at Bella when she's going about her daily routine in her normal setting can yield great-looking images that have a photojournalistic feel to them because they tell the "real" story of Bella's life.

Fido's lair (Or, let sleeping dogs lie)

One of the photos you probably want to take is of your dog in a relaxed, resting state. These shots are fairly easy to get, considering the amount of time dogs spend loafing around during the day (but we're not jealous!).

Here are some ideas and tips for capturing a dog at rest:

- ✔ When photographing a resting dog, remember to remain calm and quiet yourself. Try to stay at a far enough distance to not disturb your dog so you can get him to look at you without becoming "alert."

- ✔ Use a zoom lens if you have a light sleeper on your hands; that way, you don't have to get terribly close.

- ✔ Take advantage of any available natural light! If your subject is sleeping (and theoretically being very still), you can make the most of that natural light by setting long shutter speeds. Just make sure to use a tripod or rest the camera on a stationary object like a book, table, desk, or the floor.

For the shot of Libby in Figure 5-4, Kim caught her snoozing by the fireplace during the holidays. Needing light but without a flash nearby, the best solution for Kim was to sit the camera on the floor and use a long (0.5 second) shutter speed. Because Libby was lying on the floor and Kim wanted the shot to be at Libby's level, a tripod wasn't necessary.

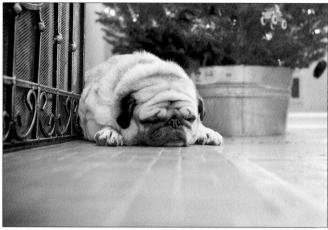

24mm, 0.5 sec., f/2.8, 160

Figure 5-4: Use a zoom lens to let your sleeping dog lie when you snap her picture from a distance.

Capturing a dog in a resting (but awake) state may seem easier said than done, but all it takes is time. To capture a relaxed-but-awake shot, try following these steps:

1. **Wait for your dog to lie down on his own.**

2. **Position yourself on the floor approximately 10 feet from your dog and zoom in to compose your shot.**

3. **Give him some time to relax and get comfortable while you set your f-stop to a low number.**

 If you're using a CDC, set your mode to portrait before you zoom in.

4. **When he's finally relaxed and dozing off, position your AF point over one of his eyes and press the shutter release halfway to lock focus.**

 Flip to Chapter 4 if you're unsure of how to select a single AF Point.

5. **Quietly and calmly say his name so he opens his eyes without actually lifting his head.**

6. **When his eyes find your lens, push the shutter release button all the way down without releasing it from the halfway position.**

 Get as many shots as you can, because you may not get another chance!

For Figure 5-5, Kim had to put on her patience cap and wait for the shot to unfold. In the meantime, she set the aperture to f/2.8 so the background would turn into nondescript shapes and colors, which draws the eye to the dog's face instead of what's happening behind her.

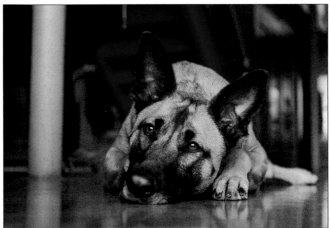

35mm, 1/125 sec., f/2.8, 320

Figure 5-5: Some static candid shots require a bit of patience.

Favorite furniture

We know not everyone lets his furry friends share the sofa, overtake the ottoman, or divvy up the davenport. If you're in the group that has a strict "not on the furniture" policy, don't worry — you can keep your lint rollers put away. We're not going to *make* you put Fifi up on the bed. You can just skip over this section (or take a peek if you're feeling daring). The rest of you can stay to hear about how to incorporate Brownie's favorite chair into a great photograph.

1. **Identify the piece of furniture you want to use.**

 You can go the sentimental route and choose somewhere Brownie hangs out all the time or decide on something because it's an interesting color or good-looking piece.

2. **Take a few minutes to clean up the immediate area and background.**

 Get rid of or straighten up pillows, blankets, toys, or anything that may be distracting.

3. **Before Brownie even gets up on the furniture, open all your blinds and curtains to assess your light, as we describe in the "Making the most of natural light" section earlier in this chapter.**

4. Position your pooch in different ways for different shots.

Try having him lie down and dangle his paws off the edge of a chair, like in Figure 5-6. That's just one idea, though; the possibilities are endless. Does Sadie sit like a human in the chair? Be sure to photograph that! How about having Poncho rest his head on the arm of the chair? Or maybe use those decorative pillows to create a big, cushy throne or have Quinn perch on the back of the chair. What about tucking Sheba under the throw blanket for a cuddly shot? Or maybe your dog doesn't like sitting *on* the chair at all but would rather lie *under* it. Whatever your pooch's pleasure, just keep pressing that shutter button!

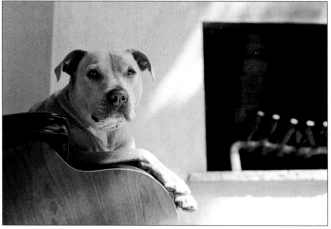

50mm, 1/320 sec., f/2.5, 400

Figure 5-6: We composed this shot to include the marble fireplace in the background, which provides a peek at the surrounding environment.

5. If your dog is used to being on the furniture, he should get settled in fairly quickly.

If he's not, you may need to sit or stand next to him as you pet him to reassure him that everything's okay so he relaxes. When he does so, move to set up your shot.

6. Back up enough to compose the shot you want.

In Figure 5-7, Spencer was positioned in the middle of the bed, and the shot was composed so the two nightstands and reading lights on the wall framed him.

7. Press your shutter release button and voilà! — a photo of Fifi on the furniture.

If you let your dog share your furniture on a regular basis, be sure to keep your eyes open for candid opportunities like Sebastian curled up with the family during movie time. Some of the cutest images come from unplanned moments, so the next time you settle in to watch the newest delightfully predictable romantic comedy, keep that camera right next to the remote!

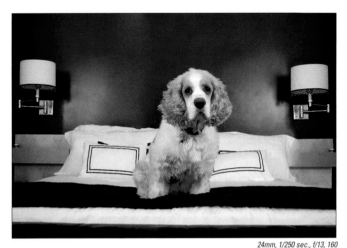

24mm, 1/250 sec., f/13, 160

Figure 5-7: Use the shape and lines of your furniture to add to your composition.

Floors, doors, and common areas

You may be surprised by how ordinary household areas can turn into stunning backdrops for your photos. Look around your house, office, or other indoor locales for things like

- ✔ **Interesting floor patterns:** In Figure 5-8, Kim thought the black-and-white checkered floor tile was the perfect backdrop for Ellie, a black Lab mix. To use the floor as your background, make sure to shoot straight down and fill your frame with the pattern while cropping out any surrounding distractions.

- ✔ **Nice doors or doorways:** Because most dogs lie right smack in the middle of doorways anyway, shooting in this location makes sense. Do you have a cool, boldly colored front door or an interior doorway arch that features old original woodwork? Have your pal sit or lie in front of or next to the door. Choose a wide (zoomed out) angle and position yourself far enough back to get the whole door in the photo.

- ✔ **Common areas:** Wherever you and your family spend most of your time, your dog is likely to follow. Whether you inhabit the living room or crowd around the kitchen table to socialize, take note of the nooks and crannies your dog calls his own. With a major entryway to their home

right smack in the middle of their kitchen, Kim's family somehow always ends up hanging out in the kitchen. It wasn't surprising when Duncan, their Great Dane, turned a quiet area under the built-in desk into his own Dane-sized cubby. Her family moved from that home before Kim ventured into pet photography, but looking back, it's one of those everyday moments that would have been nice to capture in a photo.

24mm, 1/125 sec., f/2.8, 320

Figure 5-8: Everyday floor patterns can become interesting backgrounds from the right point of view.

The workplace

If every day is "take your dog to work day" for you, don't forget to record this part of Morgan's life as well! After all, most people don't have the luxury of having their best friend around for moral support after the boss yells at them over a missing report. When snapping photos of your dog in the workplace, keep these tips in mind:

✔ If your dog is actually *part* of your job, like a K9 police unit or a mountain resort's search-and-rescue team, be sure to get some action photos during a training session, because you can't exactly pull out the camera for a close-up during a real-life rescue mission.

✔ Try to set the scene by including some clues as to *where* you work. For instance, in Figure 5-9, Morgan is lucky enough to spend every day working the vineyards with her dad. Even though this is an indoor photo, the wine barrels provide some insight into the fact that she spends her days on a vineyard.

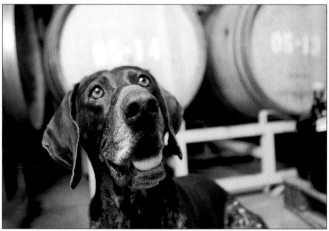

25mm, 1/160 sec., f/2.8, 125

Figure 5-9: Set the scene and tell a story by providing contextual clues in your photos.

Howliday photos

Ah, the holidays, the special moments throughout the year when we all act a little nicer, look a little fancier, and spend a little more time with our loved ones. Whether it's Christmas, Independence Day, or a birthday, a special occasion is a great opportunity to snap some unique photos of your dog. And now, may we present some ideas for the "howl"idays:

✔ **New Year's Eve:** Even pooches need a kiss at midnight! Get a shot of Titan getting (or

giving) his smooch under the grandfather clock as the new year arrives. If you want to get really irreverent, get the old calendar out and let him tear it up or lift a leg on it while you snap a funny photo.

✔ **Valentine's Day:** Find some cute dog-sized wings and transform Zoey into Cupid. Add some heart-shaped dog cookies from your favorite doggie bakery and get a few shots of Zoey digging in! Or, if she'll allow it, have

her hold a big paper heart in her mouth and get a shot of her "delivering" a Valentine to her sweetie.

✔ **Easter:** Nothing is cuter than a big ol' mastiff wearing bunny ears. Don't believe us? Try it. Or if your dog is on the diminutive side, let him get inside a basket brimming with grass and snap a photo of him popping his little head out.

✔ **Independence Day:** You can go the obvious route and dress him up like Uncle Sam, or you can be a little more subtle and go for the classic Americana feeling, posing him on a little picnic blanket or on the front porch with the American flag in the background.

✔ **Halloween:** Anything goes here. Visit your local doggie boutique to browse its costumes for inspiration. Think about dressing up in corresponding outfits, like Maggie and her mom in the following photo. If you have kids, get them in on the fun as well. Try a beekeeper and a bee or a fisherman and a fish. Make sure to get plenty of cute shots of them together. If you want a funny solo shot, take all the candy out of the trick-or-treat bowl and put some of your dog's favorite treats in it instead, and then place it on the floor. When she plunges her head in to lick up her dog-friendly goodies, snap some photos.

30mm, 1/250 sec., f/7.1, 100

(continued)

✔ **Christmas:** Obviously, a photo with Santa is a must, as is one with the tree, stockings, and presents. If you want to try something a little more rustic, consider a photo of Tippy on a sleigh ride or next to the fireplace.

✔ **Hanukkah:** If you haven't seen a doggie yarmulke yet, you're missing out! Check your local pet boutique or find an online retailer so Bruno fits right in with tradition.

✔ **Birthdays:** Canine birthday parties are becoming more common, so if you have one, you better make sure to have your camera out! Snap photos of the birthday dog in her hat, playing with her friends, and eating her "pup"cake! Of course, you have plenty of opportunities for photos at a human birthday party, too; snap some frames off when she jumps in to "help" open gifts by tugging at the ribbon or when she starts howling — er, singing — along with "Happy Birthday to You."

6

Photographing in the Great Outdoors

*W*e have good news and bad news when it comes to photographing your favorite pooch outdoors. The good news is that you should have plenty of light to sufficiently capture all of little Lexie's antics. You probably won't need any supplemental lighting, and if you do, it will be rather minimal. That alone makes outdoor photography worth it. The bad news is you have to contend with an infinite number of variables that you have no control over. Things like weather, people, and diverse terrain keep you hopping.

Even though photographing your dog outdoors can be a real journey into the unknown, we prefer it over shooting indoors. To us, natural light is far superior to anything we can configure inside, and it results in really great photographs. Also, we love that you can use and play off of so many elements outside. Despite the fact that preparing for every possible scenario is impossible, we embrace the adventure and look forward to any outdoor sessions. After reading this chapter, we hope you do, too!

Keeping Time on Your Side

When photographing outside, the best time to shoot is in the morning or late afternoon. Of course, every location is different, depending on things like trees, hills, and other features that create shade and shadows. Generally speaking, though, the wonderful warmth of the morning or late afternoon sunlight is exactly what you want for your photos.

The other thing you want to consider is how much time you have in your schedule that day. Shooting outdoors necessitates a bit more time than shooting indoors because of the traveling to and from the location and the fact that lighting and backgrounds are constantly in flux (and therefore, getting your settings dialed in takes more time). Also, you have to pause from time to time when unexpected passersby enter your frame or Allegra gets distracted by another squirrel.

If you want to use a public location, go during off-peak hours, which will vary depending on the location. Do your homework and scout out the traffic flow ahead of time. Photographing Allegra during quiet times will reduce the amount of distractions you have to compete with for her attention.

Finally, consider the dirt factor. You probably don't want Cowboy (or yourself) to get caked in mud if you (or Cowboy, party animal that he is) have somewhere to be later. The point is, anything can happen during outdoor shoots, so make sure you have ample time to play with.

If you're getting really excited about photographing every second of your dog's life and you want to capture indoor and outdoor shots on the same day, we recommend taking your outdoor shots in the late afternoon. That way, you can take your clean indoor shots first and get dirty later in the nice early evening sun.

Scouting Your Location

Where you and Titan venture for your outdoor shoot is entirely up to you. The main points to remember are that the area should be safe and secure, dog-friendly, and somewhat familiar to you. You can even go on a little scouting trip ahead of time to find what you need, like the pros do. Here's what to look for.

Find places that are safe, especially if you want to take Titan off-leash. Make sure the area is fenced in securely and Titan can't bolt into traffic, get chased by (or give chase to) wildlife, or just plain run away. Your best bet for a truly secure area is your own fenced-in yard, so we recommend going with that option if you want to go off-leash. If you keep Titan on a leash, however, that gives you a little more security, even in nonsecure areas, and therefore increases your location choices.

Also make sure your chosen location is dog-friendly. That doesn't just mean that dogs are allowed on the property; select a place that's friendly to Titan, a place with a ground surface that's safe for his paws, shady areas for him to take a break, and perhaps some water if you'll be out for a long time.

Finally, choose low-traffic venues so you can keep Titan's attention for extended periods of time. If too much is going on, the chance of him getting distracted goes up significantly (as does the probability that strangers will wander into your shots). To make the situation easy on everyone, pick locations that are out of the way or a bit secluded.

No matter how safe you are, you never have a 100 percent guarantee against accidents. Even when your best friend is on-leash in your fenced-in yard, accidents can happen. Always make sure you stay alert and aware of your surroundings.

Special Considerations for Outdoor Photos

As we allude to in this chapter's introduction, shooting outdoors presents certain difficulties, and not one of them has to do with your dog. Knowing how to turn these tricky factors into opportunities rather than obstacles is all part of becoming a photography ninja. Study well, young grasshopper, and the outdoor world will become your canvas.

Picking the perfect time of day

Pay attention to the light in your yard or favorite outdoor areas at different times of day. Notice how the light changes from orange to yellow when it arrives in the morning and from red to blue as it slips away in the evening. Look at the shadows the trees cast and whether they help or hurt the lighting situation. Sometimes leaves can block out too much light, but other times they dapple it just enough to set the perfect mood for your image.

As we cover in Chapter 3, at noon and its adjacent hours, outdoor lighting is at its harshest. The sun is directly overhead, which results in high-contrast images with details in the highlights and shadows getting lost. You want to avoid photographing during this time slot (which changes slightly with the seasons, of course). Other than that, the time you shoot is up to you. Experiment and see what you like best. Though similar, morning light and late afternoon light are different, so experiment and see what works. For softer, diffused light, try photographing during the "golden hour" (we talk more about that in Chapter 3).

If you want to try shooting during sunset or sunrise, the lighting changes very rapidly during those times, so you have to move quickly. You may want to save that challenge for a little ways down the line, after you've had some practice photographing outdoors first.

Figuring out fill flash

Yes, we know we said that you probably don't need to use any type of supplemental lighting when photographing outdoors, and that's true. But occasionally, you *do* need some extra light, so we have to talk about it (otherwise, all the trust we've built with you over these many pages will have been for naught).

Our supplemental lighting discussion centers on fill flash. Even though it sounds like it refers to a piece of equipment, *fill flash* is actually a technique whereby you use your camera's flash (often at reduced power) in situations where the natural light is so intense that it makes for an extremely high-contrast photo (the shadows become extremely dark and the highlights extremely light). The flash you use is just meant to fill in the dark areas — hence the term *fill flash* — and is particularly useful if your light source is behind your subject. For example, if Sonny is lying in the middle of the yard at high noon without any shade in sight, his adorable facial features will probably get lost in the shadows. Brighten up those shadowed areas by adding fill flash.

In Figure 6-1, you can compare the photo of Sammy without fill flash on the left with the one on the right that has fill flash. In the photo that has fill flash, notice how the dark shadows on her face are considerably lighter and her eyes have more detail instead of looking like dark black voids. Kim pointed the flash directly at Sammy (which is usually a no-no, but okay when you're outdoors because the light gets diffused so much by the competing bright light) and dialed down the intensity of the flash with a –2/3 flash exposure compensation.

Consider using fill flash when you can't avoid shooting at high noon or when your subject is backlit and cast in shadow. If you're using a digital SLR, you have to manually pop open your flash; it doesn't automatically trigger, because you have plenty of light to take a photo in the first place. Set your camera to either shutter-priority or aperture-priority mode. Your camera should dial down the flash automatically because it senses enough ambient light in the mix, but if your photo ends up looking unnatural, with your dog clearly being blasted with a flash, you may want to take advantage of your *flash exposure compensation.* This setting is buried within your menus, and you need your user manual to find it, but when you do, you're able to increase and decrease the intensity of your built-in flash by plus or minus two stops. The hardest part about using fill flash is finding the perfect balance so your photo still looks natural. Taking advantage of your camera's flash exposure compensation is the only way to tame that built-in flash beast.

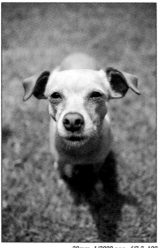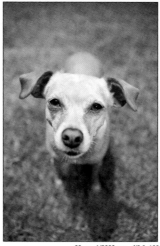

28mm, 1/2000 sec., f/3.2, 100 *28mm, 1/3200 sec., f/3.2, 100*

Figure 6-1: Using fill flash ensures that you can see every feature of your pooch's cute face!

Some compact digital cameras (CDCs) have a fill flash setting that allows you to force the flash on (when the camera thinks it's not needed) and that fires with slightly less intensity than normal. Refer to your camera's manual to find out whether your CDC is equipped with this feature.

Working with weather and seasons

As with any general statements, our guidelines about the best time of day to photograph change depending on different variables — in this case, the weather and seasons. With each variable comes a multitude of possibilities for you to learn how to work with to yield some spectacular results!

As much as they try, meteorologists aren't always right about the weather, so when you wake up to a nice sunny morning and decide that this is the day you're going to take Phoebe out for a photo session, only to see the clouds roll in an hour later, don't abort the mission — yet. Yes, some nice sunshine is helpful to have, but an overcast day can be just as workable. You don't have to worry about shadows or avoiding the high-noon time slot. On an overcast day, you can go out anytime! Because of the naturally soft, diffused light, overcast days are perfect for taking portraits of your pet, and if she's a dark color, an overcast day presents the *best* natural lighting situation you could ask for, so stay out as long as you can. If the clouds turn to rain, though, it's time to head for shelter; even if your camera *were* waterproof (and unless it's designed for underwater use, it's not), most dogs don't look all that great posing in the rain.

Making the most of fog and mist

Living in a beach town (and traveling often to our favorite foggy town of San Francisco), we've come to learn the life of marine layers and microclimates. If you and your pooch are lucky enough to find yourselves amidst fog or mist, be sure to take advantage of the natural moody atmosphere. This photo of Oliver was taken on an early fogged-in morning. We opted to convert this image to black and white because the mist de-saturated the colors in the image. The visual heaviness of the fog, coupled with the use of black and white, created a final result in which you can almost feel the thickness of the air.

Here are some tips for photographing in fog and mist:

- ✔ Fog reduces available light, so compensate your exposure accordingly by using a slower shutter speed, wider aperture, or increasing the ISO (see Chapter 4 for details about these).

- ✔ The fog makes the air more reflective, which tricks your light meter into thinking the scene is brighter than it is. You need to use positive exposure compensation here (read more about this in the "Adjusting for extra-bright locations" section).

- ✔ Keep some of your subject close to the camera. Fog disperses light and therefore reduces the contrast of your subjects. Place your pooch (or his toy) in the foreground to give the shot some saturated elements.

- ✔ If the sun (or another light source, like a street lamp) peeks through, position yourself so you can capture the light rays slicing through the fog. You need to use a small aperture setting (like f/18) to get that starburst effect, which means you may need to bump up your ISO even further and shoot at slower shutter speeds so you have enough light hitting the camera sensor.

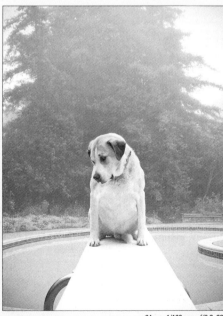

24mm, 1/100 sec., f/6.3, 320

Both of us grew up in regions that have four distinctive seasons (or at least they *had* them back then). Even though we now live in Southern California, we still appreciate the different features each season offers. No matter where you live, chances are the elements change (at least slightly) from season to season, and some of those changes can affect your photography. Here are some special considerations to keep in mind when photographing Phoebe through the seasons:

- ✔ **Winter:** The days are a lot shorter and the sun is less powerful, so you can adjust your timing accordingly. Also, if you photograph in a cold climate, make sure you and your pal are adequately protected from the low temperatures, snow, and ice. We go into details on how to shoot in snow later in this chapter.

- ✔ **Spring:** The colors in the natural world are brighter and the days get longer. Weather can change fast in the springtime, so make sure you have a Plan B!

- ✔ **Summer:** You get the longest days, so your window of opportunity increases, although your high-noon "no shoot" zone expands, too. Your options for venues generally increase and so does your time to really take your pooch on an outdoor adventure. Always remember to bring enough water for both of you and to take plenty of breaks.

- ✔ **Fall:** This is a great time of year to use the amazing reds, oranges, and yellows of changing foliage for your background. And of course, there's nothing cuter than photographing Razzmatazz in a giant pile of leaves!

Adjusting for extra-bright locations

Photographing Cassidy in extra-bright locations, like the beach, presents a lighting challenge. In the case of the beach, so much light reflects off the water that it fools your camera's light sensor into thinking you have more light than you really do, and your image comes out underexposed. But what's the remedy for a trickster? Trick him back. Use this technique when you photograph Cassidy at the beach or any bright location.

When your camera's metering doesn't seem accurate (or you're simply not satisfied with how bright/dark your image is), you have to compensate your exposure accordingly. Your digital SLR camera is equipped with an *exposure compensation dial* (not to be confused with flash exposure compensation discussed earlier in the "Figuring out fill flash" section of this chapter), although exactly where it's located varies from camera to camera, so be sure to check your camera manual. You use this dial to brighten or darken your photos overall in situations where your camera's metering isn't giving the results you want (such as on a beach or a snowy day). Use the exposure compensation dial to change the suggested metered exposure setting plus or minus a certain a number of stops (usually in 1/3 stop increments). This means if you're working in aperture-priority mode, the camera first chooses an aperture

based on your given shutter speed and the amount of light it thinks is available but then adds or subtracts to the shutter speed however many stops you have your exposure compensation set at. For instance, if you're photographing at 1/500 second at f/8 but the resulting image looks so dark that you change your exposure compensation to +1, then the next frame you take is actually shot at 1/250 second at f/8, and your image should look brighter.

Exposure compensation is not *just* for beachy days and hard-to-meter situations. Your photos may come out too dark or too light in other situations as well. For a quick and easy way to adjust your overall exposure, consider setting your exposure compensation accordingly: –1 or –2 if your scene is too bright or +1 or +2 if your scene is too dark. Kim actually finds herself using the exposure compensation dial in just about every shoot, but in Figure 6-2 at the beach, she had to push her exposure compensation to +2/3.

Exposure compensation is one area where compact digital camera users aren't left out in the cold. Just about every CDC on the market offers manual exposure compensation settings via menu options. Some manufacturers deem this setting so useful that there's a separate button to quickly access it. On our own compact digital camera, the exposure compensation scale appears right in the LCD window all the time so we don't have to go searching for it.

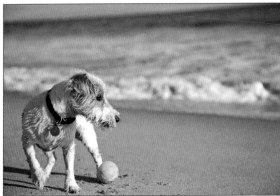

82mm, 1/2000 sec., f/5.0, 320

Figure 6-2: Be prepared to compensate for light meter trickery when shooting at the beach.

Trying Your Hand at Typical Locations

All sorts of options for outdoor photographs are just waiting beyond your front door, but before you pack your bags and head off into the wilderness with Buster, take stock of the wonderful natural world around you. You don't have to go far to get photos that look like you did. People are constantly

trying to guess where we shot various photos in our gallery, and they're always surprised to hear the reality: "Oh, that's just down the street, on that little patch of grass you always walk past."

It's amazing what you can find if you look around and get creative. That small sliver of prairie grass can look like an untouched frontier if you shoot from the right angle (see Chapter 4 for more on using unique angles in your composition). You don't need much to create an entire world within a photograph.

Backyard/front yard

If you want to take photos of your dog off-leash, your safest option is your own yard (provided it's securely fenced-in). The picture of Daisy in Figure 6-3 was taken in a secure front yard where she felt safe enough to lie down and relax. The great thing about using that location is that it's probably where you're both most comfortable.

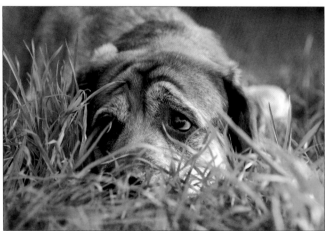

70mm, 1/200 sec., f/3.2, 125

Figure 6-3: Shooting in familiar territory, like your own yard, allows you to get the most relaxed photos.

When you shoot in your yard, incorporate unique features and even surrounding areas into your photos. Consider taking pictures of Pancake

- ✔ Peeking out of her doghouse
- ✔ Soaking up the sun on the patio or porch
- ✔ Lying in front of an interesting-looking fence or gate — or even keeping her neighborhood watch from it

✔ Sniffing or sitting among flowers or plants

✔ Resting in her favorite shady spot

✔ Begging at the grill if she's a grill hound

✔ Sitting at the mailbox if she likes to greet the mail carrier

The park

If you don't have a yard (or one that works for these purposes), a public park is a great option. The thing to keep in mind is that you want a park that's as empty of people and other dogs as possible (so that rules out dog parks). You don't need a huge area; smaller parks work just fine for your purposes. We took the photo in Figure 6-4 in a small public park at a local golf course.

28mm, 1/400 sec., f/2.8, 100

Figure 6-4: Quiet public parks are best for doggie photo sessions. Avoid dog parks and overcrowded areas at all costs!

And don't just stop with the grass. Look around to see what kinds of features you can work into your shots. For example, sit Heidi on an old bench or picnic table. Or how about a shot of her sneaking a sip from the water fountain? Or if she's up for it, try some fun photos of her on playground equipment (as long as it's safe and allowed). There are dozens of possibilities!

The city

If you live in a city with not many parks or other greenery, find locations that have other types of color. You can go literal with this approach by finding public art, vibrantly painted walls, or even graffiti to shoot against. Or look beyond the surface to bring out a city's unique beauty. In Figure 6-5, we took Tyson down to a very colorful part of Venice, California, and set him up in front of a street mural. It just so happened that a person on a bicycle passed by, and Kim snapped the photo at exactly the right moment to frame Tyson in the wheel. Not only does this photo have wonderful color but it also includes an iconic Southern California beach cruiser. Right away, the image evokes a very specific place because of the combination of these elements.

Think about what makes your city special. What are symbols of culture and identity for *you?* Here are some ideas to get you started:

- ✔ Architecture: Chicago has brownstones and Frank Lloyd Wright, New York has skyscrapers and magnificent bridges, and Los Angeles has case study houses and beach towns. Find the marvels that represent your city and capitalize on them.

- ✔ Public transportation: Chicago has the El, New York's got the subway, D.C. depends on the Metro. Most of these aren't pet-friendly (except for service animals), but you can find ways to incorporate your local public transit if you think creatively. (Hint: Station signage is usually visible from the sidewalk.)

- ✔ Sports stadiums: Again, sports stadiums usually aren't pet-friendly, but nothing is stopping you from hanging out in front of Wrigley Field, Dodger Stadium, Fenway Park, or whatever your local team's stomping grounds are. Get some shots on nongame days in front of iconic signage, statues, and architecture.

Testing Your Skills with Challenging Locations

If you and Mr. Snorkels have tried the typical locations and are ready for the next level, we have some ideas for you. We consider the locations listed in the following sections challenging for all sorts of reasons: lighting, movement, risk to equipment, and risk to your pooch/self. Read up on these tough-but-worthwhile endeavors, put a little can-do into your step, and head on out! Be patient with yourself; you may take a while to master these.

58mm, 1/160 sec., f/3.2, 320

Figure 6-5: Keep your eyes peeled for bold colors and graphic walls in the city; they can make great backdrops for your next photo session.

At the beach, lake, or river

A lot of dogs *love* water, so even though photographing at the beach, lake, or river is challenging, it's worth it if your pooch is part fish. Taking him to the water can result in some great photos of doggie joy written all over his face (not to mention some *killer* action — surf's up, dude)! But much like surfing, photographing at the waterfront can be harder than it looks; all it takes is

preparation, persistence, and practicing with techniques like exposure compensation, which we discuss in the earlier "Adjusting for extra-bright locations" section. Here are some tips for taking awesome water photos:

✔ Watch out for the sand and saltwater, neither of which is good for your camera. The best tip we can give here is to have a waterproof case or covering for your camera, just in case. Or you can go the economic route like we do and just have a plastic bag or two on hand.

✔ Be prepared to get *in* the water, too. We're not talking deep (so leave your waders at home), but you should be ready to take off your socks and shoes and roll up your pants so you can at least go in up to your calves or so. Consider doing that as soon as you arrive so you can capture all the moments as they happen. Nothing is worse than Mr. Snorkels being in perfect position and you missing the shot because you're still wearing your shoes and can't get in the water.

✔ Use a slow shutter speed to capture the classic look of a river, waterfall, or other moving water that Mr. Snorkels is sitting in front of. It's probably challenging for him to hold a pose that long, so you may want to save this idea for when he's resting near the water's edge after a full day of fun.

✔ Shoot at sunset or sunrise. We mention this earlier as a little tricky because the lighting changes fast. You have no better chance of managing it than on a wide-open beach or lakefront. Depending on your location, pick the beginning or end of the day for stunning light and colors.

✔ Use creative angles and details for a different way to showcase your waterside location, like in Figure 6-6.

✔ If you (or someone you know) are lucky enough to have a boat (and Mr. Snorkels enjoys being on it), get out there! Get some shots of him in his doggie life vest, enjoying the fresh air, and lounging on the deck.

In the pool

If you have access to a private pool, let Victor have free reign of a personal body of water for some great shots! Photographing at the pool is similar to shooting at natural bodies of water, so the same principles we talk about in the preceding section apply here. We also have a few more pointers for you, just cuz we're generous like that:

✔ Try a *polarizing filter* to cut down on glare and make your blues even bluer. You can also try one at the beach. They're easy to use and yield some pretty fantastic results. If you don't want to buy one (or if you use a compact digital camera), you can hold a pair of polarized sunglasses in front of your lens instead. Don't believe us? Try it. Experiment by rotating the filter (or sunglasses) to get the effect you want. Oh, and try to keep the sun at your side for best results.

24mm, 1/125 sec., f/2.8, 100

Figure 6-6: Even though you can't see the beach in this shot of Sandy's paws, the creative angle and details give clues to her location.

- ✔ The ideal position for you to be in is one or two steps into the pool (hold onto that camera!).

- ✔ Make sure your camera is set to shutter-priority mode because swimming and cannonballing into the pool are action-packed events.

- ✔ Setting up your shot requires a bit of extra effort so Victor doesn't look like a flailing beast and instead looks like a graceful gazelle, leaping through the water (you know, if gazelles leapt through water). An assistant would be ideal here so you can stage yourself on the steps and just

worry about photographing. Your friend can then set herself up on the other side of the pool, like we did in Figure 6-7, grab whatever toy Victor likes to fetch, and pretty much chuck it at your head (or in the pool at your feet if she has good aim). Ideally, Victor goes in after it, and as soon as he makes a move, start snapping and continue doing so until he's out of the pool. Simply repeat until you get your shot (or until Victor's done playing "gazelle in the pool").

70mm, 1/800 sec., f/2.8, 320

Figure 6-7: Recruit an assistant to help set up those perfect pool photos.

In the snow

If your pal likes the snow, it's a really fun environment to use for photos. Whether she's bounding over drifts or digging through piles of freshly fallen flakes, taking Phoebe out for a frolic yields some pretty awesome images, but the elements certainly make you work for it. The snow presents lighting challenges similar to the beach and pool, so go ahead and carry those principles over, but with even more gusto! Because the snow is probably on all sides of you (and not just one or two, like the water), you really need to adjust your exposure compensation dial (check out the "Adjusting for extra-bright locations" section for details).

In Figure 6-8, Kim had to go all the way to +1 with the exposure compensation setting before the snow looked even remotely white. Because the overall scene has so much white, your camera tries to average this out to what it perceives as "normal." Unfortunately, whiteout conditions don't really fall into the lighting category of normal, so you typically end up with muddy, gray-looking snow, unless you change your exposure compensation.

27mm, 1/600 sec., f/3.2, 400

Figure 6-8: Snow presents a challenging lighting situation for your camera and often yields unsatisfactory results unless you make use of your exposure compensation.

Before you even start fussing with the camera, here are some other things you should do to prepare for taking pics in cold and snowy locations:

✔ **Bundle up.** That applies to you, to Phoebe, and to your camera. Make sure you wear plenty of layers to protect against the elements so you don't have to cut the session short because of that pesky hypothermia. And don't forget about Phoebe! If she needs a sweater or booties, make sure she has them on. Finally, keep your camera warm, too. When you're not using it, tuck it inside your coat so your body heat keeps it nice and toasty.

When taking your camera from a cold environment to a warm one, condensation can form on the lens and other parts because of the sudden change in temperature. To avoid this potentially damaging situation, bring a zipper lock plastic bag with you. After you're done shooting in the cold winter air (but before you go inside), put your camera in the bag and zip it up. Once you're inside, leave your camera in the plastic bag so it can gradually warm up to the temperature in the room before it comes in contact with the air there. You can also use your camera bag or anything that fully insulates your camera.

Keep an extra set or two of batteries in a warm place, like your inside coat or pants pocket. The cold weather tends to suck the power right out of them.

✔ **Hold your breath.** Okay, not literally . . . just sort of be aware of it. Condensation and even ice can form on your viewfinder if you're breathing warm air onto it, so be careful.

> ✔ **Let it snow.** If it's actually snowing while you're photographing Phoebe, make sure your camera is in the bag we mention in the beach section and/or have a friend hold an umbrella over you!

In the car

Her eyes are closed in bliss, her ears are tucked back in the most aerodynamic of positions, her tongue and mouth are flapping in the breeze, her nose is taking in all the smells it could ever want, tunes are on the stereo, and the open road lies ahead. It's a car ride, man, and next to eating and sleeping, it's probably your dog's favorite thing. So grab a couple of friends, your pooch, a mix tape (yes, we said mix *tape*), and some snacks, because as everyone knows, it's not about the destination; it's all about the journey.

Like a true road trip, there aren't many compositional rules to follow when photographing Wallyjandro's head out the window. The thing that makes it tricky is that you have to get a friend to drive and you have to essentially hang halfway out the front passenger window yourself to get this shot of pure joy, like we did in Figure 6-9.

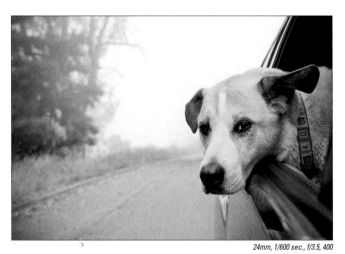

24mm, 1/600 sec., f/3.5, 400

Figure 6-9: If your dog goes bonkers at the sound of the car keys, don't forget to photograph him enjoying the simple pleasures in life.

We're not going to give you artistic rules to follow, but we *are* going to give you safety rules to follow. These are super-important. As we say throughout this book, nothing is more important than the safety of you and your beloved dog. *Nothing.* Here are some tidbits about how to keep everyone (and everything) safe and secure:

✔ Lock the doors. Seems simple, but when you're juggling a dog and a camera, you might forget.

✔ Buckle up until it's time for you to get the shot.

✔ For extra safety, have a human spotter hang onto you, if possible.

✔ Make sure your camera is around your neck. The last thing you want to do is watch as it gets smashed to smithereens on the asphalt below.

✔ Choose a deserted or little-traveled road.

✔ Stay at or below the speed limit. You don't need to go very fast to get Wallyjandro's ears to flap in the breeze.

✔ Keep a leash on your pooch and make sure someone is holding it at all times (even if you swear Wallyjandro would *never* jump out of that wide open window).

✔ Do this only during clear and dry conditions. Do not attempt this shot in wet, icy, or other inclement weather.

✔ Trust your gut. If you or your driver feels uncomfortable at any point, stop immediately, even if that means you don't attempt it at all. If you're not keen on risking life and limb for a photo of Wallyjandro flapping in the breeze, consider stationary car shots as well, like him hanging out in the back of the pickup or him sitting shotgun with his sweet "doggles" on.

7

Taking Studio-Style Portraits

In This Chapter

▶ Considering backgrounds and lights for your portraits

▶ Creating posed photos

▶ Capturing spontaneous moments

Remember "picture day" back in grade school, that one special day you got to skip P.E. class because the gym was turned into a sea of flashing lights and backgrounds (your choice of studious bookcases or totally rad laser beams)? It was the day Mom made you take a bath and sealed your hair in place with enough hairspray to hold up to a tornado. Yes . . . yes . . . of course you remember! Well, that's studio-style photography in a nutshell, and it's now your dog's turn to experience it! Don't worry, we won't make Bowser risk hair product asphyxiation or require you to use the 80s laser beams in your photos, though if you do, we want to see them so we can laud you as a modern-day retro hero.

In all seriousness, picture day is a perfect example of what studio-style portraits are all about (even in dog photography): the flexibility to choose your own background (be it a solid-colored seamless paper roll or a background you create yourself) and the ability to completely control the direction and intensity of your light. Master those elements and you may be on your way to the head of the class (sorry, though . . . Bowser already holds the title of teacher's pet).

Make Your Own Studio — Anytime, Anyplace

The beauty of studio-style photography is that it can happen anytime you feel up for it. You don't have to assess your available natural light, plan around the clouds, or even have any natural light at all. Because the lights you use in studio-style portraits are so strong, they're the only light source you need. Whether you feel like breaking out the lighting equipment one Sunday morning when you and Bowser have nothing else to do or you'd rather wait for a rainy day indoors, when it comes to studio-style portraits, the when factor really isn't a factor at all! See? You're acing the class already!

The bigger decision about studio-style photography revolves around the where factor. We're guessing you don't have a studio in your home, and that's okay (we don't either . . . shhh). As long as you have enough space to set up your lighting equipment and background and you have access to a power outlet, you can set up shop wherever you see fit. We often find ourselves shuffling around furniture to make room for our studio setup that we put right in our living room.

Special Considerations for Studio-Style Portraits

Studio-style photography isn't for everyone; you need more equipment than when you shoot with natural light and more time to set everything up. But for ambitious folks looking to try something new, studio-style photography opens up a whole new world of possibilities.

Creating a clean background

The first thing you need for studio portraits is a suitable background. Photographers generally use *seamless background paper* to get the job done, and you can buy this special paper in all different colors and widths starting at a cost of around $25 per roll. You simply slip the roll of paper through the crossbar of a background stand and pull the paper out long enough to create both a background and a floor, as shown in Figure 7-1. A flat, hard, smooth floor under the paper is best so as to avoid Gunther's toenails puncturing your delicate background paper. Tape the corners to the ground and roll up the paper just enough so that you have a nice curve between the floor plane and the background plane. That way, the paper doesn't have any sharp bends, and the transition between the floor and background is *seamless* (that's right; it's not just a clever nickname).

Figure 7-1: This sequence, taken from a time-lapse video, shows a background setup being put together.

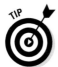

If your house is mostly carpeted, pick up a scrap piece of linoleum from your local hardware store to put over the carpet and create a harder surface for the background paper to lay over (and for your pooch to stand on).

If you don't want to spend money on rolls of paper and a background stand, you can get creative and make your own background. Hang a white bed sheet

that's long enough to swoop down onto the floor or visit your local fabric store for more options. If you have a small dog, you don't need much material to create a seamless background big enough for 5-pound Tiny Tim to model on.

Choosing lights that don't break the bank

Next, you need studio lights. These come in two varieties: *hot lights,* which are akin to really strong light bulbs and stay on continuously, and *strobes,* which use flash tubes to create powerful bursts of light. As you'd expect from their name, hot lights get very warm very quickly — not exactly ideal for a dog, unless you want photos of a panting Penelope. For dog photography, strobes are the way to go. Most dogs don't even notice that powerful flash of light.

The downside to studio-style lighting is cost. Yes, you *will* need special lights if you plan to continue shooting this way, but you *can* find ways to keep costs down. The most affordable option is to simply use your external flash unit (you know, the one that snaps into your digital SLR's hot shoe; see Chapter 3 for details) as an off-camera flash. Just purchase a light stand to hold your external flash unit, an umbrella to bounce your flash into (or a softbox to shoot through), and a radio transceiver and receiver designed to work with your camera and flash, such as a PocketWizard (see www.pocketwizard.com).

You may not even need a radio trigger; some digital SLRs can trigger an off-camera external flash unit on their own. This is called using your external flash as a *slave flash* (yes, we hate that name, too). The slave flash fires when it senses any other flash going off — in this case, another external flash unit connected to your hot shoe or your digital SLR's built-in flash if it's capable of *commander* mode, a special setting that allows it to act as a master flash. Just keep in mind that the slave flash fires within milliseconds of *any* flash firing, so if you suddenly find yourself in a room with multiple photographers, all of whom are using flashes, your slave flash will be triggered by *their* flashes, too (this may seem like superfluous information now, but you'll thank us later, when you become a famous "pup"arazzo).

Also note that your external flash unit has a limited amount of power and may take awhile to *recycle* (that is, you may have to wait for the flash unit to fully recharge before you can take your next photo). Regardless of the limitations, using your external flash unit as an off-camera flash is a great way to experiment with a studio-style setup before deciding whether to buy more powerful strobes.

If you fall in love with the look of your studio-style portraits and decide you want a more powerful external lighting system, you have two options: a monolight setup or a power pack setup, both of which are used with a wireless

transceiver/receiver setup like the PocketWizard we mention earlier in this section. *Monolights* are self-contained lighting systems, meaning they have a small capacitor (the place where all that energy is stored) built right into the flash head that provides the power needed for the flash to fire. All you have to do is plug each monolight directly into an outlet. Monolights are compact and affordable (starting at about $200 for a new AlienBees flash unit; see www. alienbees.com) but are limited in the amount of power they provide.

Conversely, a *power pack* setup includes a separate capacitor that *all* the flash heads plug into. The power pack itself then plugs into an outlet. Power pack lighting systems provide more flexibility and power than monolights but generally cost more money (starting at about $1,000 for a new two-head lighting system from Speedotron; www.speedotron.com). The good news is you don't have to buy a *new* power pack lighting system; these systems have a long life span and can last decades, so look for a used one. We purchased our own two-head Speedotron lighting system (including two light stands, two flash heads, and a power pack) on Craigslist (www.craigslist.com) for $300, and it's been going strong for over two years now!

Decide what you're looking for and do an Internet search for "how to set up a Craigslist alert" to find out how to have an e-mail automatically sent to you every time a post containing your desired words (for instance, "Speedotron," "AlienBees," or "monolight") appears on your local Craigslist site. Then sit back and wait for your item to show — you'll have pro equipment at a fraction of the cost in no time!

Always be mindful of just how powerful studio lighting equipment is and practice safe handling techniques to avoid any accidents. Never connect or disconnect your flash heads when the power is on. Never replace flash tubes or modeling bulbs when the flash heads are plugged in, and never touch the bulbs with your bare hands. Not only are they hot after use, but the oils from your skin can shorten the bulb's life and cause it to eventually explode! Also, never attempt to make repairs to your monolight or power pack; these are high voltage systems that can cause serious injury if you attempt to open them up. Familiarize yourself with your equipment's operating instructions. If you purchased your equipment used, you can usually download the user manual from the manufacturer's website.

Positioning your lights just right

With your studio lighting setup ready to go, it's time to start experimenting with the position of your lights. Being in control of your light source's direction means that you can get some drastically different looks by simply

repositioning your lights. The most basic lighting setup, shown in Figure 7-2, involves only one light and a reflector, which adds fill light to the shadows. To mimic this lighting setup, follow these steps:

1. **Create a background by hanging a roll of seamless background paper from the crossbar of your background stand.**

2. **Position your light stand so it sits at about a 45-degree angle from the front of your subject.**

3. **Attach your flash head to the light stand and point it *away* from your subject.**

4. **Attach a reflective umbrella or softbox to your flash head to soften the light.**

5. **Plug in your flash head to your power pack (or your flash head to your AC power source if you're using a monolight) and plug in your power pack to your AC power source.**

6. **Attach a radio transmitter to your camera's hot shoe and a radio receiver to your power pack. Turn them both on and make sure they're set to the same channel so they can communicate with each other.**

 If you're mimicking this setup with lower-powered external flash units (instead of strobes), you can also use the master/slave setup we discuss earlier instead of a radio transmitter.

7. **Use a reflector holder arm to connect your reflector to another light stand, or simply have someone hold the reflector for you.**

8. **Position your reflector at about a 90-degree angle from the front of your subject on the opposite side of where your light is positioned so that when your strobe flashes, it also hits your reflector, adding fill light to the shadowed side of your subject.**

9. **Set your camera to manual mode and choose a shutter speed of 1/250 second to start with. Set your aperture to f/8 as a starting point.**

10. **Compose your shot and take a photo.**

 If your image is too bright, you can either stop down your aperture to a higher f-stop number to reduce the amount of light hitting your camera's sensor or increase the distance between your light stand and your subject, which decreases the light's intensity. If your image is too dark, you can either open up your aperture to a lower f-stop number to let in more light or decrease the distance between your light stand and your subject, which increases the light's intensity.

Know your strobe's sync speed!

The *sync speed* of your flash is the fastest shutter speed you can use with your strobes. If you try to use a faster shutter speed, part of your image may turn out black because the shutter is open so briefly that it only captures part of the flash. Become familiar enough with your equipment to know what its sync speed is. Our own strobes have a sync speed of 1/250 second, so this is usually where we set our shutter speed from the get-go.

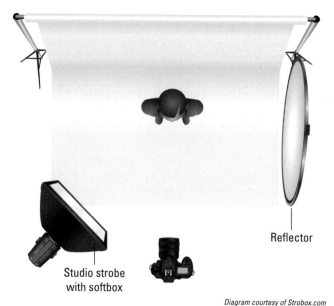

Reflector

Studio strobe
with softbox

Diagram courtesy of Strobox.com

Figure 7-2: A typical single-light setup with a reflector for fill light.

Setting up studio lights takes some time, so don't bore Max with that part of the job. Instead, use a friend or family member as a fill-in while you adjust the lights. Get your light just right and then insert Max when you're ready.

After you master the art of a single-light setup, feel free to experiment with an additional light. Figure 7-3 shows a simple two-light setup that keeps the amount of shadows on your subject to a minimum. This is a great setup to use when you want your pooch to be the focal point of the shot because it

creates an even light that doesn't distract the viewer. If you're more interested in setting a mood and getting all artsy, stick to the one-light setup and experiment with different angles and reflective materials for your fill light.

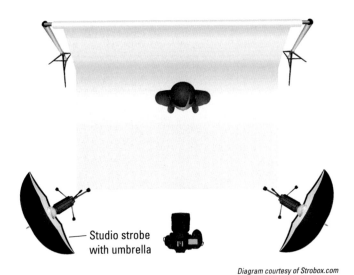

Studio strobe with umbrella

Diagram courtesy of Strobox.com

Figure 7-3: A standard two-light setup, which results in an even wash of light.

Studio-style lighting is an art, not a science. Play around with the position of your lights and/or your reflectors until you stumble upon the result you're striving for. Use the lighting diagrams in Figures 7-2 and 7-3 as starting points, but experiment with alternate light positions as well. Learning how to light your subject is all about trial and error, so don't worry about making mistakes!

Sitting Pretty for Posed Portraits

Studio-style portraits come in a variety of styles, each of which serves its own purpose. Don't fret if you're left feeling uninspired by the plain-paper backdrop approach. Whether you want to document your puppy's growth, highlight his exuberant personality, or create an artistic montage of the little details that make him so special, studio-style portraits can do it all! If you need some ideas to get the creative juices flowing, read on.

Headshots

The quintessential studio-style portraits, classic doggie headshots hark back to those embarrassing school photos we reference at the beginning of the chapter. (Sorry to keep bringing up painful memories. We can recommend a good therapist if you need one.) In the photo of Delilah in Figure 7-4, Kim positioned Delilah right smack in the middle of the frame and zoomed in to fill most of the frame with Delilah's big ol' head. If your own dog is trained enough to sit and stay exactly where you put her, have her sit at an angle so she has to turn her head to look at you. Oh, the nostalgia! Change up your angle for a different perspective as well. For example, shooting from slightly above as your dog looks up accentuates her head (it is a *head*shot after all).

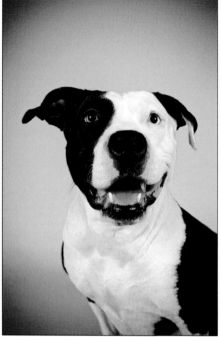

24mm, 1/250 sec., f/5.0, 100

Figure 7-4: Delilah sitting pretty for a classic headshot with a two-light setup.

Full body portraits

With the obligatory headshot checked off your list, zoom out enough to capture a full body portrait. Position yourself so that you're shooting from an angle that doesn't accidentally give the appearance of an amputated body part (we know — four legs are a lot to keep track of!). Also, keep shooting even if you think you already have the shot, especially if the dog's tail is wagging or her ears are moving. Some of those frames may just look better than the one you already took! In Figure 7-5, Sammy stands at attention, waiting for her next treat.

If you look closely at Figure 7-5, you notice the reflection of two catch lights in Sammy's eyes, a clue to the two-light setup that we used. You can even tell that we used umbrellas from the circular shape of the catch lights! If you ever wonder how a certain studio-style photo was set up, just find the subject's eyes — you'll be amazed at how much they tell you!

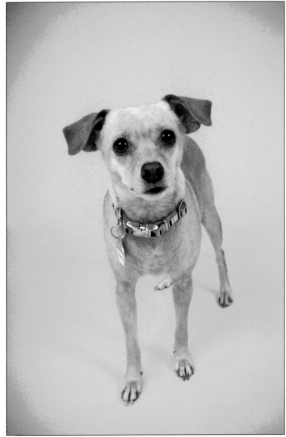

24mm, 1/250 sec., f/5.0, 100

Figure 7-5: Sammy's full body portrait reveals more than just her size.

Artistic details

Photos of your little furry Monkey don't necessarily have to include his mug at all. If he has adorable spindly legs, try to get a shot that capitalizes on exactly that! You can even add in a human model for comparison, like we did with Monkey and his mom in Figure 7-6. These artistic details are more about composition than anything else. In this example, the legs take up about two thirds of the frame, but we leave enough negative space (areas in the photo void of the subject) to balance out the shot. Get creative with your cropping when you go for those artistic details! (For more insights into doggie details,

head to Chapter 9. You can capture some of the ideas we present there in a studio setting.)

27mm, 1/160 sec., f/9.0, 160

Figure 7-6: Monkey and his mom stand side by side for this artistic detail.

Prepping for Photojournalistic Photos

Photos you take in the studio don't always have to be posed. Some of the greatest shots come from shooting on the fly and catching Sadie doing something spontaneous and unplanned. Be sure to spend some time photographing your dog just being a dog! Recruit a family member or friend to play with Sadie while you sit back and snap away. Experiment with your perspective and stay on the move so you end up with many different angles of view to choose from. These photojournalistic photos may actually capture more personality than a posed photo ever will!

Playing

To get a photo of your dog at play in a studio setting, you likely need an assistant to play with your dog while you're photographing. You can include the person in the shot or, if the shot you're going for is all about Indiana, have the person stand off to the side, just out of the frame. Figure 7-7 captures Aidan and his doggie sibling Libby playing with one of our props. They're both completely in the moment and paying zero attention to Kim or the flashes going off, a perfect example of how an unplanned moment can convey such great emotion.

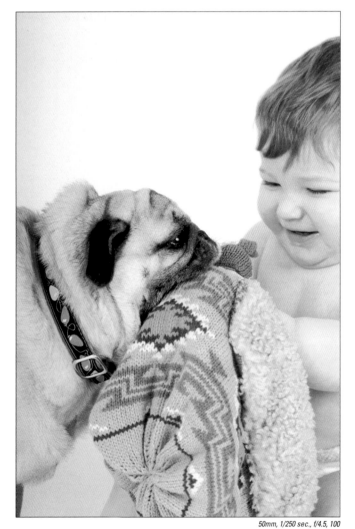

50mm, 1/250 sec., f/4.5, 100

Figure 7-7: Aidan and Libby are caught playing in this candid moment.

Begging

Most dogs go crazy for treats, and although you may discourage begging at the dinner table, begging for a treat in the studio can result in some pretty hysterical photos. Again, recruit a helper, and have the person dangle a treat over the dog's head. If your own dog is anything like little Piko in Figure 7-8, he'll be up begging for that biscuit in no time. We're not entirely sure why,

but photos of dogs standing on their back legs always seem to be a big hit. Perhaps they're popular because of the novelty of a position you don't often get to see your dog in, or maybe people like them because of the goofy way the dog's front paws wave around for balance. Regardless of the why, these shots are guaranteed to elicit a chuckle.

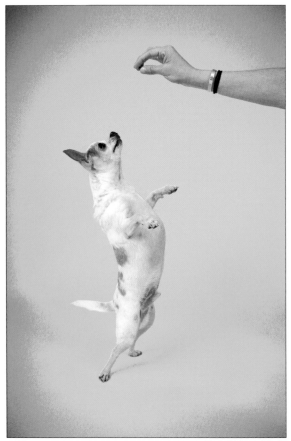

24mm, 1/250 sec., f/5.0, 100

Figure 7-8: Piko balances on his hind legs while begging for a tasty treat.

Interacting

If you're a multidog household, set aside some time for your dogs to interact without coercion. Do so at the end of your photo session because they'll be

a little more tired at that point and will feel more comfortable on the background paper. The chances of them interacting normally when they're only seconds into an unfamiliar situation are slim to none, so be patient with this one. Doggie siblings Buddy and Chloe in Figure 7-9 were settled down enough at the end of their photo session to engage in one of their everyday routines, which consists of Chloe licking Buddy's tongue!

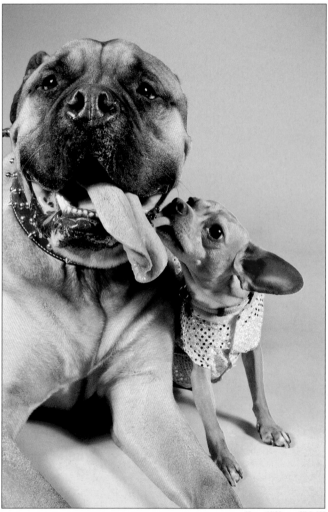

30mm, 1/100 sec., f/9.0, 100

Figure 7-9: Capturing the everyday interactions of your dogs in a studio setting takes patience, but wait it out and you may just catch them interacting without regard for the camera.

8

Capturing Flawless Action

. .

In This Chapter

▶ Choosing the best time and place to take action shots

▶ Preparing your camera settings for shots in motion

▶ Capturing particular doggie movements

. .

*H*ave you ever gazed wistfully at your dog, fantasizing about trading places as he lies there chasing rabbits and squirrels deep into the forest of dreamland while you go off to work? Of course you have — all dog lovers do. By our estimate, dogs sleep away a good 97.5 percent of their lives, which makes them the envy of overworked and underpaid humans everywhere. This enviable laziness also makes them that much more difficult to catch in action, so when the opportunity arises, grab your camera and just try to keep up! Whether a morning run around the neighborhood, a swim in the lake, or just a crazy game of fetch in the yard sets your pooch's tongue flapping and tail wagging, going the distance to photograph Buddy engaged in his favorite activity makes for some incredibly dynamic images.

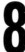

An *action photo* is any image in which you capture your subject in motion — any motion at any speed. Action photos convey a sense of movement by either freezing your subject in mid-action, or, conversely, blurring your subject to exaggerate its speed.

If your dog isn't the active type, don't despair. He doesn't have to be the Richard Simmons of the canine world to give you opportunities for cool action shots. If you do it right, even everyday stuff like stretching or chewing on a favorite toy can turn into art!

In this chapter, we show you how to capture these special moments with your camera. Action shots can be hard and sometimes dirty work. Let's get down to business!

Getting the Timing Right for Interesting Action Shots

You can take action photos of Chloe anytime she decides to play, but a more coordinated effort sets you up for success. You want to consider such factors as your dog's natural energy and routine, the energy or busyness of the location you're using, and the amount of light available at different times of day.

Think about what your dog is like at different times of day and what you want to capture. If you want stretching or yawning images, try photographing Kingston when he's sleepy, maybe during the day. If you'd rather get shots of him playing fetch or running around, choose a time when he's most energetic, perhaps right when he wakes up. The key to getting the most genuine images is to follow your dog's lead.

Similarly, think about your location. If the location you want to use is a public place (or even if it's just your house, which may *feel* like a public place sometimes), figure out what time of day it's least crowded and go then. Shooting somewhere your dog can freely romp is great, but if he's overstimulated by what's going on around him, he probably won't pay much attention to you or the direction in which you want him to run.

Finally, natural light constantly changes throughout the day (and seasons), so you want to know ahead of time when your location gets the best light and take your photos then, especially because action shots require as much light as possible. Remember that "never shoot at high noon" rule? Well, with action shots, that rule of thumb gets tossed away like yesterday's celebrity gossip (more on that later — the lighting stuff, that is; not the gossip). There's a reason that the saying goes, "*Lights,* camera, action!"

Recently, we had a situation in which the timing of both the location and lighting played a role. A client requested an action photo shoot on the beach. Sounds simple enough, but because we live in overpopulated Los Angeles, we chose to visit the beach early in the morning to beat the crowds, and we even had to reschedule one morning because it was a bit too cloudy for photographing at such a high shutter speed. We would've had to push our ISO up higher than we were comfortable with, so we postponed for a better day. If you want the best shots, you have to remain flexible!

Finding a Place That's Light-Filled and Fun

The most important variable for action photos is available light. Because action shots require you to shoot at such a high shutter speed, the more light you have, the easier your job is. You can use natural light, flashes, or a combination; just don't scrimp on the light. Stay away from the dark alleys and shadows (save that for your weekend club-hopping) and choose places that have lots of open sunshine. If you're shooting indoors, turn on some lights and throw open your drapes with wild abandon! Doing so helps you get good shots, and it just *feels* good.

Also, think about your dog's favorite activities. Does he go crazy for a tennis ball? Berserk over the pool? Or get the "zoomies" as soon as his toes hit sand on the beach? When going after action shots, be sure to choose an activity he loves, because more than likely, you'll be clicking away for a while before you end up with that frameable photo. Plus, the more fun you can make it for Nala, the more fun it will be for you, too.

Finally, consider the backdrop. For action photography, this can be tricky because your dog may be moving across different backgrounds while you're photographing her. Capturing a dog in motion can be difficult enough; make your job easier by choosing a simple, consistent background when you can. Position yourself at a vantage point from which your background remains as consistent as possible throughout the whole potential panning area. If you're on the beach, the water is your best option. If you're in the backyard, point toward that hedge that lines the yard as opposed to the deck with patio furniture everywhere.

Here are some location ideas to get your creativity flowing:

- ✔ Spot's favorite park
- ✔ The beach (make sure it's a dog-friendly one!)
- ✔ Your sister's three-acre property filled with rolling meadows and a lake
- ✔ Your college friend's vineyard and winery
- ✔ That funky strip on Main Street with all the graffiti
- ✔ The baby pool that Zoe splashes around in
- ✔ The agility class that Tigger looks forward to

Whether grand or simple, take stock of who and where you know. You probably have a lot more options within your reach than you think!

Before using a public place for a shoot, scout it out (even if you go there every day). Taking a specific trip ahead of time allows you to notice the elements we mention that you may not be aware of usually. Try to choose low-traffic places and you'll have an infinitely easier and more enjoyable time. If

you want to use a business (like that dog-friendly café), talk to the manager first and see whether it's okay for you to do a photo shoot there. And remember: Never have a dog off-leash unless you're in a secure, fenced-in area.

Special Considerations for Action Photos

When it comes to action photography, you want to put into motion (pun intended) a couple of specific skills to supplement the basic skills and equipment you're already using (turn to Chapters 3 and 4 for a full rundown of equipment and techniques).

Setting your shutter-priority mode

Because your dog will be moving at lightning-fast speed during most of these activities, you should adjust your camera settings before you start the activity. Switch to shutter-priority (TV) mode so you can control how fast (or slow) you want the shutter speed to be.

For extremely fast movements, like running, playing, and jumping, start with a shutter speed of at least 1/800 second. Take a few test photos and inspect your results on your camera's LCD monitor. If you want to freeze the action, like we did in Figure 8-1, but Spike is still a bit blurry, increase your shutter speed even more — try 1/1000 second or even faster.

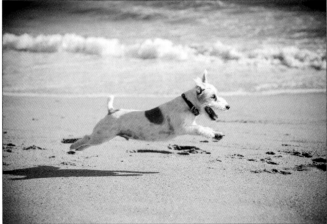

75mm, 1/4000 sec., f/2.8, 100

Figure 8-1: A very fast shutter speed enables you to freeze action, but you typically need lots of light.

We purposely set up the shot in Figure 8-1 during the middle of the day, when the most light was available. This may seem counterintuitive to the general rule of thumb of not shooting at high noon, but when shooting a very fast-moving subject, you need lots of light. Often, you need to bump up your ISO even more than normal to achieve a greater depth of field if your dog is a good distance from the camera. (See Chapter 4 to review the ins and outs of shutter speed and ISO.)

 If you're using a compact digital camera (CDC), switch to sports mode (sometimes called kids and pets mode). This triggers your camera to choose the fast shutter speeds you need for freezing action. For more on CDC camera modes, see Chapter 4.

If you want your image to have background blur, experiment with lower shutter speeds, like 1/125 second. Just remember to use the panning technique (see Chapter 4). In addition, if you're not worried about your subject being totally crisp but would rather convey him moving at the speed of sound, forget about panning and choose a slower shutter speed for a more abstract look. Although Dino isn't nearly "frozen" in Figure 8-2, this photo still conveys the speed at which he was tearing around the beach and frantically kicking up sand.

 If you're using a CDC, experiment with the portrait or landscape mode if you're looking for more movement in your action photos.

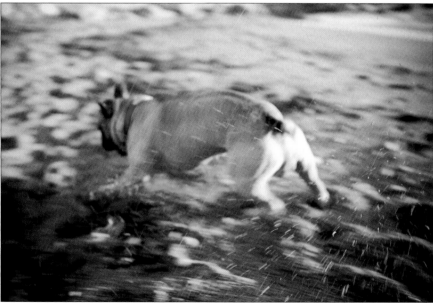

24mm, 1/60 sec., f/4, 400

Figure 8-2: Choose a slower shutter speed for more abstract action photos.

Keeping memory card rate speed in mind

When shooting action photos, you should shoot a lot because things change so much from one second to the next. Clicking constantly helps ensure that you capture the exact moment you're looking for. And because you'll be shutter button–happy, you need plenty of storage so you can make it through the whole action session. Choosing your memory card (or media storage device) is an important part of action photography.

Don't let the plethora of memory cards overwhelm you. You can cut through the massive selection to find something that's right for you. In this case, because you're shooting action photos, pay particular attention to the memory card's *rate speed* — the maximum speed at which the card can save your image file and be ready to take the next shot. This designation is often shown as an MB/s (megabytes per second) number. The higher the rate speed, the faster you can snap photos without waiting for the camera to catch up with your trigger finger. Look for a card with at least a 15 MB/s rate speed if you plan to shoot action.

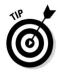

Some manufacturers stray from the MB/s rate speed designation and instead use an x-speed rating. For instance, you may see the speed rating listed as 133x or 266x. This is simply an alternate method of indicating the card's rate speed. Just like the MB/s number, a higher x-speed rating means it's a faster card, so look for cards with x-speed ratings of at least 133x. This is equivalent to a rate speed of 20 MB/s. An x-speed rating of 266x is equivalent to 40 MB/s.

As a rule of thumb, the larger storage capacity and the higher rate speed a card has, the more it costs. The cards we're carrying in our camera bag right now are SanDisk Extreme III CompactFlash 4GB 30MB/s cards and 8GB 15MB/s cards. You may be asking yourself why our larger capacity card has a slower rate speed, and the answer is simple: cost. Today, a 16GB 90MB/s CompactFlash card runs around $165, whereas a 16GB 30MB/s CompactFlash card currently goes for $65.

For more on memory cards, see Chapter 3.

Snapping Specific Action Photos

Dogs do the craziest things. Anticipating all their wild maneuvers is impossible, which means we can't tell you how to photograph every possibility. But we can cover the most common canine actions. Read on for more about how to successfully snap specific doggie movements.

Stretching

You may think it's a stretch to photograph a stretch, but stretching is most likely part of your dog's daily ritual, and it can actually make for a pretty

striking image. Most dogs stretch in a very slow, almost sloth-like movement, but it's still movement, which is why we're talking about it here.

Stretching is really hard to predict in most dogs, so you just have to wait for it. You can beat your buddy out of bed in the morning and set up camp with your camera to try to capture the stretching he does when he wakes up, or you can just keep your eyes open for opportunities throughout the day. If you happen to be lucky enough to have your camera handy when this fateful moment arrives, act on it! You'll be glad you did.

Here are some ideas and tips for capturing that perfect stretch:

- ✔ Pull out your camera and get it ready to go. Consider your settings *now* because you probably won't have much time to futz with them when Luka finally does decide to stretch those long legs.

- ✔ Set your camera to shutter-priority mode and choose a somewhat fast shutter speed. Try starting with 1/250 second, which should be fast enough to freeze the action of a stretch.

- ✔ Gauge the amount of light you have to work with and choose your ISO appropriately (see Chapter 4).

- ✔ Decide what it is about the stretch you're most interested in so you can compose your shot accordingly.

 - • Exaggerate your dog's outstretched toes by shooting head-on with a wide-angle lens and selectively focusing (see Chapter 4) on the front feet.

 - • Accentuate that "downward dog" yoga pose by shooting a profile shot that captures the deep arch in his back.

 - • Zoom in tightly for a detail of that smiling face he makes mid-stretch, or creatively crop the back feet as he comes out of the stretch and kicks out for that hind-leg-toe-point-one-foot-at-a-time move.

- ✔ Keep your camera within arm's length, and as soon as you see signs of a stretch, get on the floor and compose your shot while keeping in mind the details you want to focus on.

- ✔ Our dogs tend to stretch after a long nap; a nice big yawn often signals an impending one. Your own dog may be different, so figure out what his individual signs are and get into position when you see them!

In Figure 8-3, Kali went for an impromptu stretch while we were already photographing her on a studio background. To get this angle, Kim had to lie on the floor to be at Kali's level and compose the shot at an angle so you can see not only her outstretched toes but also the arch in her back. Kim also cropped her back end out of view so it looks like she's entering the frame, which leaves some nice negative space around her.

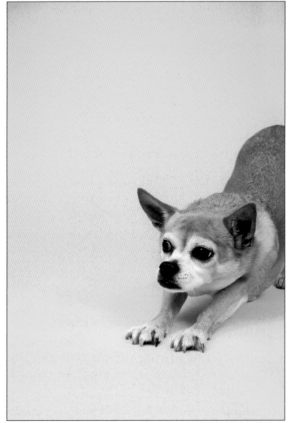

24mm, 1/250 sec., f/5.0, 100

Figure 8-3: Know the details you want to capture before your dog starts to stretch.

Chewing

Let's face it: Most dogs chew. Whether he's laying into his favorite toy or your favorite pair of shoes, chewing is probably a big part of your pooch's life. Unless you have Cujo as a pet, this little activity falls on the slower end of the action spectrum, so you have a little more leeway than you have with running or fetching (more on those high-energy activities in a sec).

Here are some ideas and tips for capturing the gnaw:

- ✔ Check your camera settings.
- ✔ Use something enticing to promote a nice, long chew session — the plush bunny that Murphy likes to nibble the ear of, that rope toy that

he still thinks he'll get through one of these days, or even a Kong toy stuffed with frozen peanut butter.

✔ When he's really into his chewing, coordinate your colors and background. Because you have a little more control over this action than, say, a stretch, consider the color of the chew toy and the best backdrop for the setup. For example, have him chew his bright orange bumper toy in the green grass, or if he's already plopped down on the bed, perhaps find a complementary-colored pillow or blanket to place behind him.

In Figure 8-4, Cody enjoys a Kong toy stuffed with goodies. Because the Kong toy was bright red, we decided to position Cody on a similarly colored couch to add even more red to the shot.

43mm, 1/250 sec., f/8.0, 200

Figure 8-4: When capturing slower actions, like chewing, you have more time to coordinate your background elements.

Alternatively, consider working with different colors that complement each other well. If you're shooting color photos, be aware of your surroundings; try not to shoot a black dog against a dark carpet, for example. You want your subject(s) to always "pop" off the background. In Figure 8-5, Lulu sits with her pink donut chew toy, which was strategically placed on a light blue chair for her to find.

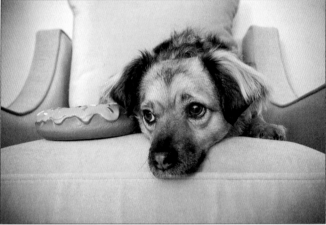

28mm, 1/250 sec., f/6.3, 250

Figure 8-5: Choose background colors that complement the colors of any toys you use.

✔ Get down on your stomach and shoot at the dog's level. You can even rest the camera on the ground if you have to.

✔ To get a different look, shoot from above and try to get just enough of his attention so that he looks at you with his eyes but continues chewing. Try making a clicking sound (like you would to call a horse) as opposed to calling his name or using a squeaker, which will likely elicit too much of a reaction.

✔ If your dog likes to chew his toy on a chair or sofa, you can take advantage of the angle by getting on the floor beneath him and shooting up.

✔ Remember to continue shooting even if he stops chewing. There's just something about a sleepy dog that's pooped-out from chewing his favorite toy that'll get you every time.

Running/fetching

Fetch! It's the quintessential doggie delight. Humans and canines alike give countless hours and lost balls over to this hypnotic (albeit slobbery) pastime. Not all dogs play fetch, but if yours does, you've *gotta* photograph it.

And even if your pooch would rather take a bath than a trip across the yard to bring back something you threw, that's okay. You can still get some running shots with a little planning!

When planning your running and fetching photographs, try to think of anything that's unique about the way Daisy runs or fetches and aim to home in on that. Does she have a special toy she *always* has to have to play fetch? Does she like sticks? Maybe she runs with a sort of lopsided gait. These details are great material to work with, and you should strive to bring them out in your photos. After you take a quick mental inventory of Daisy's quirks, it's time to follow the steps for getting that freeze-frame action:

1. **Turn on your digital SLR and set it to shutter-priority (TV) mode (see Chapter 4 for details on TV Mode).**

2. **Determine how much light is available and set your ISO accordingly.**

 Keep in mind that you may have to stray from the general ISO rule of thumb settings and opt for higher ISOs if you need a deeper depth of field (larger f-stop number).

3. **Change your autofocus setting to AI servo.**

 This setting may also be dubbed continuous focus, tracking AF, predictive autofocus, focus tracking, or continuous servo AF. See Chapter 4 for more on autofocus modes.

4. **Change your drive mode to continuous shooting (see Chapter 4).**

5. **Set your shutter speed to at least 1/800 second (if your image is still blurry, go even higher).**

6. **Align your moving dog in the viewfinder with your active AF point always overlaid on your pooch by panning with the motion.**

7. **Press and hold the shutter release (while still panning) for a rapid burst of images!**

When working with AI servo, you have to move your camera with the subject, always making sure that your AF point is overlaid on the subject. Otherwise, your camera will focus on the tree right next to Oliver that your AF point happens to be hitting instead of on Oliver himself.

In Figure 8-6, we recruited an additional assistant and staged ourselves out of frame while Dino ran back and forth between us chasing his ball. We repeated this little dance of moving around assistants and coaxing Dino to run at certain angles over and over until we actually got the flawless shot we were looking for.

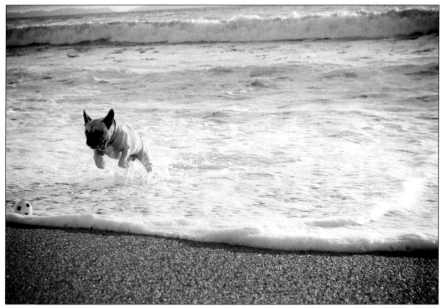

42mm, 1/400 sec., f/5.0, 250

Figure 8-6: Sometimes you need to do some planning to get that great action photo.

If you're using a compact digital camera (CDC) without TV mode, be sure to choose a mode (sometimes referred to as a *scene*) that's appropriate for action photography. Different manufacturers use different terms for these settings, but look for modes like *sport* or *action.* Canon's latest CDCs even dub this mode *kids and pets!* Also, when adjusting your ISO on a CDC, remember that some manufacturers denote higher ISO settings simply as *HI* as opposed to using a number.

Here are some ideas and tips for capturing a dog in flight:

- ✔ Come prepared to shoot, shoot, and shoot some more! You'll likely wear out before your dog does.
- ✔ Bring an arsenal of toys so your dog doesn't get bored.
- ✔ Recruit a friend to assist.
- ✔ Set your shutter speed to at least 1/800 second, but also keep an eye on the f-stop your camera chooses. Remember, the farther away your subject is, the greater you need your depth of field to be (that is, a larger f-stop number).
- ✔ Bump up your ISO if your camera chooses very small f-stops because this triggers your camera to compensate by choosing larger f-stop numbers. The ISO rule of thumb goes out the door here!

✔ Vary the distance from your subject and the angles at which your subject moves through the frame.

✔ Experiment with somewhat slower shutter speeds. If you can accurately pan your camera at the same rate at which your dog is moving, you should be able to create background motion blur. This is what gives the appearance of speed. This technique takes a lot of practice to master, but if done correctly, it can result in stunning images.

✔ Use your zoom or position yourself close to the action for extreme close-ups of your dog catching a toy, a Frisbee, or a stick, like in Figure 8-7.

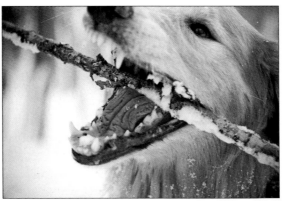

54mm, 1/1000 sec., f/2.8, 400

Figure 8-7: Close-ups can convey a sense of action.

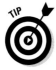

Photos of your dog running or fetching often take place outdoors and require you to get down on the dog's level, so be prepared for your environment. If you're heading to the beach, ditch your shoes so you can wade into the water; just be careful not to get your camera wet in the process. If you're shooting in snowfall, like we did in Figure 8-7, bring an assistant with an umbrella or fashion a protective cover out of a plastic grocery bag to protect your camera and lens from getting hit with falling snow. It may not be the prettiest looking solution, but it worked for us during an impromptu romp in the snow!

Swimming

If your dog loves being in the water and is lucky enough to live near some, pack up your pooch and your camera and get out there! Water offers a bunch of opportunities for great photos: diving in, getting out, shaking off, and, of course, the doggie paddle. But be prepared to get your feet wet — literally!

Your camera settings for photographing Peanut swimming follow the same rules as the settings for when you photograph her running (see the preceding

section). Set your camera to shutter-priority mode, choose a very fast shutter speed, and pick an appropriate ISO for the amount of light available.

Here are some ideas and tips for capturing a dog in water:

✔ Plan an outing to a natural body of water like an ocean or a lake, but remember to pack your zoom lens for the occasion. Although you can wade into the water, you can't get *all* the way in, so being able to zoom in for a closer shot is key.

✔ If it's a very bright day, consider using a *polarizing filter* to cut some of the glare coming off of the water. See Chapter 6 for the lowdown on polarizing filters.

✔ Use the pool in your backyard to capture Sampson diving through the air. Position yourself on one side of the pool and recruit an assistant to stage Sampson on the opposite side. Have the assistant throw a toy into the pool and release Sampson after it.

✔ You won't have long to capture Sampson's plunge, so be sure to have your camera set to continuous shooting mode. Press and hold down the shutter release as soon as he begins running at you. Don't let go of the shutter release until he lands in the pool and has surfaced!

✔ Take advantage of stairs in the shallow end of the pool to get a lower vantage point. Feel free to walk in a few steps, like Kim did when she took the photograph in Figure 8-8; just remember to use your neck strap and keep a *very* good grip on your camera!

Playing with toys

Earlier in this chapter we discuss how to capture low-energy chewing, but it's only a matter of time before Brooklyn is over the bully stick and ready for a serious game of tug-of-war or destroy the brand-new plush toy! When chewing becomes more intense, you have to switch gears from lower shutter speeds to much faster shutter speeds to capture these fun "ruff"-housing images.

Here are some ideas and tips for "ruff"-housing shots:

✔ Survey your surroundings and assess the lighting situation. Because these are still action shots, you need a lot of light to achieve the settings you're after. Consider taking the play date outdoors.

✔ Focus on individual moments, like the few seconds that Chelsea wildly thrashes her toy around before completely destroying it. (Because she obviously has to snap the plush toy's neck before it can be thoroughly devoured, right?)

59mm, 1/3200 sec., f/3.5, 125

Figure 8-8: Don't be afraid to get your feet wet when photographing
your dog swimming.

- ✔ Become an active participant. Use your free hand to engage your dog.
 Try playing tug with her and shooting from above for an interesting
 angle.

- ✔ Try not to torture him too much, but an obligatory shot of Randall
 guarding his bounty of toys never hurts!

- ✔ Attempt "shooting from the hip," which simply means positioning your
 camera and composing from angles that you can't even physically see
 through the viewfinder from (like at your hip — get it?). You'll be sur-
 prised by some of the cool shots you get!

When documenting your dog playing with his favorite toys, also consider capturing the in-between moments that lead up to or follow an actual toy-playing session, like him rounding up his toys before deciding which one is going to make the cut or him flipping a toy through the air to get your attention when he wants to play. Although Figure 8-9 doesn't actually depict Randall playing with his toys, it does tell a story about Randall's unique personality. To this day, Randall is one of the more vocal dogs we've photo-graphed, and his propensity to bark at you while guarding his favorite toys was a playtime ritual not to be missed.

25mm, 1/250 sec., f/3.2, 125

Figure 8-9: Pre- and post-play moments make for interesting photos.

9

Zooming in on Close-Ups and Details

*F*illing out the big picture of your dog's life are a bunch of little things that make worthy photography subjects all on their own: his different-colored eyes, the way his tail curls up when he's trotting around town, and his spotted tongue. Even his collar, leash, and favorite toys should have a place in the photo collection. In people's day-to-day lives, these details tend to fade into the background; most folks don't have time to sit around gazing at their dogs for hours on end, memorizing every inch. Dog guardians often aren't even conscious of the little things because they're too busy feeding, walking, and playing with their dogs and making sure they don't terrorize the neighbors. But taking the time now to zoom in on your pooch's cute little pads or her crazy fur is totally worth it. You'll end up with images that can stand alone or be grouped together for a subtle and artistic portrayal of your dog.

You don't have to go around photographing every single inch of Maggie and her belongings (unless you want to, of course). Choose details that mean something or automatically conjure her up, even though the photo doesn't reveal her full face, or any of her at all. Getting shots of the bottom of her two front feet that she crosses when she's sleeping or the worn-down blanket she lies on are little glimpses that can pack a lot of power. Whether you have an only dog or a full pack, whether you're on your 12th pooch or you're just starting out

with your first puppy, the differences among them are in the details — details you'll one day be glad you have photographs of.

Working Out the When and Where Factors

If you want to get close-ups of Maggie's good-looking features, you may have to sneak them in during some quieter moments when you can easily focus on the details without her jockeying for the next treat. If you're taking photos of Maggie sitting on her favorite recliner while smiling at the camera but she needs a break from concentrating, let her chill and forget about the camera. However, you shouldn't relax. Take a moment during that calm, still state to steal some shots of her tongue dangling out of her mouth or her ID tag resting on her neck. Don't worry about giving her commands; let her stay in that naturally relaxed position. This makes it more likely that she'll hold her position long enough for you to get all your settings dialed in for a great photo.

You can take these close-ups anywhere your pooch is and anywhere you have enough light. Because these are detail shots, you don't have a lot of background, so you don't need to go in search of a nice setup. Zooming in when the opportunity presents itself is all you need to do.

If, on the other paw, you want photos of some of Maggie's accouterments, you may have to be a little sneaky about it. The best advice is to make sure you don't photograph her things when she knows about it or you may have a doggie on your hands who simply won't get out of the shot. If you want to snap her bowls, for example, don't do it around mealtime. Wait until she's napping quietly in the other room. Same goes for her toys; don't set them up for your photo shoot in plain sight of Maggie. That's just asking for a swift pounce to the back of the head, and that's no fun for anybody . . . except maybe Maggie.

As for where to take photos of your canine's inanimate objects, you can pretty much call the shots, so to speak. If the objects look good where they are and you have enough light, go for it. But try your hand at being a little creative, if you like. Stage Maggie's favorite toy in the grass outside or floating in the pool. Move her bowls to that cool, striped throw rug and place a half-eaten dog biscuit nearby. Hang her leashes on an interesting doorknob or coil them up in colorful stacks.

Special Considerations for Close-Ups and Details

Documenting the details of your furry friend is a subtly different type of photography than you may be used to because it's so focused on the minute

details, but it's easy enough to get the hang of. When photographing the little things that make your dog unique, try to do more than simply *record* a trait. For us, detail shots tend to evoke a sense of intimacy. They're about getting up close and personal without being mundane. They possess a quietness about them that you can almost feel. To achieve these special close-up and detail shots, consider using the techniques we outline in the following sections.

Moving in close versus zooming from afar

Instead of zooming in, set your camera lens to the widest focal length possible and move as close as you can to your subject. The wide-angle close-up creates a really cool image that makes viewers feel like they're actually right in the middle of the photo. Figure 9-1 was taken inches away from Truffle's face, which exaggerates her big, round, pug eyes. It's a totally different perspective from simply zooming in from a distance. Most people think that wide angles are reserved for capturing vast, flowing landscapes, but experiment with shorter focal lengths and very close proximity — you won't be disappointed! (Refer to Chapter 3 for more on wide-angle lenses.)

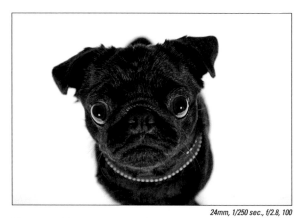

24mm, 1/250 sec., f/2.8, 100

Figure 9-1: This wide-angle close-up puts Truffle right smack in the viewer's face — an effect that's only achievable with this technique.

Sometimes, dogs that are okay with the camera when it's several feet away get scared when that distance shrinks to mere inches. To keep Truffle from bolting as you move in close, go slowly, repeat a "stay" (or "sit" or "down") command, and treat along the way. Give the command, move a few inches, treat. Repeat the sequence until you reach your desired closeness.

If your compact digital camera has a macro mode, give it a try for achieving these wide-angle close-ups. In macro mode, you can focus on your subject at a much closer distance than in any other mode, making it ideal for close-ups and details.

Getting creative with your cropping and angle of view

When photographing your favorite furry friend, you should also experiment with different angles and creative crops for a more interesting and dynamic image. Particularly when you're photographing close-up and detail shots, trying different angles is important because the viewer sees only a small portion of your subject. Without a unique perspective or artistic cropping, it's easy to end up with a boring detail.

No matter how cute Maggie's little button nose is, it won't be that cute in a photo without a little help from your artistic side, so try experimenting with unique angles and framing. Figure 9-2 was framed so Rocky's head fills a majority of the frame, but the image is cropped in a unique way. (See Chapter 4 for more on composing artistic photos.)

Documenting Doggie Features

How many times have you heard (or said), "Oh, your dog is so cute! What is he?" only to have the response come in the form of a resigned but enamored shrug? Though you may be convinced that he's clearly a cross between a Lab and a Chihuahua, your friend swears he's a basset hound–poodle mix. Even in the purebred world, dogs' appearances vary as much as humans' — well, even more so, seeing as how dogs *are* the most diverse species on the planet. Time to home in on those muddy paws, rogue tufts of fur, smushed noses, and everything else that clearly proves your dog is who you say he is — a Great Cockaschnauterrier. *Duh.*

Paws

What you want to convey about your pooch's paws determines *how* you compose this detail shot.

- ✔ If he's got huge clodhoppers, photograph them as they dangle off the edge of a bed or couch. Get below him but still in front of him so you can get some perspective on just how huge they are.

- ✔ If he has dainty little pads, you may want to capture him midstride as he tiptoes down the street. Frame your photo to include a good chunk of the ground, his tiny paws, and his legs while cropping off the rest of his body.

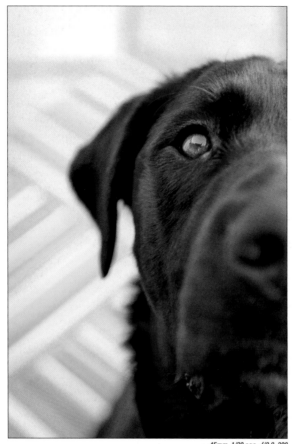

45mm, 1/30 sec., f/2.8, 200

Figure 9-2: Creative cropping and unique perspectives take your detail shots from boring to beautiful.

✔ If you don't need to emphasize size or you just feel like being a little artsy, position him on a cool (or favorite) piece of furniture, like in Figure 9-3.

Tail

A dog's tail is such a huge part of him, even if it's just a nub or nothing at all. Curly or stick-straight, furry or bald, his tail is a key part of his makeup. He sends it a-thumpin' when he just can't contain his joy and tucks it far under his legs to tell you he's sorry. Maybe his tail points when he finds a squirrel or bends in a strange way because he broke it once.

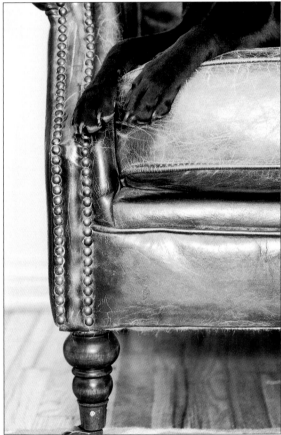

70mm, 1/125 sec., f/2.8, 320

Figure 9-3: Using a piece of furniture as a backdrop for your dog's paws can yield a dynamic and interesting image.

When you take a photo of this most adorable of all back ends, choose an angle or crop that highlights his special tail. Try not to amputate the end and be sure to include a bit of his body to anchor the appendage and avoid a floating tail. In Figure 9-4, Kim shot straight-on but left enough negative space to accentuate the cuteness factor of Brecken's question mark tail that fades into his matching backside. (For more on negative space and how to use it to your artistic advantage, jump back to Chapter 4.)

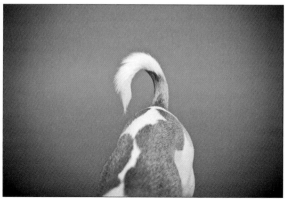

40mm, 1/250 sec., f/3.2, 100

Figure 9-4: Including some of your pooch's back end anchors his cute little tail.

Nose

Noses are the cutest to photograph. You can photograph them straight-on to get that fishbowl, her-nose-is-ridiculously-large-and-cute look that everyone likes. If you want to see a few more details, like her whiskers and a little of her graying muzzle, try taking an angled approach, like in Figure 9-5.

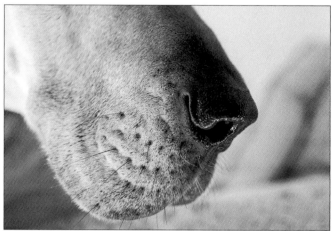

32mm, 1/60 sec., f/2.8, 500

Figure 9-5: Photograph your dog's nose from the side to include additional details, like whiskers and her muzzle.

Eyes & eyebrows

If a dog wears his heart on his tail, then he wears his soul in his eyes. Dog guardians know how many things their beloved furry pals communicate through the expressions in their eyes. Sometimes, all you have to do is look at your dog to know exactly how he's feeling. When your dog's eyes speak to you — like Butch's do in Figure 9-6 — it's time to grab the camera, get close, and take a listen. You don't necessarily have to go the soulful route; you have many possibilities:

- ✔ Getting a shot of just his eyes above the dinner table, begging for scraps
- ✔ Photographing the look he gets in his eyes when he has spotted something outside
- ✔ Taking a profile shot of him looking deep into the eyes of someone he loves (someone other than you — sorry, photographer)
- ✔ Capturing his eyes searching for something or waiting for someone to get home

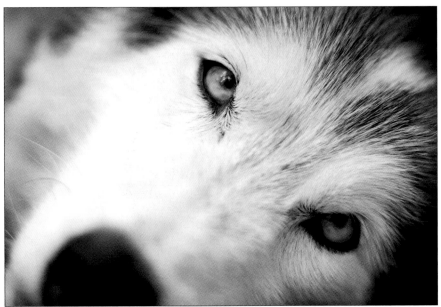

50mm, 1/400 sec., f/1.8, 125

Figure 9-6: Lie down next to your dog when he's relaxing to capture a permanent peek into his eyes and soul.

Ears

We don't know whether anything on the planet is softer than a dog's ear. We also don't know who finds rubbing a dog's ears more soothing — the dog or us. So why not create a photo that represents that softness visually? Bring out the individual characteristics of your buddy's ear:

- ✔ If she has tiny little hairs sprouting out of the top (like in Figure 9-7) or from inside, try to position yourself so you get some backlight behind her and make those sprigs of hair really stand out.

- ✔ If her ears do a weird half-floppy, half-upright thing, try photographing down at them to get them to "fly out."

- ✔ If her ears are really long hound ears, get your pal to lie down so her ears spill out across the floor or get her to rest her chin on a table so her ears dangle well beneath her chin.

60mm, 1/250 sec., f/2.8, 125

Figure 9-7: Highlighting specific traits, like the little hairs on top, adds a sense of texture and softness to the image.

Mouth, teeth, & tongue

Photographing your dog's mouth area is another type of shot where you can really home in on what's unique to your dog. Here are a few ideas for taking close-ups of his mouth:

- ✔ Him eating his dinner or chewing on his favorite bone
- ✔ His open mouth grabbing for a stick
- ✔ His closed mouth while he's asleep
- ✔ The underbite or overbite that's distinctly his
- ✔ His tongue flapping in the breeze

For Figure 9-8, Kim wanted to show that Sandie does, in fact, love the sand. We spent a few minutes getting shots of her lying in the sand, and when we gave her a break, she gazed off into the distance. When she did, Kim snapped a photo of her sand-covered mouth.

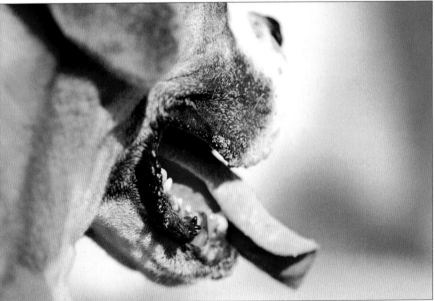

70mm, 1/640 sec., f/2.8, 100

Figure 9-8: Snapping a photo of a dog's mouth covered in sand tells viewers exactly what she loves to do!

Quirks

Okay, so if your awesome furry friend has something weird, funny, or amazing about her looks, you definitely have to photograph it — and then post it

on the Internet so she can become the next virtual sensation. Don't worry, you're not exploiting her; it's called *loving* her. And if she happens to get a million hits, then the world loves her, too! If you notice a quirk and you love it, photograph it:

- ✔ The spot on her side, which looks like Elvis
- ✔ Her furry feet, which make her look like a sasquatch
- ✔ The little white tuft of hair on her otherwise black chest
- ✔ Her tail, which bends at a 90-degree angle
- ✔ Her scruffy beard, which always has something in it

In Figure 9-9, we're obviously highlighting Piko's tongue, which is too big for his mouth. It's always sticking out a little (and sometimes a lot). Kim shot him straight-on to get the full effect. He may look a little dopey, but that just makes us love him more.

Whatever makes you love your dog more is what you should capture in your photos.

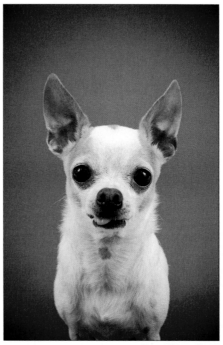

24mm, 1/250 sec., f/11, 125

Figure 9-9: Have a sense of humor when photographing your dog's quirks.

Embellishing the Story with Pooch Paraphernalia

Your dog's world is full of dog things that help keep him healthy, safe, and happy, so why not turn those inanimate objects into elements in the story of his life? The objects may not seem like very dynamic subjects at first, but you can do a lot to create interesting images of them, and — bonus — *they'll* stay where you put them.

ID tag and collar

A photo of your dog's ID tag and collar is a must-have. It's a great establishing shot that makes the perfect addition to a collection of several photos. You can try to snap some shots of the tag and collar while your pooch is wearing them, or you can take his collar off and get a shot of just that. You especially want to spend some time getting a nice photo if the tag or collar is particularly unique or

special, like the tag in Figure 9-10. In this case, the tag itself is quite lovely, and it also looks nice against the dog's white-and-black Dalmatian markings. It makes for a beautiful image, one that even those who don't know Clover can appreciate.

Other ideas for photographing your dog's ID tag and collar:

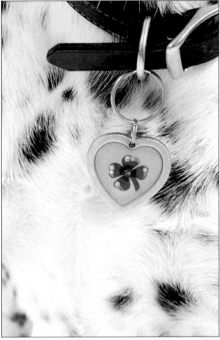

- If he likes the water, get a photo of him right out of the lake or pool so you can capture the water droplets on the tag/collar

- Make sure to take a photo of the side engraved with his name

- Take the collar off of him and group it with some of his other belongings, like his bowls and leash

- Let him chew on the tag and get a shot of it hanging out of his mouth

70mm, 1/200 sec., f/9.0, 100

Figure 9-10: Your dog's ID tag and collar can make sentimental photographic subjects.

Bowls

If your pooch dines out of bowls that are all her own, snap a photo of them. You can leave them where they are if you have a decent background and lighting, or you can stage them in the grass. You definitely want a few shots of the bowls if they're personalized in some way, like in Figure 9-11. We photographed Jill's bowl, which her owner made right after adopting her. You can see how well-loved the bowl is, and therefore, how well-loved Jill is. A photo like this says everything you need to know about the relationship between Jill and her human. Again, get creative. You can

- Shoot with or without food and water in the bowls

- Stack the bowls

59mm, 1/800 sec., f/4.0, 100

Figure 9-11: The most worn objects are the most loved; look for objects that say love.

 🖊 Lean the bowls against a wall

 🖊 Let her face disappear into one of the bowls

Bed

Because dogs spend the majority of their lives slumbering away, you may want to get a few snaps of Tonka's bed. That is, assuming he has his own. If he sleeps in yours, we're perfectly fine with that. If you and your dog are among the lucky ones who have your own beds to yourselves, you should celebrate with photos!

In Figure 9-12, we caught Delilah dozing off and on one afternoon. For once, she was on her own bed, and we wanted to capture the momentous occasion. Kim got down on the floor so she could capture as much of the bed as possible. She could've photographed Delilah from above, but the bed would've turned into a nondescript background. Here, you can actually see the thickness and the softness that keeps Delilah all snoozy-woozy.

Get even closer than this to get a shot of your dog's face pressed right down into her comfy bed. Or, if you have a little dog who likes to burrow, make sure to get a shot of her poking her little head out of her nest of blankets that she so furiously arranged.

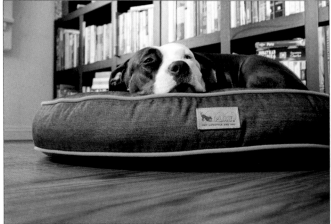

24mm, 1/10 sec, f/4.0, 250

Figure 9-12: When shooting your pooch's bed, get on the floor to show the viewer the bed's dimensions and texture.

Special toys

If your canine companion has companions of his own that aren't you, take the time to photograph them as well. We realize that may sound a bit out there — even for people who are reading a book about dog photography — but it goes back to the humor thing. If your pal really loves his rubber squeaky newspaper, maybe you should sneak a quick shot. Or if he has a habit of hoarding all his toys into one corner, that would make a great photo. Perhaps he has one ratty old toy that's barely hanging on but has been through everything with your pooch. Isn't that worth at least one shot?

For example, Figure 9-13 is a real photo from a real client shoot. This cheeky fellow is Burrito Bunny, and he belongs to a certain canine client friend of ours. Every spring, the clients put this photo of him, framed, onto their mantle to enjoy all season long. And it actually works quite well up there, if we do say so ourselves!

50mm, 1/800 sec., f/4.5, 250

Figure 9-13: Don't take yourself too seriously. Snap a few frames of your dog's favorite toys.

So the bottom line is this: Never take yourself too seriously. Make sure you're having loads of fun at any given time throughout your dog photography journey . . . or we may have to sic Burrito Bunny on you.

10

Capturing the Love: Dogs and Their People

In This Chapter

▶ Capturing special moments that reflect the human-doggie relationship

▶ Working with a dog's human family

▶ Taking specific posed and interactive photos

▶ Pairing dogs with babies and seniors

*T*he love between a dog and her human is unmatched. It's unconditional and pure. It's a decades-long interspecies affair that's understood only by other dog lovers, because it's impossible to describe in words. And that's why we've written this book, when we stop to think about it. So you can take all those moments — those genuine, heart-filled moments — and put them somewhere you can look at again and again.

No matter what kind of day you had at the office (or at home), you can always count on being greeted by someone who's out of her mind with excitement to see you. You can bank on the fact that when you enter your home (or just come in from the other room), you'll come face to face with someone who thinks you hung the moon and will trot behind you from room to room, dancing with pure glee. And the kicker is, the feeling's mutual. People don't spend time with dogs because they want to *receive* unconditional love. They share the company of dogs because they want to *give it back*. Yeah, we get mad at them when they break something or do something scary, like run out into traffic. But that's all small potatoes compared to how much we adore them.

Your goal in photographing a dog with her human is to *show* us these feelings, to put on your photojournalist scuba gear and dive into the souls of these wonderful creatures (dogs and dog-loving humans alike). Seek to reveal the connection, the wonderment, the respect, and the utter joy that exists when the right human meets the right dog. Don't just snap photos; capture hearts.

Recording Special Moments between a Pooch and His People

If you want to capture some images of your favorite canine with his favorite humans (well, aside from you), think about what is specific to the relationship and aim to photograph at times that present those special moments. For example, if Argos is amazing with your young son, you may want to pull out your camera when the two are napping together or playing their daily game of chase. If you want to convey the special bond that Swayze has with your husband, try snapping a few posed photos of them nose to nose. Capturing these connections is all about being aware of the precious moments we share together and having your camera at the ready, like when you come home from work and Delilah is ready to give you a big hug. Now, if you want to get some photos of yourself with your pooch, you have to either share this book with a friend or buy an extra copy for him. We're guessing you know our vote on the matter.

Because the star of these photos is the relationship between a dog and his humans, the shooting location doesn't really matter too much, as long as it has decent light and a usable background. You could consider choosing certain settings that are meaningful to the pair, such as the two of them

- Sharing a pillow and blanket in bed during a lazy Sunday morning
- Watching TV together on their favorite chair
- Watching the world go by from the front porch
- Tackling their favorite hike together
- Lounging in the sun with each other

Special Considerations for Group Shots

As you're probably all too well aware, getting photos of dogs can be a challenge, to say the least. Trying to get them to sit still long enough or move back a little or ignore that squirrel in the distance can be downright *hard*. Now add to that a couple of humans who have their own concentration issues (as any wedding photographer can tell you). Between fixing their shirts, brushing the hair out of their eyes, or shifting their weight because their feet are starting to fall asleep, people aren't much easier to wrangle

than dogs. Combine all that with the formidable goal of getting and keeping everyone in focus, and even the most even-keeled among you may break out in tears of desperation (or perhaps a fit of delirious laughter).

Fear not, our fair friends. Whether your group shots are posed or interactive, include one human or ten, we have all the tricks you need to keep your photos looking harmonious so that when you check out the finished product, you see one big happy family instead of an image worthy of the title "Five Surly Adults and a Big Dog's Butt."

Getting crisp detail with depth of field

Because depth of field is basically how much of your image is in focus and is determined by your aperture setting, understanding it is key to getting good group photos (see Chapter 4 if you need to brush up). With so many different subjects, you need to stay focused on what's in focus.

To make sure that all your subjects are in focus, your efforts must start before you even pick up the camera (but after the pep talk you give yourself in private, of course). Begin by setting up the humans in the group first. Arrange them so they're all roughly on the same plane, or distance from the camera, similar to Figure 10-1.

24mm, 1/160 sec., f/9.0, 200

Figure 10-1: For traditional group photos with everyone in focus, place everyone about the same distance from the camera.

After you set up the humans, insert the dog into the group and dial in your aperture setting. Try to keep your aperture small (around f/11.0 or higher) so you can make sure that all your subjects are in focus. If you set your aperture low, you'll likely end up with some blurry subjects in the group.

You don't always have to follow these guidelines. Now that you understand a little about how depth of field pertains to group shots, feel free to experiment with different setups, such as a shot where one of the subjects is in focus and the others aren't. We go into more details about those fun options a little later in this chapter.

Giving clear directions to your furless models

Working with dogs and humans at the same time . . . um . . . *builds character*. There's no telling which species is easier to manage until you're right in the midst of photographing, but one thing's for certain: You have to speak the language of your subjects. Just like little Feather needs clear commands, the humans need clear instructions to make the photo a success, whether it's a posed or candid shot. Here are some tips for working with humans:

✔ Tell them to pay attention to you, not the dog. Tell them that *you'll* worry about the dog.

✔ If the shot is interactive, tell them to ignore the camera and just keep interacting with the dog. If the shot is posed, tell them to keep looking at the camera and smiling, no matter what (well, unless zombies suddenly descend upon you; then you can give them permission to run).

✔ If you have to tweak their positioning, be as specific as possible. Saying "move a little to your left" isn't as helpful as "move about 2 inches to your left."

✔ Though you want to make sure they're paying attention to you and are staying quiet enough to hear your directions, a few jokes and silly banter to keep them relaxed and laughing helps you capture genuine expressions instead of fake smiles.

And here's a true insider's tip from the pros: When you snap off a few shots after the official, "one, two, three, say 'cheese'" countdown, keep shooting. People naturally relax in the seconds immediately following the release of the shutter. Those are the *real* faces that you want to be sure to get.

Have a friend act as an assistant to wrangle the canine subject during group shots. That way, the humans can concentrate on themselves and you can worry about your settings and getting the shot.

Positioning Everyone for Posed Photos

Setting up posed photos is great when you want to get a crisp, clear image of all your subjects. You can go casual or formal, silly or serious — whatever represents this particular human-canine relationship the best! Here are some ideas to get you started.

Family portrait

The family portrait (refer to Figure 10-1) is a classic must-get, and you can go as traditional or creative as you'd like. Just remember our point about depth of field and keeping your subjects on the same plane (see the section "Getting crisp detail with depth of field" earlier in the chapter). Generally, the easiest way to keep your subjects on the same plane is to put them all in a straight line, but that's about as exciting as watching paint dry, so think creatively:

- Set them on the staircase or front porch to create two rows. Have the front-row folks lean back a little and the back-row folks lean forward to make one plane.

- Gather them in a corner of the couch, using pillows and cushions to create different heights.

- Use a cool-looking chair or two; a couple of people can sit on the chair while others lean on it.

However you choose to set up, make sure all the subjects stay on the same plane as much as possible. That is, of course, unless you don't *want* them all on the same plane. Maybe you're bored with the traditional setup. Maybe you want to try something new. Well, we have just the thing. Intentionally place your subjects on different planes for a more unique family portrait.

For example, have Mom and Dad (or two brothers or whomever) sit down in the middle of a staircase. Position them in your frame like you want and then bring Beau in and give him a sit-stay command a few steps down (closer to the camera). Set your aperture at a low f-stop number (that is, a wide aperture for shallow depth of field) and focus on Beau. This results in Beau being in sharp focus while the humans are blurred. It's still a family portrait (like Figure 10-2), but the emphasis is on the dog. Remember though, you can still *see* the humans in the background; their details are just obscured, so make sure you have them do something cute, like look at Beau with googly smiles of love on their faces.

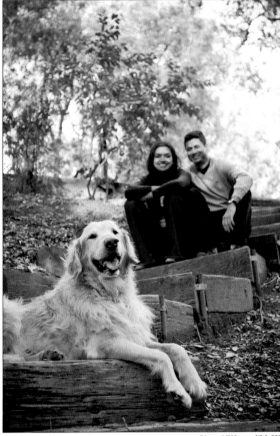

34mm, 1/200 sec., f/2.8, 320

Figure 10-2: Experiment with depth of field for a portrait that focuses on the dog but also includes his or her family.

This approach is not only a nice twist on the family portrait but also perfect for people who are camera-shy or self-conscious. Also, it gets you around that extra step of having to Photoshop the humans later. You can try this approach with any setting, such as

- ✔ A pooch standing on-leash in the park with humans sitting behind on a park bench
- ✔ A doggie on the ottoman and a human sitting in the chair
- ✔ A canine on the end of the couch and humans in the far corner of it

Paw in hand

There's something so soft and gentle about a person holding her dog's paw in her hand. It's one of our favorite photos to get and one of those instances where you can feel the love without having to see much more than a paw and a hand in the frame. But you can also try different setups, like these:

✔ For the most relaxed shot, have the human lie down with little Jill and gently hold her paw. Zoom in tight and fill the whole frame with just the paw and the hand, like in Figure 10-3. Capture the little details, like a wedding band on the human's hand or the little tufts of fur poking out between Jill's pads.

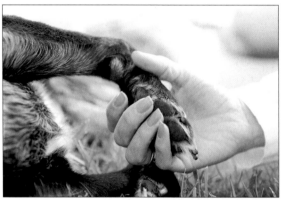

70mm, 1/125 sec., f/3.2, 160

Figure 10-3: Capturing a bond is about the little moments, like the touch of a paw.

✔ You can have the dog sit and "shake." Get a shot from the side so you can see how the dog and human connect with each other. You can also try photographing from over the human's shoulder (or *at* shoulder level) so the dog's paw is blurred in the foreground and his face is in focus farther from the camera.

✔ If the dog's paw has something quirky about it (funny-colored nails, "socks" on his feet, webbed toes, and so on), be sure to capture that. Quirks and contrasts make for great photos. For example, if the human is a big, burly, tough guy and the dog is a tiny Chihuahua, set up a shot where the dog has his paw on top of the human's hand so you can see the size difference.

Face to face

The possibilities with face-to-face photos are endless. Nothing melts your heart faster than an image of a dog and his human gazing lovingly into each other's eyes. It just says everything about the true bond between a dog and a human, really. Try these setups:

- ✔ Both human and dog lying on their stomachs, and you on yours so you can put the viewer right in the moment with them. Experiment with different amounts of space between their faces, and photograph from the side, like in Figure 10-4, or even try shooting from above.

 If you're having trouble capturing that human-animal bond, focus your attention on their gaze and start snapping the moment they lock eyes.

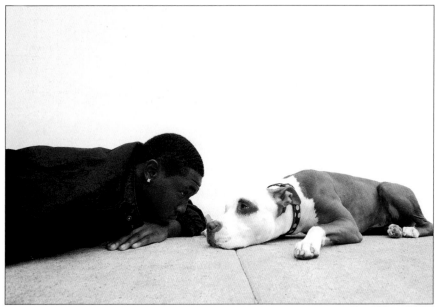

17mm, 1/100 sec., f/9.0, 1000

Figure 10-4: A heartfelt gaze shows the love and loyalty between human and dog.

- ✔ Dog and human facing each other while sitting. The human can take the dog's face in her hands while maintaining eye contact as you photograph from the side.

 A slight variation on this idea is to have them get close enough so their foreheads are touching, like in Figure 10-5. Experiment with closed and open eyes.

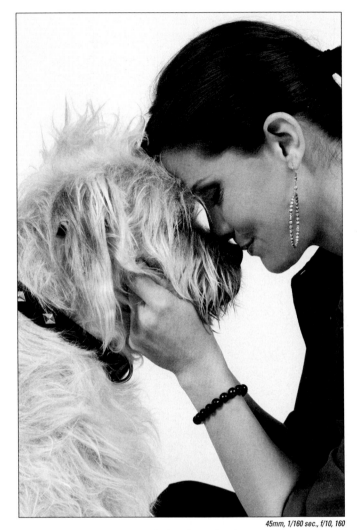

45mm, 1/160 sec., f/10, 160

Figure 10-5: Have the human in the photo shut her eyes for a tender moment with her pooch, like award-winning journalist and animal welfare advocate Lu Parker does here with her rescue dog, Monkey.

✔ You can get silly, too. Try to get the human to mirror whatever the dog's expression is for a fun image. If the dog is panting, have the human pant. If the dog is looking up at something, have the human look up, too.

Dog in lap

The doggie-in-the-lap shot is an obvious choice for little pups, although we know plenty of 80-pound lap dogs out there, and if they and their owners are

game, you can try taking these shots with them, too! Again, the motto in this chapter is, "Go for whatever represents the relationship!"

If the dog is little, you have a few more options to consider. You can have the dog lie on the human's lap and instruct the human to look down at her, like in Figure 10-6. Wait for the moment when the dog looks up at the human and snap away. Zoom in tight to capture the expression on the human's face or go wide to get the whole body in the shot.

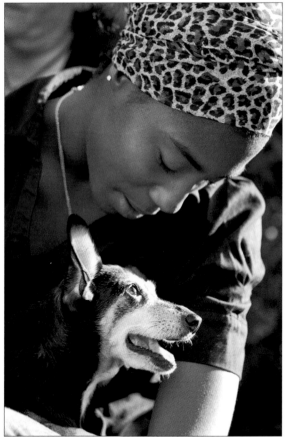

70mm, 1/125 sec., f/2.8, 100

Figure 10-6: Mama gazes lovingly at her human mama in this shot.

Capture the person's hands wrapped lovingly around Ruby's body, keeping the pooch safe and secure, for example. Or maybe you notice grass and mud stains on the person's jeans from when she was romping in the yard earlier with Ruby; including that detail in the shot conveys that human and dog like

to play and get dirty together (and if Ruby still has dirt on her paws, so much the better). Or have the person give Ruby a good scratch under her chin or behind her ear or lean down and give Ruby a kiss on the head. Or maybe Ruby isn't the get-dirty type at all; maybe she prefers well-groomed fur and to be carried around in her bag. That's fine, too. You can set her bag on her human's lap and let her pop her little head out. If someone's really into the formal thing, you can use a chair and have Ruby sit up straight and proper on her human's lap while both of them look directly into the camera.

If Ruby's a big-boned gal, you can still get some lap-oriented shots. Try having her lie on the couch (or floor) with her human next to her so that just Ruby's front feet and head are in her person's lap, and then zoom in on Ruby's momma planting a kiss on that big mush's head.

Gearing Up for Interactive Photos

Some of the best, most telling moments in a relationship happen when you're not even thinking about it. When you're truly living in the moment, not self-conscious, and not aware that anyone's watching, that's when the truth comes through. So for interactive photos that reveal the truth about the love between one specific dog and one specific human, follow them out into the world as they do their favorite things. The images you capture will speak volumes.

Only do things that they *already like to do together.* Trying something new is great, but not for this type of photography. You want to show the dog and person in their best, most relaxed light, so keep them in familiar and beloved environments.

Taking a walk

Ah, the time-honored tradition of walking together. There's nothing quite like it, although, yes, we know there's some debate about who leads whom. Whether it's the quiet time humans and dogs share every morning before the rest of the neighborhood wakes up or the hustle and bustle of the evening rush hour in which they delight, you want to be there when paw meets pavement, when two wandering souls are joined together by one length of well-worn nylon and maybe a plastic poop bag. A walk is a great opportunity to get some pretty dynamic photos. Consider these ideas and tips:

- ✔ Position yourself several yards in front of the pair and get down on the dog's level, like in Figure 10-7.
- ✔ Keep your eyes open for nice backgrounds as you stroll through the neighborhood: blooming flowers, green shrubs, and brightly colored garage doors or alleyways.

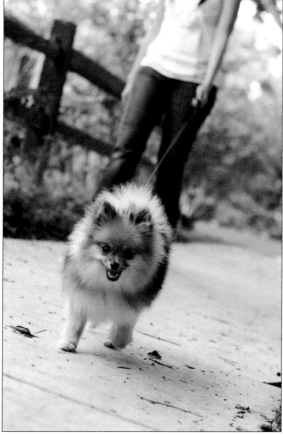

50mm, 1/320 sec., f/3.2, 160

Figure 10-7: Get down low and shoot from the dog's level when you're out on a walk.

- Don't forget about the seemingly small moments: when Jaxxon's human snaps his leash onto his collar, when he helps Jaxxon get untangled from his leash one paw at a time, or when he waits patiently for Jaxxon to finish sniffing the hydrant. All these moments fall into the "we don't think anyone's watching and therefore you're seeing our true selves" category.

- If they like hiking, join them out on some trails. Look for great views and use trails that have a grade to them to create dynamic composition and perspective.

✔ If they like hubbub, get some photos of them all up in the mix. Find a busy corner and let them interact with the people around them or just watch the world go by together. As they respond to their environment together, be ready for anything!

Playing

Because we cover how to get photos of your dog playing on his own in Chapter 8, this section is all about how to capture a human and a dog playing *together*. In other words, your aim is to get both subjects in the frame. Here are some ideas for you to contemplate:

✔ **Tug:** This is a fairly easy game to get photos of because dog and human generally hold their stance for a few seconds. Get a wide shot from the side to show how they both throw their whole bodies into it. Or zoom in to really see their facial expressions, like in Figure 10-8!

55mm, 1/250 sec., f/11, 100

Figure 10-8: When photographing dogs and humans at play, try to capture moments when they're *both* in the frame.

✔ **Fetch:** Because your goal is to get photos of the relationship, focus on the part of fetch where the two are together, like the moment Harlee drops the ball, all slobbery and wet, at Dad's feet. Or get a shot of her expectant eyes meeting her human's. You can also have both of them just settle for a moment and let Harlee roll around with her toy while Dad looks on with adoring eyes.

✔ **Tummy rubs and more:** However Simi likes to get his affection is what you want to capture. If it's a belly rub, get low and perpendicular to him. Let his human's face peek up and over his protruding tummy while he

pets Simi. Then try a different angle by lying in front of Simi's face (make sure Simi is cool with you getting so close) to capture his smile of bliss in the foreground and his adoring human in the background. Be prepared for any variation on the pet-me theme: ear rubs, chin scratches, head pats, and ticklish spots.

✔ **Special games:** Do Payton and her human play hide-and-seek together? Hunt the hand under a blanket? If there's something unique to them, make sure you get it!

Doggie kisses

Among the most obvious types of canine PDA (that's "poochie displays of affection") are dog kisses! Before you say "Ew, gross!" and slather this book with hand sanitizer, keep in mind that we're not suggesting a full-on make-out session between Hampton and his mom. Granted, Mom does need to be cool with a little doggie breath in her face.

27mm, 1/250 sec., f/3.5, 125

Figure 10-9: Doggie kisses are a two-way street. In this shot, coauthor Sarah plants a smooch atop Kali's head.

✔ **Dog kissing human:** Many dogs are pretty generous with their kisses, and all it takes is a little kissy sound from their human to start the full-face tongue bath. All you have to do is choose a nice setting, cue the kissy sound, and start snapping! Also be on the lookout for the doggie kisses to start spontaneously while you're taking other photos.

✔ **Human kissing dog:** Some dogs aren't into giving kisses, but they're totally game to *receive* them. If your canine subject won't kiss on command, try having her *human* do the smooching! In Figure 10-9, Kim caught such a moment (it happened to be spontaneous in this case, but you get the idea). If you want to coach your human subject, give directions like: kiss the top of the dog's head, kiss the side of his face, close your eyes, open your eyes, and so on. The goal is to capture a moment of pure love, like Sarah and Kali show in Figure 10-9.

Unique Pairings

In addition to having special adult humans in their lives, some dogs are lucky to have other types of humans to share their lives with. If your canine subject has a human infant for a sibling or a senior citizen for a dad, this section is for you. Certain considerations and ideas come in handy when you want to photograph these most special among special humans with their dogs.

Awwww! Dogs and babies

You may think trying to photograph a dog — a being that doesn't understand English the same way humans do — is the pinnacle of difficulty. But you'd be wrong, because, see, babies don't really know what humans are saying to them, either. It's not like you can have a little conversation with them: "Okay, so now we're going to take your photo, and we want you, Michael, to sit up against that pillow and look happy but not excited and kind of gaze at Keeto. Now Keeto, what you're going to do is" No. That doesn't happen in the real world. (But if you know of an alternate universe in which it *does* happen, let us know. We'd like to drop off some business cards.) Working with human babies is just like working with dogs (the two of us constantly debate about which subject is tougher; currently, babies are leading 6 to 5), so put them together and it's quite the . . . um . . . *skill developer.* The one exception tends to be infants. The younger they are, the easier it is to work with them (typically). Here's a little breakdown of tips and tricks, based on the ankle-biter's age:

- ✔ **Newborn:** Make sure he's fed, and then crank up the thermostat, strip the little pork chop down, and swaddle him up. As long as he has a full belly and he's comfy, he should pretty much sleep through the whole episode, and that's a good thing (unless you want his eyes open; then you have to sort of wait for that to happen). After he's all wrapped up, place the pooch and then place the infant. If the dog is calm, have the dog lie down, and place the swaddled infant right against the dog's side, in the space between the front elbow and the back leg — again, only if the dog is used to the baby and is calm enough for this sort of thing. After that, get creative. You can try a face-to-face shot by placing the infant on his tummy in front of the dog's face or anything else you can think of. As long as the baby keeps sleeping and the dog tolerates it, keep shooting! When the baby is old enough to start crawling and tugging at Buster's tail, Buster may not be so tolerable anymore. And if you've got a high-energy dog on your hands, pairing him with a newborn may not be the best idea. Always remember, safety first!

- ✔ **Toddler:** Put the dog and child in an enclosed area and let them interact freely and naturally. To encourage them to play with each other, give them toys or other accessories to share. Things like long rope toys, scarves, and big plush balls all work well. Every second is different, so be sure your memory card has plenty of room. Also look for sweet moments between play, like if they stop to look at each other, or if

the dog licks the child's face, or if the child goes in for a full-body hug. Figure 10-10 was caught when Aidan and Libby took a break from playing with each other. They were in perfect position for a portrait, so we called both of their names to get them to look at the camera.

35mm, 1/250 sec., f/4.5, 100

Figure 10-10: Natural interactions are best when it comes to babies and dogs. Catch your portrait moments as they come without trying to force them.

✔ **Preschool through about 10 years:** Children in this age range have their own personalities, likes, and behaviors. Because these factors can vary widely, how you handle kids this age all depends on your specific situation. Basically, play to their strengths. If the child is quiet and calm, set up shots that highlight that trait. Maybe the two sit together near a lake or pond at sunset, or you get a shot of the child reading her favorite story to the dog at bedtime. If the child is active, take them outside and get some shots of them running around, skateboarding, or playing together!

✔ **Other ideas:**

• Dog and child sharing food

• Dog looking in on baby in the cradle

• Child crawling on dog

• Dog and child napping together

• Dog and child watching a movie together

• Dog and child getting dirty, knocking over a plant, or otherwise getting into trouble together

Before you set up any shots with a child of any age, be certain that the dog is good with children. Ideally, you're working with a dog and child who already live together and are familiar with each other. You should know the limits of what the dog will tolerate and respect those limits. Safety is a priority at all times!

So sweet: Dogs and seniors

Some of the most poignant human-dog relationships happen between dogs and senior citizens. Seeing how the two rely on each other and give each other so much love and companionship can be truly amazing (and if the dog is a senior, too, it's just doubly amazing). Photographing seniors is pretty similar to photographing your average adult, but you have to keep a few things in mind:

- ✔ Seniors' mobility and endurance may be limited. Make sure you talk with your senior friend about physical issues, decide how long you can go before she'll need a break, and be prepared to modify setups. For example, a senior may not be able to crouch down on the floor, so be prepared to use a chair or something else to sit on. In Figure 10-11, we used a set of stairs and placed Hannah a few steps below.

- ✔ Seniors may not be able to hear well. Again, talk this over ahead of time. If hearing is an issue, come up with a few hand signals to use so your friend knows what to do ("smile," "look at the dog," "pet the dog," and so on).

- ✔ Seniors may rely on a wheelchair, walker, or other assistive device. Think about how you can incorporate those into the shots ahead of time and discuss with your friend whether he'd like them in the photos. Some people may want them and others may not.

- ✔ If the dog is a therapy or service dog for this individual, work that into the photos as well. Get some shots of them working together through their daily routine and some shots of the dog in his service vest.

- ✔ If both of them are seniors, make sure you get some shots of their wrinkles, graying hair/fur, and other marks of wisdom. Seeing two beings who have shared so much life and time together in one image is truly touching.

- ✔ One final thought that a senior friend of ours likes to remind us of: "I may be old, but I'm not dead!" In other words, let your senior pal tell *you* what his limits are; don't automatically rule things out based on assumptions.

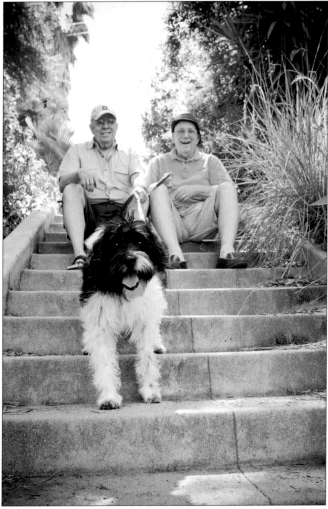

24mm, 1/80 sec., f/4.5, 100

Figure 10-11: Be aware of your human models' needs and limitations so the photo session is enjoyable for all.

Part III

Sit! What to Do after the Photo Shoot

The 5th Wave — By Rich Tennant

"Those are photos of my dog chasing a bee. It's cool when I catch him doing something interesting."

In this part . . .

Taking the photos is only half the fun of dog photography. You also want to make your photos look great to show off to your friends and family. In this part, we discuss the art of postprocessing — that is, tweaking your photos with the help of computer software. We take you through all the ways of adjusting your color, tone, and sharpness. We even show you how to completely remove unwanted items (like a leash) from a photo.

In addition, we discuss how to take your photos from files to actual products, how to show them off, and even how to make a business out of them!

Introduction to Postprocessing

*O*kay, here's our big secret: Our photos right out of the camera don't actually look like the final images you see in our portfolio — *gasp!* To be honest, Kim doesn't even like showing her in-camera photos to people because she considers them to be a pizza without the toppings — only halfway done.

For us (and most professional photographers), postprocessing is a huge part of creating great photos. Can you get good photos right out of the camera? Sure! Can you get *great* ones? Sometimes, but more often than not, *postprocessing* — enhancing your photos after you take them — makes the difference between a good photo and a great one. If you're serious about getting the best photos possible of your dog, sit down and stay awhile. In this chapter, we cover the basic tools of postprocessing and how to download and organize your photos after you've shot them. We also introduce you to the basics of the photo-editing software Adobe Lightroom. (When you're ready to edit your photos, head to Chapter 12.)

Tools of the Postprocessing Trade

When it comes to postprocessing your images, you need a few essential tools beyond the camera gear that we describe in Chapter 3. Without these fundamental tools, you can't transfer photos off of your camera's memory card, view them outside of your camera, or edit them to perfection. Plenty of people take photos and *never* touch them up or even consider taking them off of their memory card, and that's okay! Postprocessing is

certainly not for everyone, but if you want to explore the world of photo editing and take your images to the next level, here's what you need to get started.

Computer

Chances are, you already own a computer, and if you bought it within the last few years, it's probably more than capable of handling your photo-editing needs. Computer technology advances at breakneck speed, and with each advance comes a reduction in price, so these days, you'd be hard-pressed to find a computer that *isn't* capable of photo editing.

When we talk about a computer being capable of handling the task of photo editing, we're really referring to the computer's hardware specs. If you want to find a new computer for the job, just let your friendly sales associate know that you'll be using it to touch up photos, and he'll point you in the right direction when it comes to processors, RAM, hard drives, and the gazillion other technical specs that make up a computer.

If you plan on purchasing a new computer to complement your photography workflow, look for a system with a *minimum* 2GB of RAM (Random Access Memory). Photo-editing software takes more processing power than typical software programs that come preloaded on your computer, so the more RAM you have, the smoother your touch-ups will go!

Your computer is the gateway to your images. It's where you download your photos to save them for future use. It's the place to view them at a larger size than on your camera's LCD. And it's the piece of equipment that runs your photo-editing software. If you don't have a computer, you may as well be up the postprocessing creek without a paddle!

Card reader

So you've taken some great photos of Joanie, and now you're sitting at your desk wondering how to get them off of your camera and onto your computer. Some cameras come with a USB or FireWire cable that you can connect directly from your camera to your computer, but most of the time, it's easier to use a little USB device called a *card reader,* shown in Figure 11-1, to transfer your files.

You'll find tons of affordable (under $25) card readers on the market, most of which read multiple types of memory card formats, from CompactFlash to miniSD and everything in between. When buying a card reader, the important part is knowing what type of memory card *your* particular camera uses so you can be sure you purchase a card reader that's compatible with it. Later in this chapter, we take you through the actual steps for transferring your photos from your card onto your computer.

Figure 11-1: Use a card reader to transfer files from your camera's memory card to your computer.

Photo-editing software

After you transfer your photos to your hard drive, it's time to manage your image files and touch up any imperfections. Again, you need to take this step only if you're serious about making the best photo possible. In order to take this step, you need to purchase some photo-editing software. Some camera manufacturers bundle simple photo-editing software with their cameras, so be sure to check all the discs that came with your equipment. You may already have photo-editing software and not even know it!

If you want to give photo editing a go but you're not sure you want to purchase software, consider downloading Picasa, a free photo-editing program. You can download it here: `http://picasa.google.com/`.

For the purposes of this book, we refer to the industry standard when it comes to photo-editing software: Adobe Lightroom and Adobe Photoshop. We can hear the protests of "Whoa, whoa, whoa! I need *two* programs?!" now, but hear us out. These programs actually serve two separate purposes, but you may not need both, depending on how far you want to take your editing.

Adobe Lightroom is considered an all-encompassing file management system. It allows you to import your photos, organize them into collections, rate them so you know which are keepers and which don't deserve a second look, tag them with keywords, search and filter through them using just about any criteria imaginable, create proof sheets, and easily publish a web gallery. On top of all this, Lightroom has basic photo-editing capabilities like rotating, cropping, white balance tools, exposure tools, and clarity tools. Basically, you use Lightroom to do all your initial photo editing just as you would in an old-fashioned darkroom. When working on our own photos, we dub this step *first-round edits*. For many people, using Lightroom to perform these first-round edits is enough, but others may want to take things a step further.

Adobe Photoshop picks up where Lightroom leaves off. After exporting your photo from Lightroom (we tell you more about exporting photos later in this chapter), you can open it in Photoshop to make more detailed touch-ups and really fine-tune things. For instance, using Photoshop you can zoom in on a photo and remove a leash or darken a senior dog's cloudy eyes. When working on our own photos, we dub this step *second-round edits*.

Keep in mind that the programs *do* overlap somewhat; all the editing capabilities you have in Lightroom you also have in Photoshop. If you're looking to save some money and you want to do detailed retouching, doing all your editing within Photoshop *is* possible.

You can also save some cash by choosing Adobe Photoshop Elements instead of Adobe Photoshop. Photoshop Elements has less functionality than the full version of Photoshop, but it allows you to do most of your tweaking at a fraction of the cost. (If you decide to go the Photoshop Elements route, be sure to pick up *Photoshop Elements For Dummies,* published by John Wiley & Sons, Inc. Although the postprocessing concepts we discuss here are the same, the process in Photoshop Elements may be slightly different.)

Consider how much time you want to spend postprocessing and whether you need basic or advanced functionality. Also, consider your budget; Lightroom is about half the cost of Photoshop! If you're only interested in color correcting and fixing exposure, go with Lightroom. If you're more interested in editing every single detail, you also need Photoshop. You're not required to have *both* pieces of software, but personally, we like Lightroom so much that we now do *all* our first-round editing in it. We only open Photoshop when a photo needs further touching up. In Chapter 12, we go into detail on how to make basic edits in Lightroom and more advanced edits in Photoshop, but for now, you just want to decide which program(s) you need.

Managing Your Masterpieces

Have you ever tried sifting through your hard drive for a specific photo you took years ago, only to be defeated by your own disorganization? If you're the type (like Sarah is) to dump photos on your desktop or plop them in the most convenient folder at any given second, this section's for you! When you photograph your sweet pooch, you end up with *a lot* of files. Snapping that perfect photo usually involves taking more than one shot, and if you don't pay attention to what you do with those files after they're off your memory card, things will get hairy real quick. From developing a systematic routine when you transfer files to making smart choices when you organize those files, managing your masterpieces is an important part of every photographer's workflow.

Downloading your photos to your computer

One of the most anxiety-ridden parts of a photo session (for us at least) is the time between our last shot and the downloading that takes place back at the home office. This period is a little tense because we're stuck with our photos in *one and only one* place — on our memory card. There's so much room for human error, especially if we fill up multiple memory cards. Sometimes, focusing on anything else is tough until we get home and successfully transfer our photos from our memory card to the computer.

Transferring your photos as soon as you can is always best so you avoid inadvertently reformatting your card or forgetting about it in the shuffle of everyday life. We also suggest having a standardized routine for making transfers to minimize the risk of human error. If you do something one way and you do it that way every time, you're less likely to make a mistake. At this stage in the game, losing all your data in a split second is way too easy — trust us, we've learned the hard way!

Some people refer to the process of transferring photos from memory card to computer as *uploading* instead of *downloading* or *transferring*. Try not to get too caught up in semantics. The only thing that matters is getting those photos safely from your memory card to your computer.

To transfer photos from your memory card to your computer using a USB card reader, do the following:

1. **With your computer turned on, connect your card reader to a USB port on your computer.**

2. **Remove the memory card from your camera and insert it into the card reader.**

 Note that your card reader probably has multiple slots. Your memory card only fits snugly into the correct one!

3. **After the card mounts, you should see a new drive listed under My Computer (Windows) or Devices (Mac). Navigate through the folders on your memory card until you reach your photo files.**

4. **Open a second window and navigate to the location you'd like to copy your photo files to.**

 You should now have two windows side by side — one containing the photos that are still on your memory card and another opened to the folder you want to save your photos to on your computer.

5. **While in the memory card window, choose Edit⇨Select All to highlight all your photos, and then click and drag the highlighted photo files from your memory card window to your second window, where you ultimately want your photo files saved.**

You'll see a pop-up box that indicates the amount of time it takes to copy your photos from the memory card to your computer.

6. **When your photos are done copying, demount the memory card from the card reader by right-clicking (Control + clicking for Mac users) the drive and selecting Eject.**

After your memory card is demounted from your computer, you'll no longer see it as an option on your computer screen. You can now safely remove the card from the card reader and return it to your camera.

Developing a folder structure that actually works

Whether you're organizing old photos or transferring new ones, remember to develop a logical folder structure so you can easily find your photos down the road. Granted, a logical structure may mean one thing to you and another thing to someone else (or it may mean one thing to you *now* but cease to make sense a few months down the line). How does *your* brain work when you go hunting for something? We tend to break things down by year and then further by the dog or owner's name, as seen in Figure 11-2, but if you're not photographing other people's dogs, perhaps some of these suggestions will work for you:

Erasing photos from your memory card

The process we describe in the "Downloading your photos to your computer" section is the simplest way to transfer photos from a memory card to your computer because you don't need any special software to do it. If your computer automatically opens software that wants to assist you in transferring your photos, feel free to give it a try, but know that every program does this differently. In our experience, it's easiest to just cancel out of those programs and do it manually.

Any program that assists you in transferring your photos from memory card to computer will likely ask you if you want to keep or delete the photos from your memory card after your transfer is complete. *Always* keep your photos on your memory card until you're absolutely certain that they are safely transferred to your computer and backed up somewhere else as well!

Also, never delete your photos from your memory card by sending the files to the trash while the card is attached to your computer. If you do, you'll get rid of those files but you won't get the space back that they were taking up on the memory card. Always delete the files from your memory card in-camera to be on the safe side! This is called *formatting*, and it permanently deletes any and all data so you can reuse all of that precious space on the card. In Chapter 4, we discuss how to format your memory card using your in-camera menus.

✔ **Chronological:** Start with a root folder of the current year, and within that folder, create other folders with specific dates (for example, the date of that particular photo shoot).

✔ **Location-based:** Start with a root folder of your dog's name, and within that folder, create other folders with specific locations you've photographed him at. Take it a step further by adding dates if you photograph somewhere more than once.

✔ **Age:** Start with a root folder of your dog's name, and within that folder, create other folders that correspond to how old your dog is at the time you take the photo.

Figure 11-2: Developing a folder structure that makes sense to *you* is the easiest way to find your photos fast.

Backing up your photos . . . and backing up your backups!

If the photos you take of Joanie are precious to you, be sure to maintain backup copies of all your work. Nothing is worse than having your hard drive inexplicably die and realizing that every photo you've ever taken has vanished into thin air, along with your dreams of Joanie albums, wall art, and

calendars. This is another one of those lessons that most people learn the hard way at some point in their lives. Remember, as sophisticated as your computer may be, it's *not* going to live forever!

The good news is that you have lots of affordable methods to automatically back up everything — photos, spreadsheets, word processing documents, music files, and whatever else is on your hard drive. You just have to choose one that's right for you:

- ✔ **External hard drive combined with backup software:** Simply purchase an external hard drive, connect it to your computer, and configure a backup software program. If you're a Mac user, you already have the backup software Time Machine that came with your computer. When you plug in an external hard drive, it usually asks you if you want to make it your Time Machine device. If you're a Windows user, simply visit your favorite search engine and type in "Windows free backup software" and you'll find many options to choose from.

 Because the cost of external hard drives has plummeted over the years (and continues to fall), using one of these devices is our preferred backup method. Shop online and you'll probably find a hard drive big enough to backup your whole computer and then some for under $100. Choose a size that is slightly bigger than your computer's hard drive.

- ✔ **Online backup services:** With this option, you don't need to purchase a piece of hardware. Instead, you purchase a yearly subscription plan, and your computer gets backed up through your Internet connection. A major advantage of online backup services is that your data is stored *away* from your home, so unlike with an external hard drive, you won't lose your photos if you're the victim of a burglary or a house fire. If you're interested in an online service, hit up that search engine again and enter "online backup services." The price will fluctuate depending on how many gigabytes of data you need to store, but expect to see yearly subscription plans ranging from $50 to $100.

No matter what type of backup plan you choose, it's always best to overprotect yourself, especially if you're running a business. Our own backup plan is purposefully redundant: We use Time Machine on our Mac computer, which is hooked up to a hard drive that has RAID technology. RAID separates the hard drive into multiple drives; one drive has all our information on it, and the other drive simply mirrors the first drive. Essentially, we're backing up our backup. In addition, we like to buy cheap external hard drives and copy our photo files onto them at least twice a year. We keep one drive at home and store the other drive at a friend's house. Keeping at least one copy of your files *away* from your home is always smart. Redundant? Sure. But hey, at least we can sleep at night knowing that the chance of ever losing all our photos is *very* slim.

Managing Files within Lightroom

In Chapter 12, you go knee-deep into photo editing, but before you dive in, we want to make sure you familiarize yourself with the ins and outs of Adobe Lightroom.

At its core, Lightroom is actually a *database*, which is why, when you open the program and instinctively navigate to File⇨Open to open a photo, you may be utterly confused by the lack of an "open" command. To actually work with your photos in Lightroom, you first have to *import* them. Seems annoying, right? We know, we know — thinking this way was new for us when we first started using Lightroom as well. In reality though, the fact that Lightroom is a database makes it a far more powerful tool than file-browsing software in which your entire computer is immediately at your fingertips.

Here are the main parts of Lightroom's workspace, as seen in Figure 11-3:

> A. Panels for working with source photos
>
> B. Filmstrip
>
> C. Toolbar
>
> D. Panels for working with metadata and keywords and for adjusting images
>
> E. Module picker
>
> F. Image display area

If you want even more details about Lightroom, check out our blog post at `http://barkpetphotography.wordpress.com/2011/02/02/adobe-lightroom-review`. For most people, this entry provides way more info than they care to know about Lightroom, but if you really want to wrap your head around *how* Lightroom works, it's a great read (if we do say so ourselves)!

Importing photos to Lightroom

When you import your photos to Lightroom, you don't actually move or copy files to the program. Instead, you create a link to the place where those photos live on your computer. In addition, Lightroom is a totally *nondestructive* program, meaning that when you start editing your photos, you don't change the original photo. Lightroom simply creates a small "side car" metadata file that accompanies your original file and contains all your adjustments. This is a great feature because you can always revert back to your original file no matter how far along you are in your edits!

F

Figure 11-3: An overview of Lightroom's workspace.

To import photos into Lightroom, do the following:

1. **With Lightroom open, click the Library module in the upper right-hand corner of the screen.**

2. **Click the Import button on the lower left-hand side of the screen.**

3. **Under the Source pane on the left-hand side of the screen, navigate to the folder where the photos you want to import reside.**

 Your photos appear as thumbnails on your screen. Choose Check All or individually check the photos you want to import.

4. **Look at the top-middle part of the screen and make sure the word "Add" is highlighted (see Figure 11-4).**

 This adds your photos to Lightroom without actually moving them.

5. **Click the Import button at the bottom right-hand corner of the screen.**

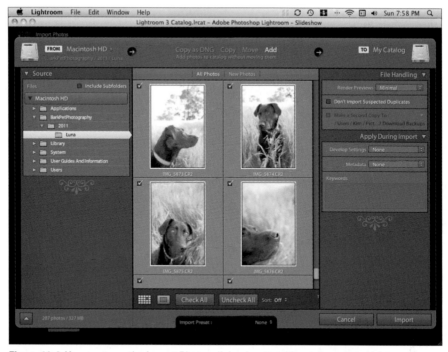

Figure 11-4: You must use the Import Photos dialog box to add your images to Lightroom before you can work with them.

6. **When your photos are done importing, you're taken back to the Library module, and the photos you imported appear on the screen.**

Because Lightroom creates a link to your photo files, if you later move your photos to a new folder, the link is broken. If this happens, a question mark appears in the right-hand corner of the photo preview within the filmstrip that runs across the bottom of your screen. To locate the missing file, click the question mark and a dialog box will open. Click Locate and simply navigate to the new location.

Exporting photos from Lightroom

After you make your necessary adjustments in Lightroom (see Chapter 12 for specific Lightroom photo-editing techniques), you need to export your photos to see your changes in other programs besides Lightroom. To export photos from Lightroom, do the following:

1. **With Lightroom open, click the Library module in the upper right-hand corner of the screen.**

2. **Choose the photos you want to export by selecting them in the horizontal filmstrip pane that runs across the bottom of your screen (see Figure 11-5).**

 To select a photo, simply click the thumbnail. To select multiple photos that are contiguous, click the first photo in the sequence, hold down the Shift key, and then click the last photo in the sequence. All photos between the first and last one are selected. To select photos that are noncontiguous, click the first photo and then hold down the Control key (Windows) or Command key (Mac) to select other photos.

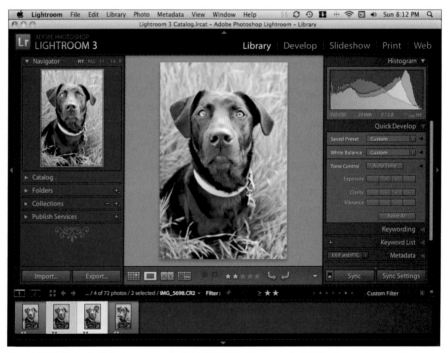

Figure 11-5: Selected photos appear with highlighted frames. In this instance, two photos are selected to be exported.

3. **With your desired photos selected, click the Export button on the lower left-hand side of the screen.**

4. **In the Export dialog box (see Figure 11-6), choose a destination folder in the Export Location section.**

 To choose a specific destination folder, first choose the Specific Folder option from the Export drop-down list and then click the Choose button within the Export Location section. You can now navigate to the folder you want your photos saved to.

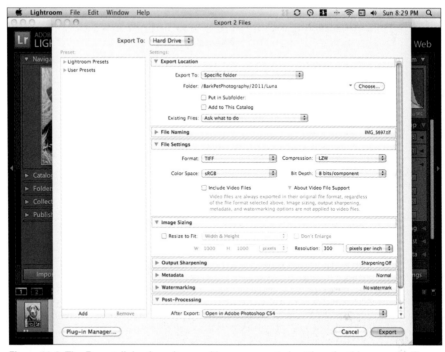

Figure 11-6: The Export dialog box shown with our suggested settings for this example. The sections in which the settings remain at their defaults are minimized.

5. **From the File Settings location, choose TIFF from the Format drop-down list.**

 Keep the other options set at their defaults. For information on other file formats, such as JPEG and when to use them, see Chapter 12.

6. **In the Image Sizing section, type "300" into the Resolution box and choose Pixels per Inch from the drop-down list.**

7. **In the Post-Processing section, choose Open in Adobe Photoshop from the After Export drop-down list if you want to make additional edits in Photoshop.**

 If you simply want to save the file, choose Do Nothing from the After Export drop-down list

8. **Click Export and you're done!**

Setting up collections within Lightroom

Now that you're familiar with how to import photos into and export them out of Lightroom, it's time to start organizing all your photos! As we mention earlier, Lightroom has some pretty awesome organizational tools, the crux of

which is a little feature called Collections. You see, when you import photos into Lightroom, the software automatically adds them to the Folders panel, through which you can navigate, just like you navigate to a specific folder in any other program. Collections, on the other hand, are customizable groups of photos that make filtering out specific images a breeze.

You can add any photo from your folders to a collection or even multiple collections. Say, for instance, you want to group together all your photos of Joanie in which she's sleeping. Even if all those photos are in different folders, you can still group them together in a collection. To create a collection, follow these steps:

1. **With Lightroom open, click the Library module in the upper right-hand corner of the screen.**

2. **Put your screen in Grid View by clicking the icon made up of small boxes in the lower left-hand side of the toolbar.**

3. **Select your desired photos from the Grid View.**

 To select a photo, simply click the thumbnail. To select multiple photos that are contiguous, click the first photo in the sequence, hold down the Shift key, and then click the last photo in the sequence. All photos between the first and last one are selected. To select photos that are noncontiguous, click the first photo and then hold down the Control key (Windows) or Command key (Mac) to select other photos.

4. **Find the Collections panel on the left-hand side of your screen. Then click the + button and choose Create Collection (see Figure 11-7).**

 If you don't see the Collections panel, use the scroll bar to scroll down until you do.

5. **Type the name of your collection in the Name box (see Figure 11-8).**

 For instance, "Luna."

6. **Choose None from the Set drop-down list.**

 If you have already selected photos in grid view, select the Include selected photos check box under Collection Options. The Make new virtual copies check box should not be selected.

7. **Click Create.**

 You now see your new collection listed under the Collections panel. At this point, if you already had photos highlighted, they are already in your collection. Otherwise, your collection has zero photos in it, as noted to the right of the Collection name.

8. **To add photos to your new collection, go to the Folders panel and navigate to the first photo you want to add.**

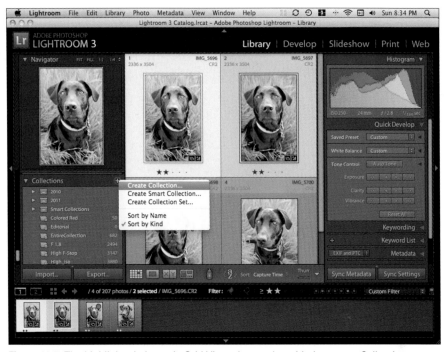

Figure 11-7: The highlighted photos in Grid View about to be added to a new Collection.

If the folder has multiple photos, feel free to choose multiple thumbnails at once in the Grid View.

9. **With your desired photos selected, simply click and drag them to the collection you created in the Collections panel.**

When you release your photo(s), you should see the number indicator next to the Collection name jump to include these new photos.

10. **If you want to add more photos from other folders, simply repeat Steps 8 and 9.**

If you want to further break down your photo categories, start with a Collection Set instead of a Collection. You can then add different Collections within the Collection Set container. We break down our own photo sessions by first creating a Collection Set denoted by the dog's name and then adding the following Collections under the main Collection set: All, Bark Picks, Client Picks, and Finals. This way, we can easily choose to view all photos from a session, just the best photos we presented to the client as proofs, the actual photos the client picked, or the finalized, retouched photos. As you can see, the Collections progressively get pared down in size along the way.

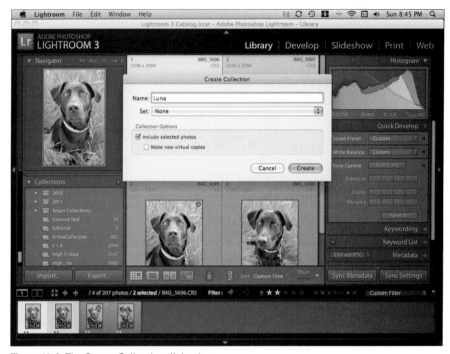

Figure 11-8: The Create Collection dialog box.

Use Smart Collections to create rules that instruct Lightroom to automatically place certain photos in a collection based on specific metadata within the photo. For instance, you can create a Smart Collection called "Joanie in Action" and have Lightroom automatically place all your photos shot at 1/800 second or faster into this Smart Collection. Or create a Smart Collection called "Best" and instruct Lightroom to automatically place any photos you mark with five stars in this Smart Collection. The possibilities are really endless!

When you add or remove photos from a collection, you don't actually move or delete the real photo from your hard drive; you simply add it to or remove it from that specific category.

Editing and Saving
Your Final Shots

*A*ll photographers end up with duds along the way. Especially with dog photography, you almost always end up with more throwaway shots than keepers. Don't get discouraged if you download 500 photos off your memory card but only like 50 of them — it's totally normal! The cardinal rule of dog photography is to "click, click, and click some more" because the more exposures you take, the more likely you'll end up with great imagery at the end. The bad news is that most of those clicks won't be worth your postprocessing time. The good news is that most of those clicks won't be worth your postprocessing time.

At first, contemplating your dud-to-keeper ratio may be depressing, but think of it this way: If you had to touch up all 500 photos, you'd be sitting in front of your computer for almost a week. Because you'd probably rather spend that time hanging out with the real Henry than the digital one, this chapter focuses on making your postprocessing manageable. We help you identify and perfect your keepers and show you the ins and outs of saving your images to an appropriate file format.

Digging Through Your Images: How to Choose the Keepers

After you import your photos to your computer from your memory card (see Chapter 11 for the how-to on importing files), take stock of what you have and filter out any images unworthy of postprocessing time. The characteristics of what makes an image a keeper or a dud are largely subjective. You may love an image, but someone else may hate it; that's the nature of any art. What matters is that you come up with your own system of qualifications so you can quickly sift through your work and determine which images you like and which ones you don't. You may develop different qualifications along the way, but as a starting point, these are the characteristics we consider when filtering through our own work:

- **Subject:** Does your main subject in the photo stand out as you intended? For example, if the photo is supposed to be of Beckett's name tag but Beckett's tail takes prominence in the frame instead, your intended subject doesn't stand out.

- **Expression:** Is your subject's expression a good one? Because you can't tell a dog to "say cheese," you may end up with some pretty gnarly looks, so be sure to filter out any shots in which your dog is obviously looking away from the camera, snarling his upper lip, looking unsure or scared, and so on.

- **Focus:** Is the image clear and sharp? This is more important for portraits than action photos, in which you may want some blurred parts to your image for effect.

- **Exposure:** Overall, is the image too light or too dark? A little bit of overexposure or underexposure is fine because you can fix it in postprocessing, but if the photo is drastically overexposed or underexposed, it may not be salvageable.

- **Response:** Does the photo elicit an innate response? For example, does it make you smile, laugh, or let out a long "awww"? If so, it's probably a keeper!

- **Distractions:** Does the photo have any unfixable distractions you can't live with? If you capture your dog in a spontaneous moment zipping around the house but the background is a cluttered mess from the birthday party you had the night before, the shot may never be a great one, even *after* postprocessing. On the other hand (er, paw), if you position your dog for a portrait and don't realize that the stop sign in the background appears to be growing out of his head, you may be able to salvage the photo in Adobe Photoshop by removing the stop sign completely! (We tell you how later in this chapter.)

When we go through our own images from a one-hour shoot (anywhere from 200 to 400, depending on the dog's cooperation level), we usually take about

a half hour to view every single image on the screen and mark it as a keeper or a dud. To expedite your process, use software that has a photography management component to it — like Adobe Lightroom or Apple's Aperture — so you can easily and simultaneously view and rate your keepers by assigning them one, two, three, four, or five stars. Later, you can ignore the duds by filtering out all the keepers you tagged. It's up to you whether you want to permanently delete the duds from your hard drive. We like to keep ours, but everyone's different.

Adjusting Photos in Adobe Lightroom

The first step in your postprocessing journey begins in the same program you use to view and filter your photos — convenient, eh? We use Adobe Lightroom ourselves, a "virtual darkroom" if you will, so that's the program we focus on here. If you don't have Lightroom, keep in mind that you can find most of these tools in other image-editing software. All our photos go through two stages of postprocessing, but you can skip any steps you feel aren't necessary for your own images.

The first stage of postprocessing, after you import your photos into Lightroom (see Chapter 11), encompasses basic technical editing like adjusting white balance, exposure, brightness, contrast, and so on. Some photos only need to be adjusted in a few of these categories, whereas others need to be adjusted in all of them. In the following sections, we explain the situations in which you need to use each of these adjustments. (If you find this stuff really fun and want to explore Lightroom's functions in more depth, pick up the most recent version of *Photoshop Lightroom For Dummies* by Rob Sylvan [published by John Wiley & Sons, Inc.].) From there, you just use your best artistic judgment. The second stage of postprocessing takes place in Adobe Photoshop and gets into more detailed retouching like removing eye goobers and leashes or darkening a senior dog's cloudy eyes. You can think of the second stage as more cosmetic, so feel free to skip that section altogether!

Cropping and straightening your photos

Not all photos need to be cropped or straightened, but if you want to crop out that ugly trash can you didn't realize was peeking into your frame, or if the horizon line seems a bit off-kilter, use the Crop Overlay tool by doing the following:

1. **With Lightroom open, click the Develop Module in the upper right-hand corner of the screen.**

2. **Click the Crop Overlay tool, as shown in Figure 12-1.**

 A frame with little adjustment handles appears around your image. Click and drag these adjustment handles to adjust your crop.

3. **After you've cropped your image as you'd like, you can use the Straighten tool located just below the Crop Frame tool by simply clicking and dragging the Angle slider.**

 A grid appears over your image to help you align your horizon or any other straight line that appears in your photo.

4. **When your image looks straight enough, just release your mouse button and leave the slider in its new position.**

 Finish by clicking the Done button located in the bottom right-hand corner of the screen (or simply hit Enter on your keyboard) to apply your crop/straighten adjustments.

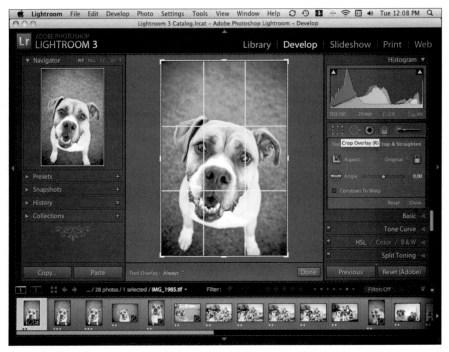

Figure 12-1: Your Crop Overlay tool is located under the Develop Module in Lightroom.

To maintain the proportions of your crop, hold down the Shift key while dragging the adjustment handles.

Correcting white balance

Finding the right white balance for your photo is all about getting your photo's color to look as true to life as possible. In general, this means making sure that the whites in your photo are completely neutral, without any sort

of color cast added to them. *Color cast* is an unwanted, even tint of a certain shade that affects your photo and can occur if you shoot using the wrong white balance setting (like "outdoors" when you're actually indoors or vice versa) or if you bounce your flash off of a colored wall. Like many things in photography, color is a subjective topic that depends on what looks right to *you*. If the colors in your photo don't look quite right, you can adjust your white balance by doing the following:

1. **With Lightroom open, click the Develop Module in the upper right-hand corner of the screen.**

2. **Click the Basic pane and choose a preset from the WB (for white balance) drop-down menu as a starting point.**

3. **If your color still looks far from accurate, try an alternate adjustment method by choosing the White Balance Selector tool, as shown in Figure 12-2, and clicking an area in your photo that should be a neutral gray.**

 If your color balance already looks decent from using your preset options, skip this step.

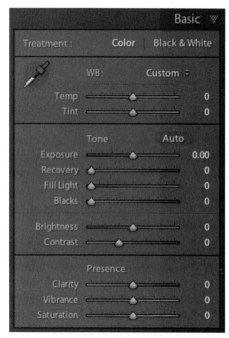

Figure 12-2: Use the White Balance Selector tool as an alternate method of setting your white balance if your WB presets don't yield good results.

4. **Fine-tune your white balance by using the Temp slider to adjust the warmth of your image.**

 Moving the slider to the right makes your colors appear warmer by adding some yellow and red, and moving it to the left makes your colors appear cooler by adding blue.

5. **Fine-tune the overall color cast of your photo by using the Tint slider.**

 Moving the slider to the right adds a magenta tint to your photo, and moving it to the left adds a green tint to your photo.

To reset any slider back to its original setting, simply double-click the word (in this case Temp or Tint) that's directly to the left of the slider.

Perfecting tone

Adjusting the overall tone of your image is probably the most important part of postprocessing. *Tone* is the range of brightness levels in your image, from the lightest whites in your highlights to the darkest blacks in your shadows. You adjust tone through a combination of factors, including exposure, recovery, fill light, blacks, brightness, and contrast. This is where you compensate for an overexposed or underexposed image, where you bump up brightness or contrast if needed, and where you make sure your highlights and shadows contain bright whites and deep blacks. Essentially, if you didn't nail your exposure in-camera when you took your photo, now is the time to perfect it! Without perfect tone, an image looks dull and flat because it doesn't represent the full range of tonal values — deep black to brilliant white. Adjusting tone has a way of making an image "pop."

Although postprocessing is a powerful tool to have at your disposal, it can only do so much. Getting as close as you can to perfection in-camera is always wise so that you don't have to make drastic alterations after the fact. Slightly missing your target exposure is fine, but grossly missing it may leave you with unsalvageable photos. Use postprocessing to take your images to the next level but don't become complacent when it comes to getting your in-camera exposure as accurate as possible.

Under the Develop Module in Lightroom, click the Basic panel to reveal the following tonal controls (refer back to Figure 12-2 to see where each control is):

- ✔ **Auto:** Simply click Auto and Lightroom automatically adjusts your tonal sliders (the ones that follow in this list) accordingly.

 The Auto button is a great starting point if you're new to postprocessing. It doesn't always yield perfect results, but from here, you can fine-tune your overall exposure with the rest of the tonal controls if you want.

- ✔ **Exposure:** Use this control to adjust the overall brightness of your photo. Move the Exposure slider to the right to brighten a dark (or underexposed) image, and move it to the left to darken a bright (or overexposed) image.

- ✔ **Recovery:** Often, when you increase a photo's exposure, your highlights (or the lightest parts or your image) get overly bright (or *blown-out*). Use the Recovery control to dial down your highlights a bit without affecting the overall exposure level.

- ✔ **Fill Light:** When you have an image in which parts of the shadowed areas are too dark (for example, half of your dog's face looks like a blob of black instead of actual fur with detail), use the Fill Light slider to reveal some of the detail lost in that blob of darkness. This tool can be very valuable, but be sure to use it judiciously; increasing fill light too much adds *noise* (or graininess) to your shadows and degrades the quality of your image.

✔ **Blacks:** Your image's tone should always contain a rich, deep black in its shadowed areas. If your shadows look a bit dull, use the Blacks slider to make them darker.

✔ **Brightness:** Only use this tonal control after you've set your exposure, recovery, and fill light, because most of the time, you don't need to touch your brightness after you adjust these other settings.

✔ **Contrast:** Use the Contrast slider if your image still looks dull or muddy after you've set your other tonal controls. Moving the slider to the right causes your photo's dark areas to become even darker and its light areas to become even lighter. Moving the slider to the left does the exact opposite.

When using sliders to control a particular setting, small adjustments usually go a long way. Experiment with the slider by pulling it all the way to the left or right to really see the changes that take place. Moving the slider *too* far and then bringing it back to where you want it can be a helpful approach, as opposed to trying to hit your mark in tiny, incremental adjustments.

Using your histogram as a guide

You may have noticed that scary-looking, spiky graph at the top of your Develop Module by now. That's your *histogram*. Every time you move one of your tonal controls, your histogram also moves. Sure, it can look overwhelming at first, but when you understand your histogram, it becomes a great tool that can guide you to the perfect exposure.

A photo's histogram is a graphical representation of the tones in the image. The left side of the graph represents the darkest blacks in your image, and the right side represents the brightest whites. Figure 12-3 shows an example of a well-balanced histogram that spans the entire range of the graph and falls off on either end, like a gradually sloped mountain. The histogram of an underexposed photo is bunched up near the left end of the graph, and the histogram of an overexposed photo is bunched up near the right end of the graph. Whenever you adjust your tonal controls, keep in mind that you should strive for a well-balanced, properly exposed histogram and use its appearance as a guide.

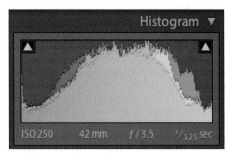

Figure 12-3: A well-balanced histogram.

Obviously, your eyes are always your first tool in deciding what does or doesn't look good, but using your histogram as a guide during postprocessing is kind of like having a second set of eyes to help you out. Instead

of "seeing" the photo, your histogram "reads" its pixels. When we do our postprocessing, our eyes constantly jump back and forth between the photo we're adjusting and its histogram.

Although we're talking about well-balanced, perfect-looking histograms, keep in mind that this is only a general rule (and every rule has an exception). For example, a photo of a light-colored dog in the snow *never* has a histogram that spans the entire graph because so much of the image is made up of light tones, and that's okay! If your photo looks good to *you,* don't go bonkers trying to make your histogram look "right." After all, in the end, people are going to see the photo, not the histogram that's behind it.

There's no "right" way to postprocess an image. In fact, your individual workflow for adjusting your image's tone may be a very different process from ours, but if you need some guidance to get going, these are the steps we take when adjusting the tone of our images.

1. **Before you start adjusting your image's tone, make sure you've finished adjusting your white balance.**

2. **Under the Develop Module in Lightroom, click the Basic panel to reveal your tonal controls.**

3. **Look at your image and its histogram to determine whether it's underexposed or overexposed.**

 If it's underexposed, move the Exposure slider to the right while keeping an eye on your histogram. If it's overexposed, move the Exposure slider to the left while keeping an eye on your histogram. In either case, continue moving the slider until your histogram stretches out and spans most of the graph.

4. **If you have to brighten up your image, you may need to recover some of your highlights (the lightest areas of your photo) if they've been blown out.**

 Look at your image to determine whether your highlights have lost a lot of detail. Also look at your histogram as a guide; if your graph has a tall spike at the right-hand end, you need to use the Recovery control. Just slowly move the Recovery slider to the right until the spike on your histogram comes down. If your highlights aren't blown, skip this step.

5. **Look at your image again and determine whether you need to use the Fill Light control.**

 If your shadowed areas seem too dark and you want to regain some detail in them, slowly move the Fill Light slider to the right. You can also assess this need by looking at the histogram. If the middle peak of your histogram mountain is still hanging out on the left-hand side of your graph, try adding some fill light. The histogram's peak should slowly shift more toward the graph's middle. Don't go overboard with this tool — a little goes a long way!

6. **Again, look back to your image; if you don't see a nice, rich, deep black anywhere in your image, it's time to increase your blacks.**

 Your histogram can also clue you in here. If the histogram doesn't reach all the way to the left-hand side of your graph, your photo likely lacks those deep blacks. Move the Blacks slider to the right while keeping an eye on your image and your histogram. Watch as your histogram shifts to the left-hand side of your graph. Keep going until the histogram hits, or even slightly spikes up, the left-hand side of the graph.

7. **Next, assess your brightness and contrast.**

 You really only need to adjust the brightness if, overall, your image still seems too light or dark and your histogram still appears slightly bunched on the left- or right-hand side of your graph. Move the Brightness slider to the right to make your image lighter; your histogram also shifts to the right. Move the Brightness slider to the left to make your image darker; your histogram also shifts to the left.

8. **If your image can still use some more "pop," try adding some contrast to it.**

 Move the Contrast slider to the right to add contrast and to the left to decrease contrast. Notice that when you add contrast, your histogram spreads out to either end of the graph, making it look more like a plateau than a mountain (oh, the highs and lows of photography . . .). See Figure 12-4 for a before-and-after comparison of adjusting tone.

Detailing presence

The Presence controls in Lightroom (located within the Develop Module and under the Basic pane) allow you to even further fine-tune your image. Your Presence controls are Clarity, Saturation, and Vibrance, all of which can add a nice pop to your photos but can also result in drastically unrealistic colors if you're too heavy-handed. Your Presence controls function in the following way:

- ✔ **Clarity:** The Clarity control adds extra sharpness to a slightly soft (or out-of-focus) image. The Clarity control isn't a miracle cure for extremely out-of-focus images, but it *does* add some serious detail to barely out-of-focus images. Particularly in dog photos, adding clarity (or moving the slider to the right) brings out individual hairs in dogs' fur that may not have been visible before. Generally speaking, you probably don't want to decrease a photo's clarity, but if for some reason you do, simply move the slider to the left.

- ✔ **Saturation:** The Saturation control works equally across the board on all colors in your photo. Increasing saturation (moving the slider to the right) strengthens colors by making them deeper and brighter, whereas decreasing saturation washes them out. In fact, if you move your Saturation slider all the way to the left, you end up with a black-and-white image void of any color at all.

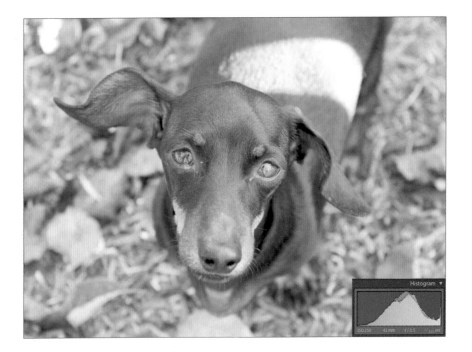

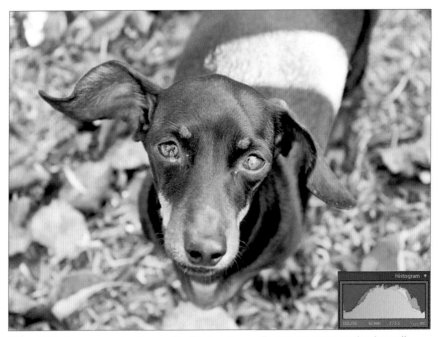

Figure 12-4: An overexposed image (top) before tone adjustments compared to its well-exposed counterpart (bottom) after tone adjustments.

✔ **Vibrance:** You can consider your Vibrance control a safer option than saturation because it *doesn't* treat all your colors equally. Instead, it leaves alone the colors that are already pretty saturated and increases the saturation level of the more muted colors. The result is more vibrant color without overly exaggerated saturation.

Retouching in Adobe Photoshop

People tend to think we're a little crazy when we tell them that the final step of our postprocessing workflow is retouching their dog: "What?! But Barley's so perfect!" Perhaps from 10 feet away Barley is perfect, but when he's super-sized on that brand-new computer screen of yours, you may notice some doggie imperfections!

Retouching a photo is the last step of the postprocessing journey. Retouching is all about homing in on tiny imperfections. Those 15 small flaws may seem inconsequential on their own, but combined, they compound and result in a less-than-perfect photo. You don't have to retouch your images, but for us, it's a crucial step toward getting that perfect photo.

Retouching doesn't have to be drastic. You actually shouldn't even be able to tell that your photo has been altered at all when you look at it. In Figure 12-5, if you look at both images, you notice the retouching, but as a stand-alone final image, most people would just assume that Barley is as perfect as they always thought! We can't stress enough the impact that seemingly minor and conservative retouching can have on your photos.

Retouching takes place in image-editing software such as Adobe Photoshop, Adobe Photoshop Elements (a more affordable, less feature-packed version), Corel PaintShop Photo, or any of the photo-editing programs made by specific camera manufacturers like Canon or Nikon. Which software program you ultimately choose isn't as important as knowing the types of common canine imperfections you should be on the lookout for. That way, if you purchase image-editing software, you know exactly what it should be capable of in order to fit your postprocessing needs.

This section assumes that you use Adobe Photoshop because it's by far the most popular image-editing software out there, although most (if not all) of these techniques translate to other programs as well. Certain tools may go by different names, but the concepts are all the same. We also assume in this section that you know how to export your images from Lightroom into Photoshop; if you don't, see Chapter 11.

So what are you waiting for? Time to dive in and airbrush that pooch to swim-suit model perfection! Be forewarned, though: Peeling away that final layer of imperfection may be addicting (check out the latest edition of *Photoshop For Dummies* [John Wiley & Sons, Inc.] if you want more details about the program than what we provide here).

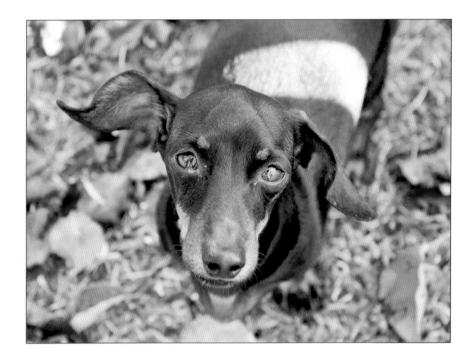

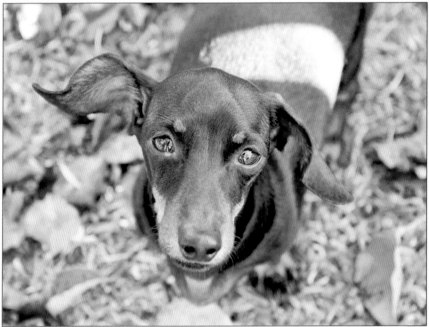

42mm, 1/125 sec., f/3.5, 250

Figure 12-5: Retouching an image provides a subtle yet affecting final touch.

Grooming away the "ickies"

Even the most well-cared-for dogs end up with some stinky yuckiness every now and then. They don't exactly have hands to wipe away their morning eye crusties, brush their own fur, or swipe away the drool hanging from their chin. At least once during every photo session, our clients yell out mid-shot, "Ew, *gross!* Should I wipe that off?" Obviously, removing any imperfections before you even take a photo is a good idea, but don't pause every two seconds to nitpick your pooch's face — that's what Photoshop's for! Whether you need to get rid of a yucky eye goober, cover up a rogue white hair on your black dog's face, or even dust away some dandruff, the following technique transforms those small imperfections, taking your dog from dingy to debonair in no time flat!

In this example, we focus on the ever-intrusive eye goober, which you can easily fix in Photoshop if you use the right tools. Although you have about a million and a half ways to achieve any given task in Photoshop, we mostly use the Spot Healing Brush tool or the Patch tool to cover up doggie blemishes. Follow along with our own method, but feel free to experiment with other tools as well!

1. **With your image open in Photoshop, zoom in on the dog's eye region using the Navigator palette.**

 If your Navigator palette, shown in Figure 12-6, isn't already visible, choose it from the Window menu in the Photoshop toolbar that runs across the top of your program's window. When your Navigator palette is open, look just below the "mini image" of your photo. You'll see a percentage next to a slider, which is your Zoom tool. Move it to the right to zoom in. If you need to adjust *where* the tool zooms, hover your mouse inside the red frame that appears in your mini image. Then you can drag the frame to the position you need.

2. **If you're using Photoshop CS5 or later, choose the Spot Healing Brush from the Tools palette by right-clicking the Patch tool, as shown in Figure 12-7, and then choosing the Spot Healing Brush tool.**

 If you're using an older version of Photoshop, choose the Patch tool instead, because the Spot Healing Brush tool in older versions isn't as "smart," and you'll probably have better luck with the Patch tool. If you use the Patch tool instead of the Spot Healing Brush tool, skip to Step 5. Again, if the Tools palette isn't already visible, choose it from the Window menu in the Photoshop toolbar.

3. **If you choose to use the Spot Healing Brush, you have to adjust the size of your brush.**

 After you select the Spot Healing Brush, the Brush Picker drop-down menu appears in the options bar on the upper left-hand side of the screen, as shown in Figure 12-8. Click it to open the Diameter window. Drag the Diameter slider to adjust your brush's size. Choose a diameter

that's slightly larger than the goober you want to remove. As you adjust the slider, you can go back and hover your mouse over the goober to see how the brush's diameter changes so you know when it's big enough.

Figure 12-6: Zoom into the area you want to work on using the Navigator palette.

4. **Next, position the brush over the goober and click, as shown in Figure 12-9.**

 If you can cover the entire goober with your brush (top), use one click to remove the imperfection. If not, click and drag over the area (bottom) and then release. If the Spot Healing Brush was your tool of choice, congratulations — you're done!

5. **If you're using Photoshop CS4 or earlier and you've settled on the Patch tool instead of the Spot Healing Brush tool, make sure you select the Source radio button in the Option bar.**

6. **Next, outline the goober with your Patch tool by clicking and dragging around the goober until you circle it.**

 When you release the mouse button, you see the area you've selected. Figure 12-10 shows an outlined area about to be removed. For better results, don't try to outline the goober precisely; instead, leave a small buffer so the outline actually runs through non-goobered area the whole way.

7. Now you can click within your selected area and drag it to the area you wish to sample to replace the goober.

As you drag, you see the original area change according to the sampled area you're hovering over (see Figure 12-11). You need to move your selection around until you find a sampled area that appears to be a good match for the goobered area (top). When you find an area that blends nicely, release the mouse button and relish in the perfection (bottom). When you find the perfect sampled area, simply release your mouse button and let Photoshop do its job. Your final results appear as if you did no touch-ups at all.

Figure 12-7: Find the Spot Healing Brush in the Tools palette.

The Spot Healing Brush tool works by sampling surrounding pixels and matching them in order to cover up the imperfection. Because of this, depending on where your imperfection is located and what surrounds it, you may need to try a couple of times before it looks good. For example, if your brush covers the whole area and you do *one* click but the result doesn't look good, try choosing a slightly smaller brush and use the click and drag method instead. Experiment with dragging from top to bottom versus left to right. Sometimes, the *way* you drag can even make a difference in which areas have been sampled. Similarly, with the Patch tool, you actually *tell* the tool what area to sample, as opposed to it deciding for you. If one try doesn't work, simply choose Edit⇨Undo and try sampling a different area. After you get the hang of these tools, anticipating which sampled areas work best becomes second nature.

Figure 12-8: Choose your brush size based on the size of the spot you'll be removing.

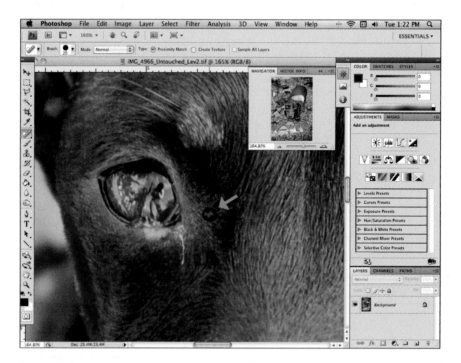

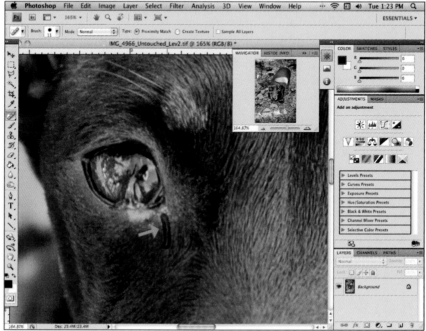

Figure 12-9: The goober's size determines whether you need to do one mouse click or click and drag to remove it.

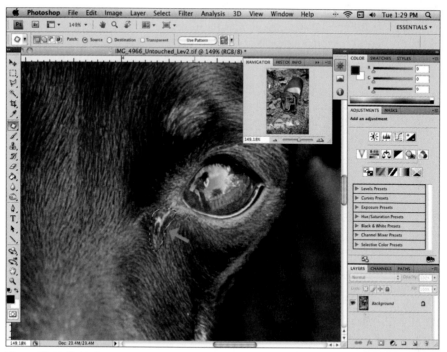

Figure 12-10: If the Spot Healing Brush isn't yielding good results, try using the Patch tool.

Some of the tools in the Tools palette may not be immediately visible because multiple tools can share a position in the palette. For example, the Spot Healing Brush tool, Patch tool, Healing Brush tool, and Red Eye tool all reside in the same little box, but only the chosen tool is visible at any given time. Click and hold your mouse button to reveal the hidden menus.

Achieving sharpness

No matter how skilled your trigger finger is, even the best photographers can sometimes end up with *soft* (or slightly out-of-focus) images. The good news? Photoshop has a pretty powerful feature for sharpening your photos. The bad news? Although it's a sophisticated feature, Photoshop's sharpening function can only do so much; it really only creates an *illusion* of a sharper image by increasing the contrast around any edges in the photo. Figure 12-12 illustrates the difference between a well sharpened image and an overly sharpened image. The effects of sharpening should be subtle enough so that you don't degrade your image. Use textured areas, like the dog's fur, to gauge whether you've gone too far. The fur should have some definition, but you don't necessarily want every individual strand of hair jumping out at you.

Figure 12-11: Move your selection around (top) until you find an area that appears to blend well for a perfect final product (bottom).

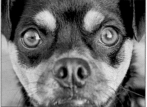

Figure 12-12: Compare a softly focused image (left), an appropriately sharpened image (middle), and an overly sharpened image (right).

To sharpen a soft image in Photoshop, follow these steps:

1. **From the Photoshop toolbar, choose Filter➪Sharpen➪Unsharp Mask.**

 This is one of those tools that must have been created on Opposite Day. The Unsharp Mask actually functions to *sharpen* your image.

2. **In the Unsharp Mask dialog box, make sure the Preview box is checked.**

 The Preview window shows a small portion of your image. Click and hold down on the Preview window to see how the image looks *without* sharpening. Release the mouse button to see the image sharpened. Seeing the preview change between sharpened and unsharpened allows you to better see the impact of your settings.

3. **Use the Radius slider to increase or decrease the number of pixels around the edges that are included in the sharpening.**

 As a rule of thumb, never increase your Radius above 2.0 pixels. In our own work, we like to keep this number somewhere between 1.0 and 1.6 pixels. This control is sensitive; increasing it too much causes the edges in your photo to have a jagged glow, negatively affecting your overall image quality.

 Even though your Radius slider appears second in the Unsharp Mask dialog box, you should always adjust this setting first.

4. **Use the Amount slider, shown in Figure 12-13, to increase or decrease the amount of edge contrast (or perceived sharpness) in your photo.**

 In general, never increase your sharpness above 100 percent. We like to keep this number somewhere between 75 and 90 percent, depending on how much sharpening is needed.

5. **Finally, use the Threshold slider to smooth out some of the areas that may look a little *too* sharpened.**

 We like to start with this slider set at four levels. Areas without a lot of contrast, like skin, can sometimes start to look grainy when you sharpen a photo. Your Threshold setting can smooth that out.

6. **When you're satisfied with your preview, click OK.**

TIP

If your dog's eyes are the central focus of your photo, make them as flawless as possible by sharpening only her eyes. The eyes not only give the viewer a glimpse into your dog's state of mind but can also literally act as mini mirrors, hinting at what was happening in *front* of your dog at the very moment you took the photo. Even if your overall image doesn't need sharpening, you can still consider sharpening just your dog's eyes. Simply use the selection technique in the next section to isolate the eyes and then use the sharpening technique we just went over in this section.

Clearing cloudy eyes in senior dogs

If you've ever met a senior dog with vision problems, you know the whitish cloud that can hang over the

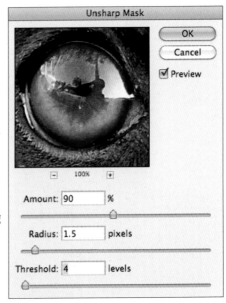

Figure 12-13: The Unsharp Mask dialog box contains the Radius, Amount, and Threshold sliders.

dog's eyes. Sometimes caused by cataracts in an aging dog, this condition becomes even more apparent in photographs. To remedy this issue and add some spunk back into Lilly Belle's eyes, use your Burn tool to do the following:

1. **With your image open in Photoshop, zoom in on the dog's eye region using the Navigator palette.**

 If your Navigator palette isn't already visible, choose it from the Window menu in the Photoshop toolbar that runs across the top of your program's window. After your Navigator palette is open, look just below the "mini image" of your photo. You'll see a percentage next to a slider, which is your Zoom tool. Move it to the right to zoom in. If you need to adjust *where* the tool zooms, hover your mouse inside the red frame that appears in your mini image. Then you can drag the frame to the position you need.

2. **Choose the Lasso tool from the Tools palette and use it to trace the circumference of the dog's eyeball, as shown in Figure 12-14, but be careful to leave a small cushion of space between the outline and the dog's eyelids.**

3. **With your Lasso tool still selected and the eyeball outlined, go to the Photoshop toolbar and choose Select⊏>Modify⊏>Feather. Enter "3" for the Feather Radius and click OK.**

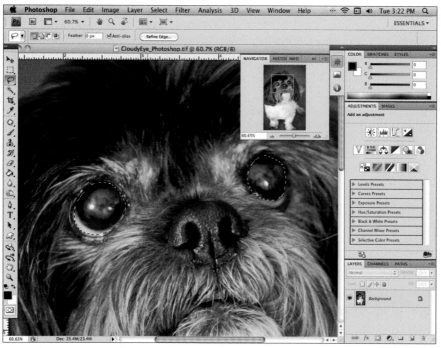

Figure 12-14: Use the Lasso tool to outline the area of the eye that needs to be darkened.

Use feathering to soften the edges of a selection so that whatever adjustments you make to the selected area smoothly transition into the surrounding area. If you don't use feathering, you may end up with an obvious hard edge defining the selection area you used.

4. **Next, choose the Burn tool from the Tools palette and head up to the Brush Picker drop-down menu, which appears in the Options bar on the upper left-hand side of the screen.**

Drag the Master Diameter slider to adjust the size of your Burn tool. Choose a diameter that's slightly larger than your selection. Also, make sure that "Protect Tones" is checked in the Options bar.

5. **Adjacent to the Brush Picker drop-down menu are the Range and Exposure drop-down menus; choose Midtones for your Range and start with a low exposure percentage, like 12 percent.**

The Range options dictate which tones are actually affected by the Burn tool. Choosing Midtones forces the Burn tool to darken only the middle ranges, leaving the highlighted and shadowed areas unaffected. Choosing Shadows forces the Burn Tool to darken only the darkest shadowed areas, and choosing Highlights forces the Burn tool to darken

only the lightest areas. Because cloudy eyes are usually made up of mid-toned grays, start with Midtones as your range.

6. **Position the Burn tool over your selected eyeball, click, and move the Burn tool in a circular motion over your selected area.**

The longer you hold down the mouse button, the more you'll "burn in" the area, so make sure you constantly move the tool while you're clicking to prevent any one area from becoming darker than the rest. You'll see the cloudy area of the eyeball darken in real time.

7. **Release the mouse button to view your results.**

If the eyes are still too light, simply take another pass to the selected area with your Burn tool.

After a few passes, if the effects of burning still aren't satisfactory, try choosing Highlights instead of Midtones from the drop-down Range menu.

8. **When you're finished, go to the Photoshop toolbar and choose Select⇨ Deselect to release your selected area.**

Your final result should look similar to the image on the right in Figure 12-15.

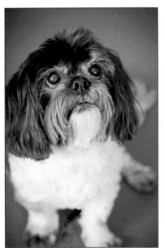 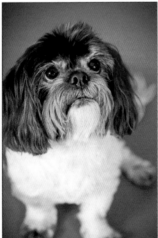

Figure 12-15: Use your Burn tool to darken cloudy eyes.

You can also burn in a dog's eyes that aren't cloudy to darken their color and make them pop. In these instances, you may have to also experiment with choosing Shadows from your drop-down Range menu. Use this technique cautiously though; the right amount of burning can really add depth to the

eyes by emphasizing the reflections therein, but too much burning turns them into nondescript dark voids. You can also experiment with the Dodge tool to lighten any shadowed areas that are too dark. Again, use the Dodge tool sparingly, because it can cause unsightly grain within your shadows if you push the boundaries. Using these tools in combination is a great way to really define your dog's features by actually "sculpting" the shadowed and highlighted areas on his face.

Removing background distractions and the occasional leash

You should always be cognizant of what's going on in the background of your photo and compose your frame accordingly, but sometimes you can't control every single detail of your background. Likewise, sometimes you may want to shoot in a public space and have to use a leash. Unfortunately, a leash can also be a distracting aspect to your final photo. Using Photoshop to remove certain elements in your photo (like that leash) takes some practice, but it's a fantastic skill to have up your sleeve should you need it! Follow along with these steps to see how to edit out annoyances. Remember, practice makes perfect here; use these tools enough and deleting a leash will be a piece o' cake soon enough.

1. **With your file open in Photoshop, use your Layers palette, as seen in Figure 12-16, to make a duplicate layer of your image.**

 Figure 12-16: The Create a New Layer icon is the square icon that looks like a sticky note.

 To do this, click your Background layer, drag it on top of the Create a New Layer icon at the bottom of your Layers palette, and release. You now have a second duplicate layer called Background Copy.

 When editing out distractions, working on a duplicate layer is always a good idea in case things don't go as planned.

2. **Use the Navigator palette to zoom in on the leash (or other object) to be removed.**

3. **Choose the Clone Stamp tool from the Tools palette and then adjust the brush size using the Brush Picker drop-down menu located in the Options bar.**

Choose a brush size that's slightly larger than the width of the leash.

4. **Position the Clone Stamp tool over an area directly next to the leash and Alt-click (Windows) or Option-click (Mac) to set that point as your sampled area.**

 When choosing an area to sample, you have to think about what *would* have been present if the object you're removing was never there and choose your sampled area accordingly. In this example, if the leash were not there to begin with, you'd see more green grass from the background, so this is the area you choose to sample from.

5. **With your sampled area chosen, position the Clone Stamp tool at the top of the leash, click, and drag down the leash — but stop before you actually intersect the dog's body, as we've done in Figure 12-17.**

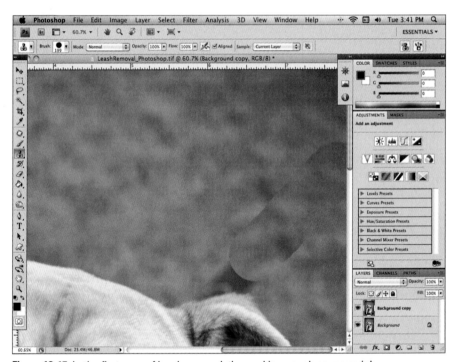

Figure 12-17: In the first pass of leash removal, the goal is a rough cover-up job.

6. **At this point, you've roughed out the first part of the leash to be removed, but you now need to blend it into its surroundings.**

 Choose the Patch tool from the Tools palette and circle the area you just painted over. Be sure to keep your selection boundary entirely within

the green background area, as shown in Figure 12-18. If you extend the boundary and cross through the bottom of the leash that hasn't already been roughed out, you'll end up with a nasty blotch because Photoshop is trying to blend together two very different areas (a green background and a purple leash). Drag your selection over to a matching area and let go.

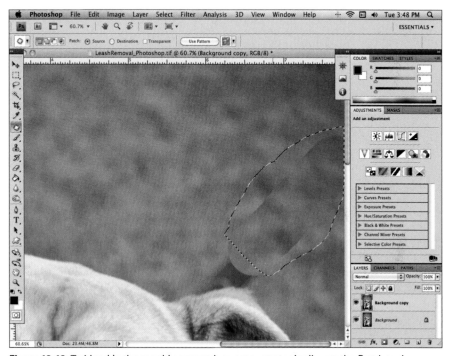

Figure 12-18: To blend in the roughly covered-up area, strategically use the Patch tool.

7. **With the top portion of the leash successfully removed, you can now get more detailed with the remaining portion, so zoom in even further to the area where the leash intersects the dog's body.**

8. **Switch back to your Clone Stamp tool and return to the Brush Picker drop-down menu to decrease the brush's size.**

 You want to choose a much smaller brush so you can accurately follow along the outline of where the leash intersects the dog's body.

9. **Again, choose an appropriate sample area and then paint over the last area of visible leash in small increments.**

10. **Switch back to the Patch tool and again outline the area you just painted, but without crossing into the dog's body.**

Drag your selection over to a matching area and let go, as shown in Figure 12-19.

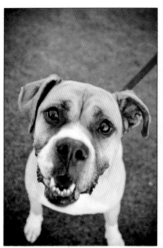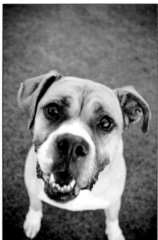

Figure 12-19: The before and after of leash removal.

In Figure 12-19, Sandy is a short-haired dog, so outlining her ear with the Clone Stamp tool yielded satisfactory results. If your own dog happens to have longer hair, you need to take your edits a step further. Rather than trying to work around individual hairs, we find it easier to simply add back some sprigs of hair after Step 10 in the previous list of steps. If you have enough untouched sprigs of hair on either side of the area to be fixed, simply sample that area and clone over the affected area. If you don't have anything nearby to sample, you can use the Lasso tool to borrow some hair from elsewhere. For example, outline an area on the dog's opposite ear, copy your selection (Edit➪Copy), and then paste it into a new layer in your Layers palette. You can now manipulate this new layer that contains only your copied hairs by rotating, reflecting, and so on (all found under Edit➪Transform) to line it up at its new home. After your copied area is in place, employ the Patch tool again to blend it into its surroundings. And there you have it — doggie hair plugs!

As sophisticated as Photoshop's tools are, they're not foolproof. Photoshop CS5 has a new and improved Spot Healing Brush tool that theoretically *could* take care of leash removal in one fell swoop. When it works, it's pretty magical and saves you lots of time, but when it doesn't work, it usually fails pretty miserably, and we find ourselves going back to this fail-safe technique. As always, feel free to try out all the tools Photoshop has to offer and see how they work for *you!*

Saving Your Masterpiece

Now that you've spent so much time perfecting your photo, you should save it as your final version. But like many things about postprocessing, you have some decisions to make before saving your final image. And before you make those decisions, you have to know how you're going to use the photos; will you print them out and frame them, or will you upload them to your blog for all the world to see? Your answer to that question determines the resolution and file format you choose. Don't worry; we help you sort through your options in the next sections.

Choosing the right resolution

Essentially, photos come in two types — high-resolution ones you print and low-resolution ones you display on the web. Image resolution is talked about in *dots per inch* (or dpi) and signifies the number of pixels present in one linear inch of your photo.

The type of media you use to display your photo (print versus screen) dictates the necessary resolution. Web images (those displayed on a computer screen) only need a resolution of 72 dpi (referred to as *screen resolution*), whereas printed images need a resolution of 300 dpi (referred to as *print resolution*). Have you ever printed an image off of a website, only to find that it looks like poo? That's because the person who uploaded it to the Internet did so at web resolution. Or conversely, have you ever visited a website and had a picture take forever to download? In this case, the person who uploaded it probably didn't know about web resolution and instead uploaded a 300 dpi image that consequently bogs down the site.

The first thing you need to know about saving your files is that you should *always* save the final version of your photo at the highest resolution and in a minimally compressed file format *before* you do anything else. This is because you can always downsize a photo to make it smaller, but you can't upsize a small photo to a larger size without seeing a degradation in quality. Unfortunately, another fact of digital photography life is that most people learn about resolution the hard way. Kim still breaks into a cold sweat when she thinks about the time she accidentally saved a retouched photo she spent *hours* working on as a web-sized JPEG instead of a print-sized TIFF.

To save a print-ready photo at 300 dpi, do the following in Photoshop:

1. **With your image open in Photoshop, go to the Photoshop toolbar and choose Image⇨Image Size.**

 The Image Size dialog box appears.

2. **Under the Document Size section, look for the Resolution value.**

 If this is already set to 300 pixels/inch, you're good to go; just click Cancel to exit out of the Image Size dialog box.

3. **If your Resolution value says something other than 300 pixels/inch, first make sure that the Resample Image checkbox is *unchecked.***

 Some digital cameras record images at a setting other than 300 dpi. For example, Kim's camera records images at 240 dpi. When you change your Resolution value from a smaller number to a larger one, you want to resize the photo without actually changing the number of pixels in the photo; that's why you uncheck Resample Image. When Resample Image is checked, Photoshop actually changes the number of pixels that exist in the image. This is fine if you're going from a larger resolution to a smaller one (for example, 300 dpi to 72 dpi) because you're only *deleting* pixels that are no longer needed, but when you're going from a smaller resolution to a larger one, Photoshop would actually be *adding* pixels that don't really exist and subsequently degrading your image quality.

4. **Click OK in the Image Size dialog box.**

 Your image is now correctly sized for print.

Settling on a file format

Before you even visit the Save As dialog box, have an idea about how you'll ultimately display your photo, because this dictates the file format you choose. The two file formats you should concern yourself with are TIFF and JPEG, each of which has a very different purpose:

- ✔ **TIFF:** Use this file format to save your photo as a high-resolution, print-ready file. TIFF files tend to be fairly large because they use *lossless compression,* meaning that the photo experiences no degradation in quality when you save in this format.

 Always save your final, retouched, master image in TIFF format *first* before saving it in any other format.

- ✔ **JPEG:** Use this file format to save your low-resolution, web-ready files. JPEG files are much smaller than TIFF files in size, but they use *lossy compression,* meaning that there's a trade-off in image quality to achieve the smaller file size. You can also save 300 dpi images in the JPEG format if you require a smaller file size or it's specifically requested from your print shop, but always be sure you already have your file saved as lossless TIFF before doing so.

Understanding color space

Color space describes the way in which the colors in your photo are numerically represented. A plethora of color spaces are available in Adobe Photoshop, but you rarely have to fuss with this setting. The only time you may need to change the color profile associated with your image is if you're preparing your files for print and someone requests that your files contain a certain color profile.

The color space of your photo is first defined within your camera. Most consumer cameras have a default color space setting of sRGB, which is the standard color space of monitors, cameras, and displays. The only other color space you may need to use is CMYK, which is the standard color space for full-color printing.

Some printers prefer to convert your files from RGB to CMYK themselves, while others prefer *you* to do it. If you need to convert your color profile, you can do the following:

1. From the Photoshop toolbar, choose Edit⇨ Convert to Profile.

2. In the Convert to Profile dialog box, choose Working CMYK from the Profile drop-down menu.

3. Click OK.

4. Save your file and be sure that the ICC Profile (Windows) or Embed Color Profile (Mac) within the Save As dialog box is checked.

To save your image in Photoshop, do the following:

1. **From the Photoshop toolbar, choose File⇨Save As.**

 Always be cognizant of choosing Save As (instead of Save). The Save command simply saves over your current file with its original name, whereas the Save As command gives you the option to rename your file to a unique name or save it in a new folder so you're not saving *over* your master file. Again, this is one of those things you don't want to learn the hard way! Accidentally ending up with a web-ready JPEG of your final photo you just spent an hour working on is never fun.

2. **The Save As dialog box appears; if you want to rename your image file, you can do so now in the text field.**

3. **Choose the location where you want to save your file, whether that be your computer's hard drive or an external drive.**

4. **From the File drop-down list, choose TIFF.**

 Several file-saving options appear as check boxes under the File drop-down list. Depending on the type of file format you choose, some of these options may not be available, but you should still know what these two basic options do:

- **As a Copy:** Check this box if you want to save your file as a duplicate. Doing so appends the word "copy" to your file name.

- **Layers:** Check this box if you used layers during editing and want to save them with your file; otherwise, the layers are merged and you can no longer manipulate them individually.

5. **Click Save.**

6. **Now that you've saved your high-resolution master copy, feel free to do another Save As if you need to create a JPEG.**

Simply choose JPEG from the File drop-down menu this time.

13

Showing Off Your Photos

In This Chapter

▷ Sharing your images freely using various websites

▷ Uploading online galleries from Adobe Lightroom

▷ Getting tangible prints in your hands

Some people think that the best part of photography is sharing your photos with your friends and family. After all, what's the point of this book if no one ever sees your masterpieces?

We always get excited to share proofs from our latest pooch photo sessions and see our client's reaction. If we've done our job well, that reaction is generally a mix of oohs and aahs with the occasional outburst of laughter. And if we've done our job *really* well, those doggie photos make the rounds among our client's friends and family, too! The photos you take of your dog are more than just a snapshot of a moment; they're memories that elicit smiles, chuckles, and even an occasional tear. In this chapter, we discuss some of our favorite ways for you to share and display your work both traditionally and digitally.

Posting Pics of Your Pooch Online

The quickest and cheapest way to share photos of your favorite furry friend is to upload them to an online gallery, be it a social media website, a photo-sharing website, or your own personal website. Using this method, your friends and family, no matter where they are on the planet, can view your pictures at their leisure, as long as they have an Internet connection. You don't have to wait until the next time you get together, and you don't have to schlep around a 25-pound photo album (remember those?).

Taking advantage of social media galleries

These days, seemingly everyone is on a social media website, with Facebook leading the pack. Why not use your Facebook powers for good and upload those adorable puppy photos to share with the world? (Or share with just your closest friends and family, depending on how you've chosen your privacy settings.) This method of sharing is free and also gives you the ability to tag photos so you can make sure certain people see them. If you don't already have a Facebook profile, it's time to jump on the social media bandwagon, folks, even if the sole reason you join is to share photos of Rufus!

After your profile is active, uploading a photo gallery is quick and easy:

1. **Log on to www.facebook.com using your e-mail address and password.**

2. **Click Profile in the top right corner of the screen to navigate to your own profile page.**

3. **Click Photos from the list under your profile picture and then click Upload Photos in the top right corner of the screen.**

4. **Click Select Photos.**

5. **Navigate to the folder where the photos you want to upload reside and click the photo you want to upload, or hold down the Control key (Command key on a Mac) and click to choose multiple photos located in the same folder.**

6. **Click Open.**

 A window appears in which you can name your album, designate the location where you took your photos, choose your image quality, and decide with whom you want to share your album (such as only your friends and family or the entire world).

7. **After you choose all your settings, click Create Album.**

8. **On the next screen, you can add descriptions to each photo and choose which image you want to appear as the album cover.**

 When you're done, simply click Publish Now and your photos are officially uploaded for all to see, like in Figure 13-1.

To *tag* a photo on Facebook (that is, alert your mom that you've added brand-new photos of her adorable furry grandchild), navigate to your photo album and click the photo you want to tag. Next, click Tag Photo, click the photo, and start typing your mom's name. Assuming you're friends with your mom on Facebook, her name pops up in a list below the field in which you type. Click her name and then click Done Tagging. Your photo now shows up on your mom's wall, alerting her that new pictures of Fluffy are online for her to ogle and brag about.

Figure 13-1: A Facebook album allows you to easily share your photos with family and friends.

Using online photo-sharing websites

Another great option for immortalizing your pooch in cyberspace is to use free photo-sharing websites specifically designed to host your images on the web. Sites like Flickr (www.flickr.com) and Photobucket (www.photo bucket.com) offer free user accounts with lots of photographic bells and whistles, such as the ability to do basic editing, create custom slideshows, and allow friends and family to download full-sized photos. The capabilities and amount of storage available for free to users of these sites grow daily, so be sure to check them out for the latest and greatest offerings. Simply create a free user account and you're ready to go. If you're not interested in the *social* aspect of a site like Facebook, photo-sharing websites are a fantastic alternative!

Uploading to a website directly from your workflow application

In Chapters 11 and 12, we talk about a workflow application called Adobe Lightroom that you can use to edit your photos. Conveniently enough, this software also comes with built-in web gallery tools that make creating a custom and sophisticated online viewing gallery a breeze! Better yet, the software has an entire list of templates to get you started.

Before we jump into the ins and outs of setting up a custom web gallery, you should already have a *domain name* (that is, the main part of a website address, such as the *barkpetphotography* in `www.barkpetphotography.com`), as well as your own hosting account. If you're remotely familiar with building websites, you likely already have these. If not, you can buy a domain name and yearly hosting plan from any domain name registration site. Just do an Internet search for "domain name registrar + hosting" and take your pick from any of these companies. A domain name costs around $10 a year to own, and hosting plans start at about $5 per month.

Domain name registrars are notorious for the ol' upsell. You *don't* need 1,500 e-mail addresses, every single version of your domain name (`.biz`, `.info`, `.org`, and so on), or the gazillion other options registrars try to sell you. Stick to the domain name and hosting plan; that's all you need to make use of Lightroom's web gallery features!

If buying a domain name and hosting plan is too much hubbub for you, Lightroom also comes with a Flickr component built right in so you can link directly to your account and upload photos from within Lightroom!

After you purchase your domain name and hosting plan, you're the official owner of an FTP (file transfer protocol) address. An FTP address is like a URL address (uniform resource locator, a fancy name for a website address), but instead of starting with `www.`, it starts with `ftp`. For example, our FTP address is `ftp.barkpetphotography.com`. Your FTP address is a password-protected location on the web where all your online files live. It's where you upload your Lightroom web gallery files to, so be sure you know your hosting plan's user name and password (you create these when you purchase your hosting plan).

Now back to the fun part. If you're ready to create a custom web gallery, open Lightroom and follow these steps:

1. **Click the Library module in the upper right-hand corner of the screen.**

2. **Select a folder or collection and navigate to the photos you want to include in your web gallery. Select images in the Grid View or filmstrip.**

 To select one photo, simply click it. To select multiple contiguous photos, click the first photo in the sequence, hold down the Shift key, and then click the last photo in the sequence. All photos between the first and last one are now selected. To select multiple noncontiguous photos, click the first photo and then hold down the Control key (Windows) or Command key (Mac) to select other photos.

3. **Click the Web module in the upper right-hand corner of the screen.**

 All the photos you selected in Step 2 should now appear highlighted in the filmstrip at the bottom of the screen.

4. **From the Template Browser panel on the left-hand side of the screen, click through the different template options until you find one you want to use.**

 The preview of your currently selected template loads in the work area at the center of the screen.

5. **Customize your website information via the Site Info panel on the right-hand side of your screen.**

6. **Customize your gallery even further by experimenting with the different options in the Color Palette, Appearance, and Image Info panels.**

 Each adjustment you make is immediately visible in your preview at the center of your screen.

7. **In the Output Settings panel, choose the level of quality you want to set for your photos.**

 This is a personal preference that depends on how you're using the gallery. If you're going to share this gallery with friends and family and you want them to see very high-resolution images, choose a quality close to 100 percent. If this is a proofing gallery for a client and you don't want the client to have access to high-resolution images, try a lower quality, like 70 percent. Also, consider the number of photos you're uploading. The higher the quality, the larger the image files are and the longer they take to load. If you have a lot of photos in your gallery, err on the side of lesser quality. Most people have an online attention span equivalent to a dog's (heh!).

8. **In the Output Settings panel, check or uncheck the Watermarking check box.**

 Again, this is a personal preference that depends on how you're using the gallery. If you're sharing this web gallery only with friends and family, you probably don't need to watermark your photos. If, on the other hand, this is a proofing gallery for a client, you definitely want to add a watermark, as shown in Figure 13-2. You can choose the standard Simple Copyright Watermark or create a custom watermark by selecting Edit Watermarks from the drop-down menu. Doing so opens the Watermark Editor, where you can type custom text, change its color, add shadow effects, and so on.

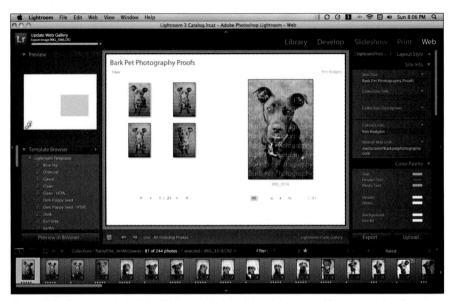

Figure 13-2: A screen shot of the Web module in Adobe Lightroom with an example of custom watermarking.

9. **While still in the Output Settings panel, check or uncheck the Sharpening check box.**

 For best results, we suggest keeping this box checked, with the accompanying drop-down menu set to Standard.

10. **Click the Preview in Browser button near the lower left-hand corner of your screen.**

 This launches your default web browser so you can see what your results look like. If you're satisfied, move on to the next step. If you don't like how your web gallery looks, adjust your settings back in Lightroom accordingly.

11. **Close your browser and return to the Web module within Lightroom.**

 The Upload Settings panel on the right-hand side of your screen is where you specify your FTP information so Lightroom can automatically upload your web gallery to your website.

12. **Click the drop-down menu next to FTP Server and choose Edit.**

 This opens the Configure FTP File Transfer window.

13. **In the Server text field, type your FTP address (for example, `ftp.yourdomainname.com`); in the Username text field, type the user name you created when you bought your hosting plan; in the Password text field, type the password you created when you bought your hosting plan.**

 If you want your gallery to upload to your main domain name, leave the Server Path text field blank. If you want your gallery to upload to an alternate section of your site, simply specify a folder name (for example, "Proofs"). If you do specify a Server Path, your gallery uploads to that subsection of your website (for example, `www.yourdomainname.com/proofs`). Leave the rest of the options set at their defaults and click OK.

14. **If you want to have multiple web galleries available at once, you need to specify a subfolder. In the Upload Settings panel, check the Put in Subfolder check box and specify a folder name.**

 For example, if you specify a folder named "Rusty," the URL that your web gallery appears at is now `www.yourdomainname.com/proofs/rusty`. To add an additional web gallery, simply change the subfolder name to something new, like "Rusty2."

15. **Click the Upload button in the bottom right-hand corner of your screen and let Lightroom work its magic.**

 When the task is completed, you have a customized live web gallery to share with the world.

Show and Tell: Printing Your Photos

Despite the world being so digitally oriented, you may at some point want physical prints of Tippy to share or display on your walls. With just as many printing options as online sharing options, it helps to have an idea of where to start.

The first thing you should determine is the size at which you want to display your photo. Is it a small print that will become part of an album or a mid-sized print that you can pop into a frame? Or maybe a wall-sized photo specially mounted to be prominently displayed in your home? After you decide on an approximate size, read on to determine the best way to make the prints.

Sticking with tradition

If you decide you want small or mid-sized prints, you have three printing options. You can

✔ **Print photos at home on a photo printer.** The quickest and easiest way to make small or mid-sized photographic prints is to do it yourself! Photographic inkjet printers are pretty affordable these days and are a great investment if you plan on printing a lot of photos. The quality of these prints may be slightly lower than that of a professional printer, but for most scenarios, you probably won't even notice the difference.

Before diving head first into a printer purchase, be sure to check out the cost of the ink and paper that the printer uses. The prices for printer supplies vary widely, so it's best to know what you're getting into!

✔ **Head to the nearest photo lab.** For a more professional and higher quality finished product, consider taking your image files to a professional photo lab. Labs have the ability to use traditional, light-sensitive photographic paper and create a digital C-type photographic print made on actual light-sensitive paper, just like the good ol' days. The lab then develops the exposed paper with darkroom chemicals, and the result is a crisp, high-quality print that rivals the quality of consumer-level inkjets any day. A print from a professional photo lab is going to cost more than an at-home print, but it might be worth the extra cost for your favorite shots!

Although convenient, those popular, do-it-yourself photo kiosk printers that you find in pharmacies and supermarkets *don't* offer professional digital C-type prints.

✔ **Order from an online digital photo printing service.** Another fantastic (and often cheaper) option is to use an online printing service. Simply upload your images, pay online, and then sit back and wait a few days. Your professional digital C-type prints are shipped right to you! Personally, this is our favorite method; it's quick, easy, and provides fantastic results.

Working with a modern touch

If you really want to make a statement with your photos (perhaps something like, "Denver is the greatest dog on the face of this earth!"), give them the wall space and attention they deserve by printing your images in a special format. You can go the traditional route and have a poster-sized print framed, or you can get a little more creative and go frameless with a stretched canvas print, like the one shown in Figure 13-3, or go modern with a photo mounted on bamboo!

When it comes to large-format specialty items, an online digital photo printing service is the printing option of choice. Sure, your local professional photo lab can probably sell you a canvas print, but it's going to be *way* more expensive than the prices you find online. Our favorite online printers are Mpix (www.mpix.com) and ProDPI (www.prodpi.com).

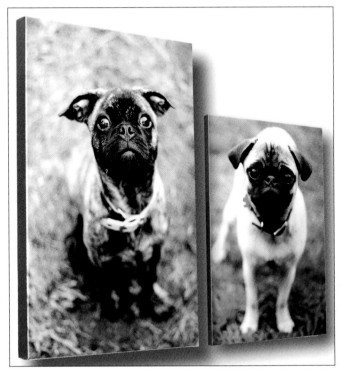

Figure 13-3: Canvases come in many sizes and are perfect for adorning your walls (while adoring your dog).

14

Make No Bones about It: The Business of Dog Photography

Does photographing your dog bring you so much joy that you yearn to do it all the time? Do you dream of quitting your job and going into business for yourself? Does the setting sun bring about all kinds of ideas for beautifully composed photographs?

You just may be able to turn your hobby into a lucrative business (that's how it started for us, after all). With the right mix of passion, creativity, hard work, and, of course, studying this book, you can successfully pursue a photography business that's truly gone to the dogs.

Figuring Out How Much You Really Love Photographing Dogs

Okay, so you love Beddy and you love photographing her. But what about other dogs? Do you love them and love photographing them too? To go into business for dogs (and their people), you really have to be honest with yourself. Do you love them enough to

✔ Spend the majority of your time with them?

✔ Learn as much as you need to about canine psychology?

✔ Keep current on doggie treats, toys, training, and more?

✔ Risk getting dirty, covered in hair and drool, peed on, puked on, and worse?

✔ Spend hours hanging out at your local doggie hot spots so you can meet their people and potentially land jobs?

✔ Spend hours looking at them on your computer screen, even when you're not physically with them?

The best way to figure out what your answers are is to get out there and start taking photos and see what happens. Spend time with as many different types of dogs (and their people) as possible. Photograph as many of them as you can. See whether you like the experience. If you do, keep going. If you don't, back up a few steps or reassess.

Dog photography is really fun, and you can be really good at it, but that doesn't mean you have to make it into a business. For some, dog photography is a hobby. For others, dog photography is, well, a job. Make sure you take your time figuring out where you land in the spectrum. Don't rush into it. Just put one paw in front of the other and see what develops.

Understanding why people hire professional dog photographers

As we were writing this book, a lot of people asked us, "Won't you put yourselves out of business by telling us all how to do this? Why would we hire you if this book teaches us how to do it ourselves?" We'd see the furrows of concern and surprise spreading across their foreheads as though we hadn't sufficiently thought this through.

The thing is, no matter how much you spell things out for people, there will always be those who prefer to leave certain matters to the professionals. A small group of people reading this book want to become professionals (like you), but the majority of readers are just everyday people who want to have a few nice photos of Brooke if the opportunity arises. And an even bigger group of people aren't reading this book and don't even know it exists but have been wanting good photos of their dog. And those people are your clients.

They hire you for all sorts of reasons:

✔ They aren't professionals but they want professional-quality images of their dog.

✔ They don't have the time or desire to learn about dog photography.

✔ They want to be *in* the photos with their dog.

✔ They enjoy luxury items of all kinds.

People hire professionals for all sorts of reasons (more than we can list here), and if you can figure out what those reasons are, you have a much better idea of what you're *really* selling.

Touching on Business Basics

There aren't many rules when it comes to starting your own business; that's why it's *your* business. You can — and should — run your business however you want. All entrepreneurs share some common tasks and responsibilities, but for the most part, starting a business is all about bringing your *own* ideas, skills, products, and philosophies into the world. In the following pages, we give you a brief overview of what it takes to start and run your own dog photography business, based on our experiences starting and running Bark Pet Photography. We've made mistakes along the way, but overall, we consider Bark to be an ever-evolving success. We hope this chapter paves the way for you to be just as successful!

Doing your due diligence

Before you run right out to buy a URL and start passing out business cards, you have to do your homework. You need to research which dog photographers already work in your area and find out enough about them to know how to set yourself apart. Usually, you can find local dog photographers with a simple online search. If none are in your area, that's either really good news (you're the first one to recognize a great opportunity) or potentially bad news (your area isn't a good market for dog photography).

Speaking of your market (in other words, your potential clients), you must get to know that, too, and the best way to do that is to get out into the community to strike up conversations with folks. Find out whether you're offering something people would buy. You can find dog folks everywhere:

- ✔ Dog parks
- ✔ Dog/pet boutiques (especially if they host events)
- ✔ Veterinary offices

Creating a business plan and setting goals

If, after doing a bit of due diligence, you determine that the conditions are ripe to set up shop and photograph dogs for a living, your first major assignment is to create a business plan, which is basically a road map to your goals. It's an actual document that you create that lays out your objectives, methods, ways of measuring success, and more. Your business plan organizes your thoughts and ideas into a workable and measurable strategy. It's something you will refer to, edit, and use to inspire yourself throughout the years. If you have business partners, make sure they're involved, too. And if you ever want to go after investors, a business plan is a must-have.

You can find all kinds of templates online that walk you through putting your dog photography business plan together; just do an Internet search for "business

plan." The U.S. Small Business Administration website (www.sba.gov) is a good place to find a ton of great info on this topic, and Bplans (www.bplans.com) has sample plans, including one for a pet photography business. If you don't feel like firing up the ol' computer right now, here are a few sections that should be in your plan, listed in the order they should appear (bear in mind that you won't complete all these sections before you open for business; you'll complete some sections as your business progresses):

- ✔ **Business Plan Executive Summary:** This is a synopsis of everything that lies within the plan, focusing on highlights — kind of like a cover letter on a résumé. You should write this last.

- ✔ **Market Analysis:** This is where the interpretation of the information about the dog photography industry goes. Include summaries of historical data, current trends, and an outlook for your industry, target market, and competitors.

- ✔ **Company Description:** This is a drilled-down write-up of what your dog photography business does specifically, who does it, and how it's unique.

- ✔ **Marketing and Sales Management:** This section answers the basic question, "How are you going to get clients?" It's about figuring out how to penetrate the market and communicate to your clients in order to drive sales.

- ✔ **Service:** This section doesn't so much answer the question, "What are you selling?" but rather, "What problems are you solving?" This is where you consider your clients' perspective and write for them.

- ✔ **Financials:** This is where all the numbers and accounting (things like cash flow reports, balance sheets, and projections) go. You won't have all these items when you first start, but as you get them, put them here.

- ✔ **Appendix:** This is where all your supporting documentation goes, such as your raw market research data and government documents.

If you're going after funding or credit lines (or think you may in the future), you should also include a "Funding Request" section. If you have a business partner or employees, you should include an "Organization and Management" section.

As you, the economy, dogs, and other factors change, your business plan should change, too. It should be a living, breathing document that's as dynamic as the subjects you photograph. Keep it somewhere accessible, read it frequently, and add to it as needed.

If you still want to start your own business after doing all this, congratulations! That's a major achievement in and of itself.

Branding your business

Your business's *brand* is its reputation, its identity, its presence in the world. Thousands of people work as pet photographers (believe us, we know), and your brand is what sets you apart from the pack. Your brand is the tangible and not-so-tangible offerings and impact of your business; your job is to figure out what that all means.

Your brand isn't just a logo and a tagline (although those elements are certainly part of it); it's really the content of your company's character. So start off with the "what." Do you want to be known for affordable prices and being accessible to everyone or for being a purveyor of exclusive luxury? Do you want to specialize in senior dogs or puppies? Do you want to be known for your speed and efficiency or your thorough retouching of images? Are you a great event photographer or do you prefer one-on-one sessions? Do you have a studio or shoot on site?

In addition to all the tangible characteristics, consider the less-visible ones as well: What values do you want your business to exude? Competitive? Smart? Friendly? Innovative? Reliable?

Combine all these things and you have your business's brand.

Completing the nitty-gritty legal stuff

In order to be a legal and legit business, you need to file all kinds of paperwork and go through a few other steps. This isn't necessarily the most fun part of starting the biz, but it's the most necessary part. Don't worry, though — it's totally manageable, and nothing feels cooler than getting a government document that lists your company name, proving that your business really exists!

Deciding on a business entity

For tax purposes, every business must identify itself as one of five types (boiled down to extremely simple terms in this list):

- ✔ **Sole proprietorship:** You're in business by yourself, for yourself. Most dog photographers fall into this category.
- ✔ **Partnership:** Two or more people agree to take on the losses and gains of the business together.
- ✔ **Corporation:** Many shareholders exchange goods for capital stock. Profits are double-taxed — once to the corporation and once to the shareholders.
- ✔ **S corporation:** All profits and losses are passed onto all shareholders.
- ✔ **Limited liability company (LLC):** Depending on the state, this is set up like a corporation but run like a partnership.

More likely than not, you'll file as a sole proprietor, but if you're unsure or just want to find out more information, contact your local chamber of commerce or visit the IRS's website (www.irs.gov).

EIN/Federal Tax ID Number

Every business needs to be registered with the IRS for tax purposes. Because most photographers file as a sole proprietor, they use their own Social Security number when receiving payments, reporting income, and filling out forms. If you don't want to use your Social Security number, you can get an *Employer Identification Number* (EIN), also known as a *Federal Tax ID Number,* for free by visiting the IRS's website. After you get that number, you use it in all your business dealings, including registering for a DBA (see the next section).

Fictitious names and DBAs

Depending on the state in which you operate your business, if you want to name your dog photography company something other than your own name (like *Bark Pet Photography*), you have to register it. This name is referred to as a *fictitious name, trade name,* or *DBA,* which stands for "doing business as" and tells the world who owns the business. Registering a DBA takes a while (up to a month or longer), so keep that in mind. The steps for registering (and whether you have to register at all) vary per state. Again, you can check the U.S. Small Business Administration's website to find out about your specific state.

Business banking

After you have an EIN and DBA (if applicable), you can march into your local bank and open an account, where you can store all your hard-earned money. Don't use your personal bank account; set up a separate account just for your business. Separating the two keeps things clean, transparent, and professional.

Sales tax

Usually, states collect sales tax only on tangible goods, which means your photography sessions (usually considered a service) are *not* taxed. But you do need to charge sales tax on any products you sell outside of your sessions, like prints, canvases, and so on.

Sales tax laws vary per state and can be quite nuanced, so you really have to do your research. In the end, the business owner is always liable to the state for the taxes the business owes, so make sure you do your homework.

Setting your prices

You set your prices based on a few different factors: what your marketing research determines your market will bear, what you think your work is worth, and what your brand is about. Do you want to be competitive? Set

your prices in line with or below your competitors'. Setting your prices significantly lower when you're just starting out helps build a client base and also takes some pressure off while you learn the ropes your first year or so. On the other hand, if you know you're ready to offer an exceptional service and want to build a premium brand, you should set your price point high — maybe even higher than your competition. If you do that, make sure you communicate what makes you worth spending the extra money on.

Operating with originality, integrity, and collegiality

Pet photographers of all sorts are popping up like crazy. It's a fast-growing industry, so chances are, you're not the first one in your area to start this type of business. That doesn't mean you shouldn't move forward with launching your endeavor; it just means you need to do so with originality, integrity, and collegiality.

Despite the fact that pet photographers are everywhere, this world is still small, so you can pretty much bank on the fact that when you emerge onto the scene, the other dog photographers will follow their canine subjects' example and "sniff" you. They'll check out your website and watch what you do and how you work. You need to be just as good with these people as you are with dogs. Even though they're your competitors, you definitely want to earn their respect. Here's some advice from a couple of people who have been there:

- ✔ **Be original:** In this growing industry, finding ways to stand out is becoming more challenging. However, as we discuss in the "Branding your business" section earlier in the chapter, standing out is vital. Sure, we're all taking photos of dogs, but what do you do or believe or see that's different from the rest of us? For your business to grow, you have to offer something unique that clients can't get anywhere else. If you don't know what that is yet, figure it out.

- ✔ **Always use integrity:** Don't copy. Anything. When you do your market research and you see other photographers' websites and materials that you like, it may be hard to come up with something unique for yourself that you like just as much (or more). But you must. From your name to your logo to promotional materials, you really need to think of your own stuff. Plagiarism and copyright infringement are illegal, not to mention an example of terrible manners, especially in the fine art world, where someone's content and images are more than his property — they are his livelihood.

 These principles apply to how you interact with and serve your clients, too. If you make a mistake, admit it. If a client is unsatisfied with your service or product, do what you can to remedy that. Build a reputation of being honest, thorough, and trustworthy. You may gain a little short-term ground by cutting corners, but is that really the foundation you want to build for yourself?

✔ **Be collegial:** Again, the world of pet photographers is small. You'd be quite well-served to introduce yourself to the people you cross paths with when the opportunity arises, to support your fellow photographers' endeavors (as much as you can without hurting your own business, of course), and to always be pleasant and respectful. Unless you live in a town of ten people, remember that there's plenty of work for everyone and that you'll probably end up at the same events as your competitors at some point.

Sometimes, you may have more work than you can handle. Perhaps someone contacts you for a gig but you're unavailable. Be prepared to give a referral to another photographer. Both the client and your fellow photographer will appreciate it, and that photographer will remember you when he finds himself needing to make a referral of his own.

At this point you may be thinking, "Wait a second, isn't this business? Shouldn't I be looking out for myself only?" Yes, you should always make decisions with the best interest of your own company in mind, but your company depends on people. And people depend on relationships. Make sure yours are good.

Taking Care of Business before the Photo Shoot

Although the photo shoot itself may last only an hour or two, you have work to do before you even get on-site. Your diligence before you even pull your camera out of the bag pays off big time. Proper preparation sets everyone up for success. After a client contacts you to set up a shoot, you need to gather and share a lot of information, so your first order of business is to ask a lot of questions.

Even though you've probably already spent hours photographing your own dog, and maybe even all your friends' and family members' dogs, someone hiring you to photograph her precious Bailey is a whole new ballgame. When people actually give you money to perform a professional service in a very short amount of time (usually an hour or two), they expect excellent results.

Identifying your subject

Find out everything you can about your subject(s) from his human ahead of time. The more you know about Fella upfront, the better prepared you are to interact with him. Ask your client to provide as much information over the phone or via e-mail as possible. And if your client can send a photo, that's extra helpful! Things to find out include

✔ What breed he is

✔ What sex he is

✔ How old he is

✔ What color(s) he is

✔ How big he is

✔ What his energy level is like

✔ What his personality is like

✔ What his favorite activities and places are

✔ Whether he's allergic to any of the ingredients in the treats you use

✔ What commands he knows

✔ Any fears or dislikes that he has

Discovering your client's needs, expectations, and reasons for the photo shoot

In addition to learning about your canine subject, you need to learn about your human client. Sometimes, this is even more vital, because the human is the one paying your fee (and humans tend to be a lot harder to please than dogs)! This is another area where it pays to be thorough. Take some time to ask your human client

✔ Why she wants this photo shoot. Her reasons may run the gamut from common ones we discuss earlier to something extraordinary, like an ailing dog or a new addition to the family.

✔ What her goals are for the session. Does she want just one good image for a holiday card? A whole action series? A surprise gift for her husband?

✔ If she or her dog have any special needs. Go the extra mile to make sure you understand any specific requests or accommodations and be sure to communicate with her if you can't meet her requests.

Does she have specific ideas in mind? A lot of times, clients don't. They just want you to "do your thing." But sometimes, clients do have ideas of what they want, so make sure you find out what those preconceived ideas are. Also find out whether she wants indoor or outdoor shots, as well as action or posed, or maybe a combination. Ask about special spots or toys she wants you to include. Take time to engage in a discussion (even over e-mail) so you can be best prepared to deliver the product she's looking for.

Guiding your client toward the right session/package option

As you find out more about your client's needs and wants, you'll know what session or package option is right for her and Franklyn and you can discuss that with her.

Sometimes, a client wants to cram too much into a session. It's your responsibility to make your best suggestion, and if that means telling her that you can't fit in indoor shots, a studio setup, *and* a trip to the beach in an hour (even though that's what she wants), then so be it; you need to be upfront and honest. Know your limits so you don't overpromise and under-deliver. If she's set on wanting several locations, then recommend a longer session, and don't be shy about it. You can explain your pricing structure and discuss the pros and cons of the different options with her (more on how to set your prices in the "Setting your prices" section earlier in this chapter). Most clients appreciate your guiding them with honesty and will work with you to make sure the shoot is set up for success. When they see how much time the shoot ends up taking, they'll thank you.

Scheduling the session and confirming details

After you have the lowdown on who you're working with and how long it may take, you can go ahead and schedule the session. Again, remember to be honest. If your client wants to do it at 4 p.m. on Saturday but you don't have the time to fit it in then, suggest some alternatives. Some things to take into consideration when scheduling the session include

- **Your current calendar:** Make sure you always update your calendar. Nothing's more unprofessional than double-booking or overcommitting yourself.

- **Time:** The time factor has two parts: how long the shoot will take and how long it will take you to get to the location (don't forget to factor in snarled traffic if you live in a large city; better to arrive extra early than late).

- **Lighting:** Stay away from the noon hour if it's an outdoor shoot. Stick with morning or late afternoon time slots.

- **Weather:** Check the forecast and keep an eye on it in the days leading up to your session. Make sure to agree on an inclement weather plan/policy ahead of time.

Preparing your human and canine clients

Continuing with the theme of "preparation is key," you should run through how the shoot is going to work with your human client ahead of time. This is a big piece of the shoot, actually, and it doesn't even happen during the session itself. Because you can't actually communicate in words with a dog and tell Gracie what's happening, there's a good chance that Gracie will get hyper, confused, or withdrawn when a new person with all this equipment and a scary flashing light comes into the house. Your goal is to keep the experience as low-key as possible, and explaining that to the human ahead of time will greatly assist you in achieving it.

If left uncoached, many human clients get nervous or stressed-out about the photo shoot for all sorts of reasons (after all, they're only human). They worry about what you think of their house, they anguish over getting their dog to behave, and they hover and try to be helpful. Don't tell them we told you, but nine times out of ten, they don't help, bless their hearts.

 When the humans have nervous energy, the dog picks up on it right away, and the session unravels quickly. So to avoid having to watch your shoot disintegrate in front of your very eyes, give your human clients their instructions ahead of time, whatever they may be.

It took us only about six months to get tired of typing out instructions every time we got a new client; now we have a handy PDF that we e-mail to all our clients before their session. You can include tips like

- ✔ Stay calm
- ✔ Let the photographer handle the dog
- ✔ Exercise the dog before the session
- ✔ Get the dog groomed before the session

For more preparation (and execution) tips, see Chapters 2 and 15.

Managing your model releases

As a photographer, you retain your rights to your photos. You can decide to waive those rights at any time, but in general, you should retain them. To protect your rights, you need to create a waiver and model release and require *all* clients to sign it. Your clients can sign the release before the session or immediately after; just make sure they sign it. Then *you* keep it. If they want a copy, you can give them a blank release or you both can sign another release for their records. It's also a good idea to briefly tell them in plain English what the release actually says (some clients like to read it for themselves, but most appreciate a quick summary). Typically, clients are quick to sign it and there aren't any problems. Should they refuse to sign the release at the end of the shoot, that should end your transaction. You shouldn't provide them with any further service or product, and it's up to you whether you accept payment for the session time. We've never had to do that, so don't lose much sleep over the possibility.

After you get home (or to your office), file the release somewhere safe and don't move it. Keep it where you can find it; you need it to back up your public usage (for example, in your online gallery or in your promotional material). Also, you never know what opportunities may come along that you need to act on right away. For example, we never could have foreseen that we would write this book. If we hadn't gotten model releases for our shoots as we went along, we'd have a very difficult time getting them now, and this

book would have a lot fewer photos and, therefore, would be a lot less interesting.

Cutest pet photo contests are very popular right now. Unfortunately, many of the companies that run these contests add to the fine print that the copyright of submitted photos becomes *theirs* so they can then use those photos in their own marketing materials. This situation has two problems: First, clients don't own the copyright to the photos you take for them, so they're actually legally prohibited from transferring the copyright to someone else in the first place because it's not theirs to transfer. Second, most people innocently submit to cutest pet photo contests without reading the fine print. To prevent this scenario from happening, explain to your clients when they sign the model release that they need to e-mail you the fine print of any contests they want to submit your photos to. You can then review the fine print and determine whether the company is trying to snag your copyright. If it is, the photos shouldn't be submitted. If the company states that the copyright remains that of the photographer, your photos are safe.

One final word of advice on the matter: Get model releases from *everyone.* Yes, everyone, even your parents, your best friend, and your spouse. (If dogs could write, we'd make them sign one, too — that's how seriously we take model releases.) Things happen all the time. Don't let anyone get a free pass. If you forget to bring the release or don't get it signed during the session, e-mail your client a copy and have the client return it before you give the client his proofing gallery. Go through this minor formality; it will save you a lot of potential migraines in the future.

Taking Care of Business after the Photo Shoot

Congratulations, you survived the session! By the time you've gone through all your postprocessing and editing (see Chapters 11 and 12 for more on that), your client will be drooling in anticipation of the proofing gallery's arrival.

Delivering client proofs

With your proofs ready to go, it's time to make them available to your client. You can get your proofs online using a number of methods; we use Adobe Lightroom's integrated web gallery functionality. It's a quick and easy way to export a professional-looking custom gallery. Flip to Chapter 13 for details on how to get a proofing gallery up and running.

One thing to make sure you include on your proofs is a *watermark,* which is a faint, semitransparent marking placed on photography proofs to protect your copyright and prevent your images from being used without your authorization or, even worse, stolen. If you don't know how to add a watermark to your images, flip back to Chapter 13.

Your watermark can be a simple line of text that says "copyright," your business name (as shown in Figure 14-1), or even your logo. It doesn't have to be obnoxious; you still want your clients to be able to *see* their photos after all, so it just needs to be prominent enough so that your photos can't be stolen right off the web.

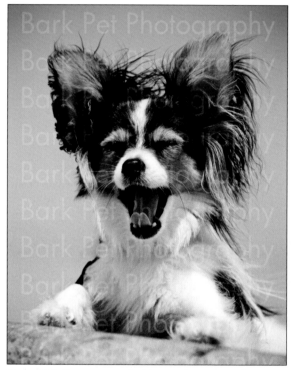

Figure 14-1: Use watermarked images in your proofing galleries.

When you upload a client's photos to a proofing gallery, set the photo resolution at 72 dpi (or web resolution). This results in pictures that are large enough to be clearly seen on a computer monitor but small enough that they won't print at a very good quality. The idea behind this is two-fold:

- ✔ You probably have a limited amount of web-hosting space to work with and you don't want to bog down your website with large files that take forever to load.

- ✔ If you ever do have an image stolen off of the web, it won't be suitable for printing.

Client viewing

After your proofing gallery is live, it's time to invite your clients to view it by e-mailing them the link. Also, let them know what the next steps are. If their package includes any photos, remind them how many they should choose. If they paid for only a sitting fee and are purchasing photos a la carte, be sure to include a product catalog or a price list so they can make some selections.

Another popular client-viewing method is the in-person viewing party. Invite your clients to your studio to view their high-resolution proofs on a large computer monitor (watermark-free) or even a flat-screen TV. This way they get to experience their images larger than life and you get to see their candid reactions and help them decide which photos are best. For us, this tactic feels a little too high-pressure sales-ish, but then again, some clients really enjoy the whole process of the photo session, and this is a natural ending to it.

If you want to offer specialty items in addition to standard prints and digital negatives, you should compile a product catalog like the one in Figure 14-2 so your clients can easily shop for things. It's up to you what you want to offer; this is another area in which you can set yourself apart from your competitors. Have a PDF of your catalog in your files, as well as hard copies, because different people like to look at catalogs in different formats. Be sure to always leave your client with a catalog after the photo session. If you forget, you can e-mail the PDF later.

Accepting payment

Getting paid by check or cash is the most direct and usually the easiest way to go, but you can also use PayPal, which is becoming more and more popular. The thing to remember with PayPal is that the company takes a percentage off the top for its service, so whether you tack that amount onto your fee or eat the cost is up to you. If your client wants to pay with a credit card, you can run it through PayPal or you can use a merchant service account provider such as Intuit. If a client absolutely has to pay with a credit card, we use PayPal.

Also, you should decide whether you want to require a deposit when someone books a session. You can make up a general policy for all clients or decide on a case-by-case basis — it's totally up to you. The advantage to requiring a deposit is that it helps weed out irresponsible or noncommittal clients. Holding a slot for someone only to have the person cancel at the last minute is disappointing and financially problematic. When clients pay a deposit, they're much more likely to keep their appointment, and if they don't, you at least aren't out 100 percent of the money you were counting on. The flip side is that sometimes deposits are a deterrent for clients, and sometimes you don't even have enough time to collect a deposit if the appointment comes in at the last minute. We typically require a deposit only for sessions that are two hours or longer.

Figure 14-2: Create a product catalog that includes specialty items your clients can purchase.

Building Your Portfolio

Your portfolio is your calling card. It showcases your work and makes people want to book you for jobs. When building your portfolio, you want to build something that represents your style, diversity, and quality. Potential clients make their decisions on whether to book you based on what they see. Your portfolio is your one shot to win them over.

Choosing images to show the world

So in order to get clients, you have to have a portfolio, but if you don't have clients, how can you build one? Ay, therein lies the problem. Well, the best way is to photograph any dogs you can. Ask your friends and family members if you can photograph their dogs for free in order to build up your portfolio.

After you start building up a hearty collection, you can select which images to use. Again, choose images that are your highest quality, that are aesthetically pleasing, and that reflect your style well. Be sure to make your portfolio as diverse as you can, but not at the cost of quality. It's better to have a few really great shots than a bunch of so-so ones.

Compiling your first portfolio

You should make your portfolio accessible in two formats: the traditional, hold-in-your-hands format and the online format. You may dread the thought of creating two portfolios, but it's not as much work as it seems, and the time spent will pay off in the long run (trust us!).

You can print out your photos and make a tangible portfolio for people to physically hold and page through. If you decide to go this route, make sure your photos are 8 by 10 inches or larger so people can actually see the details. A traditional portfolio comes in handy when you need to display it at an event or when you want to show your work in a situation where a computer isn't available.

We use two sizes of traditional portfolios: 11 by 14 inches, which we use as our main portfolio and at events like trade fairs and meetings, and 4 by 6 inches, which we use *only* in silent auction displays or other situations where space is tight and we can't accommodate our main portfolio. Whatever size you use, just make sure the print quality is as high as possible. Again, you'll land clients (or not) based on these images.

Whether you have a traditional portfolio or not, you absolutely *must* have an online portfolio. The Internet is the place your clients will most likely look for you and your work. For details on how to create an online portfolio, turn to Chapters 13 and 18.

Keeping your portfolio current

After you print your portfolio or upload it online, it's easy to forget about it. After all, you're too busy taking photos and running a business! You should, however, make it a point to update your portfolio regularly. How often is up to you, but just make sure you do it (maybe every other month). As time goes on and you get more practice (and probably better equipment), your photos will change. Make sure your gallery reflects your current style. Updating your portfolio regularly also encourages visitors to return to your website, and the more time they spend on your website, the better chance they have of becoming clients!

Maintaining a Marketing Mind-Set

Oh, marketing. It's tempting to talk about it in a little vacuum, like we lay out here, but really, marketing is all around you. Everything you do with your business is marketing. The phone calls you make (and receive), the e-mails you send back and forth with potential clients, the way you work your profession into casual conversation, the finished product your current clients

receive . . . all these things say something about your business and keep your business in the minds of others. Marketing is more like a mind-set or lifestyle than a laundry list; it's a commitment to integrating your brand into the world.

Free marketing methods

Although money certainly helps your marketing efforts, you can also do so much for free. You don't need money to be effective at marketing (but if you do have some dollars to devote to marketing, we have some ideas for you in the "Paid marketing materials" section later in the chapter). Again, marketing is all about your mind-set. If you're driven, willing to be creative, and good with people, there's no limit to how far you can take your brand on little to no money.

Understanding the power of social media (including blogging)

Gone are the days where you have to pay for mailing lists and market research. Forget about shelling out your hard-earned cash to direct mail companies to make your clients come to you; you can go to them, and do it for free! Social media is a marketer's playground, and it's time you joined the game.

If you're not on Facebook, Twitter, YouTube, and/or a blogging service, you're missing *prime* opportunities. On these sites, millions of people interact every day, not only with each other but also with companies. You need to be there. Set up a business page and then get creative! But realize that clients won't come just because you build it. You have to create a space that not only represents your business but also provides a lot of interaction (remember, this is *social* media).

Social media is all about building relationships organically, so don't expect much business to come out of it directly or immediately. Social media is more like brand-building or customer service. It's a chance for you to connect with your clients in a real way, which usually leads to long-term relationships. And that can be more valuable than selling a session to a one-time client who doesn't feel connected to the brand.

Here are some tips and hints for making your social media effective:

- ✔ **Include lots of photos.** You *are* a dog photography business, after all! Make sure you have lots of photos for people to see on your Facebook wall, and add new ones frequently (at least every week, but more if possible). If you're blogging, always include at least one photo.

- ✔ **Include short videos.** Posting YouTube videos that you make or that you find elsewhere on the web that are funny, cute, or poignant (but relevant to your business) is another great way to keep your fans engaged (just make sure you give credit where it's due).

✔ **Keep it casual.** Part of the power of social media is that people can interact with you on a personal level (and you with them). It kind of feels like being a member of a secret club or something, so you can feel free to use casual (but appropriate) language and even unpolished media when you post, like a cellphone pic of a behind-the-scenes look at your booth at a trade fair, or a self-portrait that shows how happy you are after a great session. Your fans will feel like they know the real you.

✔ **Name drop and cross-post.** Always track back to relevant people, pages, organizations, and companies whenever possible. This helps build community and introduces your business to other populations.

✔ **Stalk your own page.** Don't just set up your page and forget about it; you have to interact very frequently to get this to work. When you're just starting out, ask friends and family members to be "plants" on your page and help you generate discussions.

✔ **Edutain.** Make sure your posts and blogs are a combination of entertainment and sales-oriented content. Your fans want to have fun, but they also want to be in the inner circle of your brand, so offer discounts and updates on your business in between all the other stuff. Be sure to strike a balance.

Understanding the importance of watermarking

Unless you're giving prints or files to someone who has paid for them in some way, you should always use watermarks on all your publicly displayed electronic images. This includes images on all your social media, your blog, and your online gallery (unless it's in a format that can't be right-clicked and saved or you've disabled the right-click feature altogether). For as great as this technology-savvy society is for business, it can open you up for missed marketing opportunities (or even worse, theft). Don't get us wrong; most people are probably innocently unaware; they see an image they like, right click it, and save it to their desktop or repost it to their sites. Only a small minority are actually looking to steal professional images. Nonetheless, if there's a chance people will repost your images, watermarking them ensures that anyone who sees the photo knows who took it. Bam. Marketing (and rights protection).

By watermarking, you not only take advantage of passive marketing opportunities but also protect your financial and brand well-being. Let's say a magazine editor sees one of your photos on someone's Facebook page that would be perfect to accompany one of the magazine's articles, but the photo has a big, fat watermark on it. First of all, the person knows immediately that you produced the image, and second, she knows she can't use it in that condition, so she has to contact you for a nonwatermarked version. That's when you have the power to approve or decline the usage and set your terms.

Without such a safety net in place, your photo could end up anywhere without acknowledgement (or even your permission). These are *your* photos and *your* marketing opportunities. If you don't protect them, no one will.

Starting and maintaining an e-mail list

An e-mail list is a traditional but still relevant piece of marketing. Many websites offer free accounts. Do some research to find a service that meets your needs. Some services are simple, some more complex; some offer no frills, and others provide a bunch of freebies to account holders. Whatever your preference, start up an account. You're then able to enter all your subscribers into a database and send them e-mail blasts all at the same time. This is a good way to inform your subscribers of news and specials and just keep your brand in their minds.

Here are a few tips and things to remember:

- ✔ Make people opt-in to your mailing list. This means they specifically request to be put on it. This also means you do *not* automatically enter all your clients or anyone who has ever e-mailed you.

- ✔ Send e-mails out on a regular basis. Once a month or once a week seem to be most common for businesses. Just make sure that you're not bombarding people unnecessarily.

- ✔ Think about your format. Do you want to send a monthly newsletter? A weekly gallery of photos? Seasonal deals? Whatever you decide, keep it consistent. Your mailing list is kind of like a brand within a brand.

- ✔ Write for your current clients, but remember, you also hope that people will forward your e-mails around to others, so always put something in that could potentially attract new customers.

Special offers and coupons

People love deals. There's a whole psychology (and industry) around them; just ask anyone who's signed up for one of the many daily deal sites that abound these days. Think about what kind of special discounts and offers you can make to your audience. Experiment to find out what people respond to best, but don't be too generous — otherwise, people will never book at full price! The key with deals is to make sure you hype them up so people know about them. Create a sense of urgency with whatever you decide. If you present the deal juicily enough, it may just be enough to convert an interested party into a paying client!

Referral and incentive programs

To get an instant "street team," develop a referral program. You can set it up however you want, but the basic idea is that you offer incentives to people who refer clients to you. If the incentives are good enough and you find the right people, you can easily triple or quadruple your sales team without paying anyone an actual salary!

If people contact you to ask for a break on your fee (when you're not running a deal) or if someone lives out of your area, suggest that they become part of your referral program. Make them a deal that if they refer X amount of new clients to you, you'll do their session at a reduced rate (or free).

Word-of-mouth marketing and review websites

With cellphones, computers, and the Internet, information exchanges happen instantly. If someone's had a great experience with you, he's likely to turn right around and brag to his friends. On the other hand, if the experience wasn't so good, you could be the subject of some not-so-great marketing. Keep in mind that whenever an individual hires you, you're really serving the world. And with review sites like Yelp and Angie's List, it's easier than ever for people to broadcast their opinion to the world — sometimes before you even leave their house!

Seeing as how you'd *never* do anything for anyone to complain about, you want to encourage your clients to post reviews for you. Yelp (www.yelp. com) is definitely the industry leader here, so make sure you set up an account for people to use. Some cardinal rules when using review sites include

- ✔ Don't badger your clients for their reviews. Ask them once and that's it. If they do it, great. If not, maybe they will someday.

- ✔ Don't ask your friends and family to "stuff the ballot box" with positive reviews. If you've photographed their dogs, then it's legit. But if not, don't even think about it.

- ✔ Negative reviews may happen. You can't please everyone all the time. Sites don't allow you to edit or remove the bad ones, but even if they did, you shouldn't. Transparency and honesty are key. Instead, contact the unhappy client and try to remedy the problem. If you do this successfully, the client may end up going back to update the review.

- ✔ Thank people for posting reviews. They're taking time out of their day to review *you,* after all. You can do this with a quick thank-you over the phone or by e-mail.

Partnering with other local businesses

Partnering with other local businesses is an awesome way to do some passive marketing. Introduce yourself to your favorite local dog business owners. Tell them about your new business and ask them whether they're interested in working together on any projects. In-store events such as "mutt mingles" are quite popular right now, and doggie business owners usually jump at the chance to have a photographer there to capture all the action. Even if they can't pay you, it's a great opportunity to get your work out there, so you should still do it. You get to mingle with lots of dog people, and some of those dog people may want to see the photos afterwards . . . and after seeing them, they may decide that Harmony needs her own private photo shoot with a professional such as yourself. Bingo: an instant marketing campaign!

The more goodwill you show toward these business owners (like shooting their events for free), the more likely it is they'll repay the favor by putting out your business cards for their customers to see or even personally recommending you! Plus, people in the dog industry are just plain cool. We *love* partnering with local, likeminded, dog-loving entrepreneurs! One of our longest-standing relationships is with Pussy & Pooch Pethouse and Pawbar. The relationship started with this company hosting our mini photo sessions in its store and has grown into a very substantial and mutually beneficial partnership where we constantly think of ways to work together. Because of this, both of us have been able to grow more and reach further than we would have been able to alone. Partnerships are *key* to business growth.

Reaching out to other websites and bloggers

The online equivalent to visiting business owners' stores is visiting their websites and blogs. Contact your favorite doggie bloggers and website owners to introduce yourself, just like you would with the bricks-and-mortar shop owners. Offer your services and see whether they're interested in doing some content or review exchanges. This is especially effective when approaching bloggers because they're always looking for new content. And if you establish relationships with well-read bloggers and high-traffic websites, new opportunities may materialize. Just remember to always thank people and pay their kindness back however you can.

Every time someone online links to your website, that increases your page ranking. The more links to your website from reputable blogs and sites you get, the more exposure and reputation you build. For more on how to build your web presence and get found by search engines, check out Chapter 18.

Paid marketing materials

Okay, we know we said you don't need to pay for marketing, but if you have a little money to play with, you should add a few things to your inventory. All of them can be done within any budget. Of course, if you have tons of money to invest in marketing (maybe you finally found that buried treasure), the sky's the limit! We can't possibly list all the options here, so we stick to basic priorities for now. Figure 14-3 shows some of our own marketing materials.

Figure 14-3: A sampling of our own marketing materials including business cards, postcards, and mini fold-out portfolios.

Business cards

Business cards are pretty much must-haves. You can find websites that will make cards for you for free (aside from shipping and handling), but your design choices are slim to none. A better option is to spend some money so you can design and print nice cards. After all, you're an artist; you may as well use your business cards as a palette and get creative with size, color, and paper. Similar to your portfolio, because you're a photographer, people tend to judge you based on your business card.

Brochures

Brochures are nice to have but not necessary. They're good for handing out at events such as a trade show or gala. They can be simple or complex; just make sure they're full color. You want to show off some of your images and

give enough detail about your services so people become interested enough to contact you.

Brochures are also good to have on hand when opportunities for gift bag placement come up. For example, your local doggie boutique is having a grand reopening. It will be handing out gift bags during this event, and it approaches all its preferred vendors to see whether they'd like to put something in the bags. You can get your brochures into the hands of potentially hundreds of dog-loving people in one day.

Sample products

As you decide on the specialty products you'd like to offer in your catalog, be sure to order one of each item before you offer it through your business. Doing so helps you become familiar with your subcontractor's service and product (quality control), and then you'll have one on hand to show people when they want to get a sense of what the product looks like in person. A product catalog is nice, but having a canvas to actually look at helps your clients visualize how they'll work that piece into their home. And that can help seal the deal.

Pay-per-click (PPC) online advertising

Placing ads is always such a mystery because you can never really tell whether they work (that's why so many ads encourage customers to "mention this ad and get 10 percent off!"). One of the ways to cut down on the feeling of throwing money into the dark abyss is to launch a pay-per-click (PPC) campaign. In this type of arrangement, you pay only the website host when someone actually clicks on your link when it comes up in Internet searches. If the person doesn't click it, you don't pay. In this model, you know there was at least enough interest for someone to actually click the ad, and you know he got to your website.

The three biggest providers of this type of advertising are Google AdWords, Yahoo! Search Marketing, and Microsoft adCenter. Facebook also offers PPC, and launching a PPC ad campaign is great for building up fans on your Facebook page. You can research these hosts individually to find out more about their rates and how they work in detail.

Traditional print advertising

Everyone knows about traditional print ads; the world is inundated with them. You can't open a magazine, newspaper, or mailbox without seeing an ad. Print ads are generally expensive with little yield on their own, so if you want to go this route, do your homework. You have to know a little bit about

your demographic first and then find publications that match it. Think about whether you want a national or local ad and what you want the readers to be like. Opportunities exist in all sizes, so make sure to keep your eyes open. See what major pet stores keep on their shelves and notice what the freebie pet newspapers are. If you find an opportunity that's a good fit and you have some money to spare, trying it out doesn't hurt.

Most major print publications have online equivalents that are sometimes a bit more reasonably priced, so be sure to ask about those options when shopping around.

Part IV
The Part of Tens

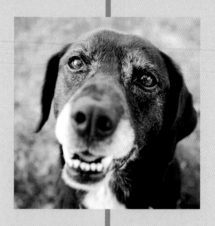

In this part . . .

We have so much good stuff to share about dog photography that we created the chapters in this part to reveal even more of our insights. These chapters are full of little tidbits of advice, best practices, and lessons we've learned from our mistakes that you now won't have to make (you're welcome). This part is like a little drive-through window — if you don't have time to eat the whole meal that is this book, this part gives you a little sustenance to tide you over until you do (but it has a lot less calories than that fast-food joint).

Ten Ways to Make Your Photo Sessions Fun

Does Matilda run and hide the second you get your camera out? Whether you and Matilda are old pals who have lived together for the past seven years or Matilda is a client's dog who hasn't warmed up to you yet, she may not be as into this photo idea as you are. For some dogs, having their picture taken can be scary, stressful, or just plain boring. If Matilda gives you the cold shoulder, try some of these techniques that'll help make the experience fun for all of you. With a few tricks, a "paws"itive attitude, and a lot of patience, everyone can enjoy themselves.

Introducing Yourself to the Dog

If you're photographing a dog you've never met before, introducing yourself is the very first thing you should do. Just like with humans, first impressions are everything, so you must get this pivotal moment right. The act of introducing yourself isn't necessarily about having fun in that moment but rather about setting the stage for you to have fun with the dog later. The main goal of introducing yourself to the dog is to build trust. Here are some tips for a good introduction:

✔ Ask the human ahead of time about any quirks the dog has so you know not to do anything that may frighten him (for example, "Honey Doo doesn't like when people whistle").

✔ When you first meet the dog, stay calm and quiet. Many people's first inclination is to use loud, high-pitched baby talk with dogs. Some dogs may like this, but for most, it just gets them into an over-excited state. If you want to greet the dog verbally, use soft, soothing tones.

✔ If the dog is very excited when you first meet, ignore him until he calms down. Concentrate on touring the location or setting up your camera and equipment. After he is calm, you can say hello verbally or by letting him sniff you.

✔ Never approach the dog; let the dog approach you — but don't force it.

✔ If the dog is small, getting down on his level can help remove the threat of your physical presence. Never tower over or reach down to pet a small dog. It's much too scary for most of them.

✔ Avoid eye contact until you've spent a few minutes together. Dogs can perceive eye contact as a threat. Let him know you are not challenging him by avoiding looking him in the eye right away. After you've built up trust, you can try it later.

✔ Once you've gotten through the first few minutes, pet the dog if he seems comfortable with it. If there is any doubt, don't touch him.

✔ All dogs are different. Some are more outgoing and plop in your lap to lick your face the second they meet you. Others forget they know you if you leave the room and come back. Observe the dog for clues about his personality, go with the flow, and use your common sense.

Filling Your Pockets with Enticing Treats

Not all treats are created equal. Be sure to have a few options on hand in case Lucy suddenly decides to turn her nose up at your bribery. Start with everyday beef or chicken treats, but be ready to try something new if she becomes bored with them. Our secret weapon is dehydrated chicken; most dogs go crazy for it even if they're not particularly treat-motivated.

If you're photographing someone else's dog, be sure to ask whether little Lucy is allowed to have treats. Some dogs have strict dietary requirements for various health reasons, and others may be allergic to certain types of protein. Always find out in advance whether your subject has any special dietary restrictions.

Getting Physical: The Preshoot Workout

Your first photo sessions with Olive are guaranteed to go much smoother if you work in a preshoot workout regimen. Whether you're planning a photo session or not, dogs are at their best when they engage in proper amounts of exercise. Exercise is good for them physically and also provides the mental stimulation they crave. Besides, most of the dogs we know — including Beddy in Figure 15-1 — absolutely love a good romp!

The preshoot workout is especially important for dogs that have a lot of energy or are easily over-stimulated. A photo session can be an unfamiliar and downright scary experience for some dogs, especially if they're carrying around a bunch of pent-up energy. So before you even unzip the camera bag, grab a leash, head for the door, and walk off some of that energy!

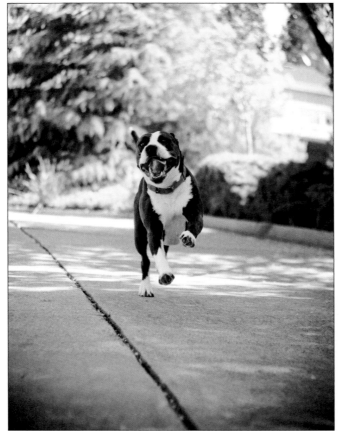

50mm, 1/1000 sec., f/2.2, 200

Figure 15-1: Exercising your pooch before a photo session can reduce a high-energy or anxious dog's stress.

Incorporating Play

Although a 30-minute portrait sitting with Atlas may be fun for *you,* we can guarantee that ol' Atlas will get sick of "staying" real fast. Keep things interesting by making your photo session feel more like a game than detention. Have all types of toys ready to go — plushy squeak toys, tennis balls, rope toys, and so on. In between frames, take a break to interact with Atlas so he feels like an old pal instead of a "subject."

The more you connect with a dog — whether your own or someone else's — the more likely he'll show you his real personality, so don't skimp on the fun stuff! If you're outdoors, have two friends play Atlas-in-the-middle with a Frisbee. With so much going on, Atlas will forget all about modeling!

Taking Lots of Breaks

Are you sick of us telling you this yet? Our apologies if you are, but it's the single most important part of dog photography. Really, we can't stress it enough — the moment Scruffy starts to lose focus or get agitated, take a break! Just as any dog trainer will tell you that short bursts of training are better than drawn-out sessions, the same is true with dog photography. Your dog should enjoy himself throughout your shoot, so whatever it takes to make sure he's having fun, do it! If Scruffy loves fetch, be sure to have a ball handy. Even if he gets bored every three frames, that's okay; you'll at least end up with a couple of good, happy Scruffy photos as opposed to a memory card full of miserable Scruffy.

Staying Home

You don't literally have to stay at home to make the photo shoot fun, but choose a location that's familiar and comfortable for your canine subject. New environments can be overwhelming or distracting, so to help Big Papa relax and enjoy the photo shoot, use his home (or an equally familiar setting) for your location.

Styling Your Dog

Yep, even dogs need to get their hair done for special occasions! Grooming is more important for long-haired dogs, like Oliver in Figure 15-2, but you shouldn't overlook it in shorter-haired dogs. Remember, though, that the grooming we're talking about is the enjoyable kind, *not* the stressful kind. You probably already know whether your dog tolerates getting dropped off

at the groomers or getting wet in the tub. If Priscilla doesn't mind the full-on mani/pedi treatment at the salon, go for it! But if it typically stresses her out, opt instead for a simple in-home brushing you can do yourself.

If a stressful grooming experience is absolutely necessary to get Priscilla's coat to perfection, consider scheduling her appointment a day or two in advance of your photo session. That way, Priscilla has some time to get back to her normal routine. Either way, some creative styling can give great character to the shot!

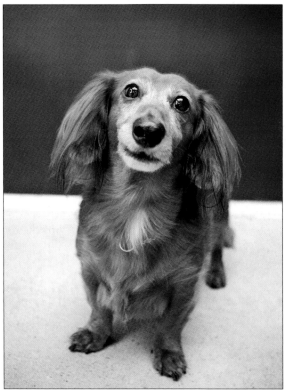

24mm, 1/125 sec., f/2.8, 250

Figure 15-2: Oliver experimented with an "up 'do" but ultimately settled on letting his hair hang loose.

Keeping Your Cool

Have you ever noticed how Ziggy starts pacing around the house and frantically following your every step any time you're stressing? It's a phenomenon you probably know all too well!

Dogs are like mirrors to their humans. They sense energy better than a seismograph. Exactly *how* they do it is beyond us, but what we do know is that all good dog photographers understand this concept and use it to their advantage. The worst photo sessions we have are the ones where the owners attempt to control their dog, fail, get embarrassed, and become frustrated. The energy is almost palpable to *us* in those situations, so we can't even imagine what the dog is feeling!

Always try to remain calm and stable during any doggie photo session. Find that Zen place and keep breathing, no matter what. If you're working with your own dog, you're in luck because you only have *one* person's emotions to control — your own! If you're working with someone else's dog, explain to the owner in advance how important it is for everyone in the room to remain calm, happy, and stress-free. Often this task is easier said than done, so if things start going south, politely ask the owner to take a break while your assistant steps in to do some wrangling. The nature of the folks you're working with should dictate who assists you.

Using Small Talk

A less obvious way of getting the humans to chill out a little is to start chatting them up. Ask them about their work, their home, the weather — anything that's *not* about their dog. After they get the focus off of their pup, the dog will feel a bit of relief and probably relax for you. Every shoot is different, so don't be afraid to give direction and switch things up if Yvette starts to get agitated (flip back to Chapter 2 for more details about dog behavior and communication clues).

Keeping Safety in Mind All the Time

Okay, we realize this topic may be a bit of an oxymoron — after all, isn't fun supposed to be carefree and lighthearted? Well, we'll put it this way: If a dog gets hurt (or worse) during the photo shoot, that's the fastest way to put an end to the fun. To make sure you two get to enjoy the photo shoot (and the years to come, if you're photographing your dog), stay safe. There's a difference between having fun and being reckless. Your canine subject is trusting you to keep him safe. Don't take any chances. (For more safety specifics, head to Chapter 2.)

16

Doggone It! Conquering Ten Common Challenges

Even if you've only taken a dozen photos of your furry best friend, you probably know that dogs aren't exactly the easiest subjects to photograph. You may have already experienced some of these challenges firsthand, but if you haven't, don't worry — you'll get your chance sooner or later. In this chapter, we cover some of the most well-known dog photography challenges, as well as some stumbling blocks you may not even realize can be problems in the first place!

Avoiding the Black Dog Blob

Probably the most infamous dog photography conundrum is the black dog phenomenon. If you have a black dog in your life, you're likely all too familiar with the issue; in every photo, Sophie looks like a big black blob in the corner instead of the regal pooch she is. (It's no wonder black dogs often sit in the shelter twice as long as their lighter counterparts — no one can get a good picture to show them off and get them adopted! It's such a widespread, devastating reality for homeless animals that it's been dubbed the "black dog (or cat) syndrome.")

Black dogs' features can easily get lost if you don't set up the shot correctly. Whether you keep the company of a black dog yourself or simply want to head down to your local shelter to take photos that *will* get a black dog adopted, follow these guidelines to get the best shot:

✔ Contrary to what you may think, direct sunlight is your enemy here. Yes, the dog is black. No, that doesn't mean he should be blasted with direct sun to light him up. Remember that rule about not shooting during midday sun? Well, the rule is doubly true for black dogs. Your best bet is to find the most evenly lit shaded area you can and set your pooch up there. We took the photo in Figure 16-1 in the late afternoon, and Ellie was strategically positioned in a shaded area.

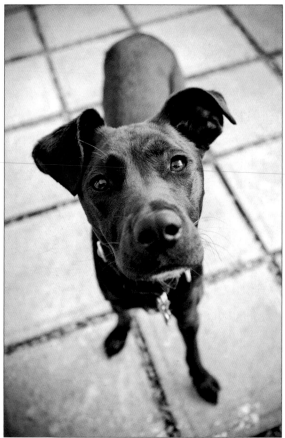

24mm, 1/125 sec., f/2.8, 200

Figure 16-1: Photograph black dogs in a shaded area for even light that doesn't take away from their features.

✔ If you can't find refuge from the sun, consider moving your photo session to an indoor location with lots of natural light. Remember to increase your ISO if you move indoors. (Flip to Chapter 5 for everything you need to know about photographing indoors.)

✔ Supplement your available light with fill or bounce flash (see Chapter 6). If you must photograph in direct sunlight, adding fill flash to your photo helps lighten the darkest shadows and better reveals the features of your black dog. If you're photographing indoors, bounce your flash off of the ceiling for some nice, soft, dispersed light.

✔ Depending on how you frame your shot, you may have to use your exposure compensation dial to darken your image. This is especially true if your dog fills up most of the frame. Just like a white blanket of snow can trick your camera sensor and underexpose your photo (see Chapter 6), a photo with an unusual amount of black can sometimes result in an overexposed image in need of negative exposure compensation. Ultimately, use your camera's preview as a gauge when it comes to setting your exposure compensation.

Making Adjustments for White Dogs

We can't talk about black dogs without giving proper attention to the other extreme, the predominantly white dog. Extremes of blacks *or* whites are not your camera's friend for a reason. Your camera's light meter assumes every photograph you take has a "normal" amount of light and dark colors in it. It then sets your exposure to a setting that takes all these colors and averages them out to a middle (or 18 percent gray). This works fantastically in situations where roughly the same amount of dark and light are within the frame, but your camera tends to get fooled in environments that have predominantly dark or light colors.

Some of the techniques we discuss in the preceding section translate to white dogs as well, while others need to be reversed:

✔ Direct sunlight is pretty much never a good thing. You want to avoid direct sunlight with your white dog so the detail in the highlights of his white fur aren't overly blown out. Head for the shade or try shooting on an overcast day, like we did in Figure 16-2.

✔ No shade? Take the photo session indoors and try to flood the place with as much natural light as you can. Because the light enters through windows and gets dispersed throughout the room, you don't have to worry about the harsh, direct nature of it.

✔ If you still don't have enough light indoors, bounce your flash off of the ceiling to add some additional light to the scene.

✔ Say goodbye to that muddy, grayish fur by setting your exposure compensation in the positive direction, especially if you fill up most of the frame with your dog's white fluffy coat.

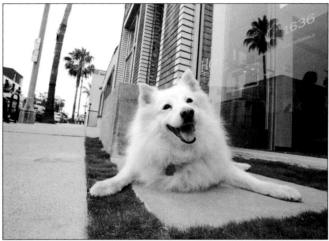

17mm, 1/100 sec., f/9.0, 1250

Figure 16-2: We photographed Snow on an overcast day for even, soft lighting.

Coping with Uncooperative Dogs

Photographing a dog that has little to no obedience training makes for an interesting photo session, to say the least. Uncooperative dogs fall into different categories: the relentless barkers and the hyperactive extroverts, as well as the shy and avoidant introverts.

Regardless of how your dog manifests his uncooperative behavior, it likely all stems from the same place — fear. The more uncomfortable and scared a dog becomes, the more signs of stress he exhibits, so your goal is to reestablish a sense of safety before diving into your photo session. If you're dealing with an uncooperative dog, try the following:

✔ Take a break so Payton can relax for a moment without the camera intruding upon his space.

✔ If he's bouncing off the walls and won't calm down, try wearing him out first with a nice long walk or even a jog. Burn off that extra energy and you'll quickly understand the phrase "a good dog is a tired dog."

✔ Ignore him at all costs — don't pet him, don't talk to him, don't even look at him. Act as if he's not even there and go about your business until he settles down. After he calms down, slowly get down on his level and let him come to *you*. Whether he's barking or hiding out of fear, he needs to approach you on his own terms when he's ready to do so.

✔ If he refuses to look at the camera, try using the shy-dog desensitization technique we talk about in Chapter 2 and be patient with him.

✔ Work the photojournalistic approach and don't *make* him do anything at first. Just get down on the floor and follow his lead.

✔ If all else fails, you may have to teach Payton some basic obedience skills like "sit" and "stay." He may surprise you with how quickly he picks up basic commands. After he has learned to sit and stay, he'll be a modeling pro in no time!

Capturing Puppies' Cuteness

The puppy months may very well be the cutest stage of your dog's life, but they also fly by in the blink of an eye. We rescued most of our own dogs when they were already a little older, so we're constantly speculating on what they may have looked like as a puppy. If you're lucky enough to know your dog as a puppy, it's a special time in his life that you definitely want to capture and hold onto. As cute as they are, though, puppies can be difficult to photograph. Here are some tips:

✔ Take five! Dogs in general don't have a very long attention span, but puppies in particular have even shorter attention spans. If your pup already knows how to sit on command, use this to your advantage, but be sure to reward him quickly and frequently so you don't lose his attention. Take a few snaps and immediately give him a break. Cisco, in Figure 16-3, uses all his patience while waiting for a treat. Immediately after we took this frame, he dove right back into crazy play mode.

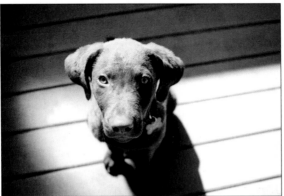

24mm, 1/400 sec., f/2.8, 100

Figure 16-3: We captured a rare still moment when Cisco put all his might into practicing his newly learned "sit" command.

- Recruit an assistant to help you wrangle your puppy. If you ever need an extra hand while photographing a dog, it's now!

- Have various attention grabbers on hand. Puppies are extremely curious by nature, so be sure to pack your bag chockfull of different-sounding squeakers, clickers, and toys. You may need to make lots of noise to get his attention away from the million other sights, smells, and sounds that are all probably new to him. Having various sounds at the ready means there's always something new to grab his attention.

- Follow his lead, even if that means he needs a break every three frames. Be patient with the little guy and remember to keep it fun!

Staying Sensitive to Senior Dogs' Needs

The transition from puppy to senior may seem a long ways off, but before you know it, little Victor's muzzle will start to go white, and eventually, you'll notice how he takes his sweet time going up and down the stairs that he used to bound off of. Senior dogs have a special place in our hearts; their soulful eyes and wise demeanors only come with age, so be sure to capture those golden years before they slip away.

When photographing senior dogs, bear in mind that they may have some special needs or limitations that you need to be aware of:

- If the dog has arthritis, repeated sitting may be too painful for him, so let him stand instead.

- If he's hard of hearing, calling his name or using a squeaker to get his attention obviously won't work. Try working with his sense of smell instead by putting a treat near his nose and slowly pulling it away in the direction you need his head to turn. If he's been deaf for a while, he may also respond to vibrations on the floor. Use your foot to tap on the floor in the direction you need his attention.

- If he has cataracts and can't see very well, be cautious about where you place him. For example, he may not necessarily realize that when you picked him up you placed him on a sofa that's 2 feet off the ground.

- Just as you should take lots of breaks with a puppy, you also want to take frequent breaks when working with senior dogs, such as Jill in Figure 16-4.

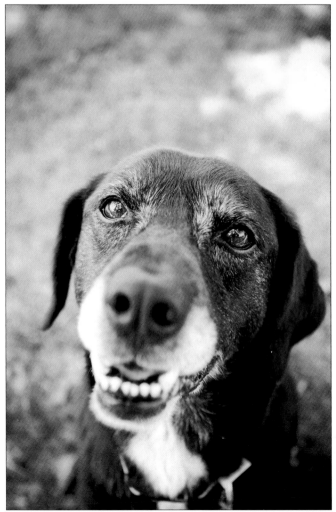

24mm, 1/125 sec., f/2.8, 160

Figure 16-4: Jill's human wanted to capture her beautiful senior dog in all her graying glory before she crossed the Rainbow Bridge.

Planning for Leashes

Ahhh, the inevitable leash debate. Some people don't mind them in photos, but others hate 'em! For us, leashes are part of a dog's everyday life, so we don't feel that they're all that intrusive in the first place. However, you need to keep certain things in mind if a leash does appear in your photo or if you plan on removing it with some postproduction wizardry.

✔ If the leash will remain in your final photo, be sure to use a newer, nice-looking leash as opposed to that old frayed one you pull out on rainy days. Also, direct the leash holder to pull it up and away so it's not lying on the dog's body. The leash should cross over her body as unobtrusively as possibly. Figure 16-5 is an example of *bad* leash handling because it cuts through so much of Andiamo's body.

✔ If you plan on doing some fancy Photoshop work to remove the leash (see Chapter 12), make your life easier by using a thin, retractable cord leash — but be sure your assistant knows how to quickly lock off the leash should he need to put the brakes on. Removing a tiny black cord from your photo is always easier than removing those thick nylon leashes. Instruct your handler to hold the leash tight enough that it's not lying on the dog, similar to Figure 16-6, but loose enough that the dog's collar doesn't get too tugged upon. Otherwise, the collar will look pretty strange when you remove the leash in postprocessing.

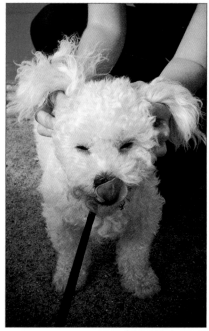

27mm, 1/400 sec., f/9.0, 250

Figure 16-5: To avoid an unnecessary distraction, always be aware of where the leash is and how much of the dog's body it covers.

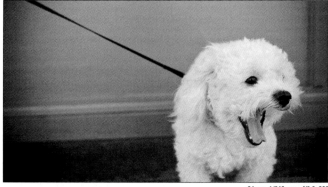

24mm, 1/640 sec., f/2.8, 200

Figure 16-6: The leash in this photo is easy to remove in postprocessing because it intersects only a small part of Andiamo's body.

Working with Multiple Dogs

Photographing more than one dog at a time raises the difficulty quotient immensely. Getting *one* dog to sit still on your own can be hard enough. Getting multiple dogs to sit still can be downright impossible if you're working alone. Sure, you may occasionally come across the amazingly well-trained pack that makes photographing multiples a breeze, but in our experience, you're more likely to hit some speed bumps in this area, so slow down and hang on tight!

- ✔ *Assistants* is the word of the day when it comes to photographing multiple dogs in the same shot. Try to recruit one assistant for every dog in the photo. Assign each dog to an assistant so every dog has a human counterpart he can look to when confused. Your assistants should be people *other* than those in the photo though!

- ✔ Have your first assistant position whichever pooch is *most* obedient and will likely sit the longest while the others get into place. Then, one by one, have each additional person position the other dog(s), all while assistant number one is making sure his dog stays in place. Try this with sit and stay commands, like we did in Figure 16-7, or consider keeping the dogs in place by attaching them to leashes that you can later remove in postprocessing.

- ✔ Have your noisemakers ready to go so that as soon as each dog is situated, you can start the next task of getting them all to look at you at the same time. Because different dogs respond to different sounds, you may have to try a few different types of attention-grabbers before you find one that they all respond to. If squeakers or clickers aren't doing the trick, perhaps the whole pack will know a certain word or phrase, like, "Who wants a cookie?!"

24mm, 1/100 sec., f/4.5, 100

Figure 16-7: Bella and Pancake were trained well enough to hold their positions without needing leashes.

✔ If you're shooting with a wide aperture (small f-stop number), try to place the dogs on the same plane so they all stay in focus (see Chapter 10 for a discussion of depth of field). Better yet, if you have enough available light, use a greater depth of field (a larger f-stop number) to ensure that each dog is within your focal range.

Managing a Menagerie

Group shots don't always consist of canine buddies. Part of dog photography can include whatever other species your dog has befriended. Whether cat, ferret, baby chick, or horse, photographing Cheyenne means capturing her buds as well!

Now the tables have turned — Jake is no longer the "ruff"est animal to photograph! Most other domesticated animals won't sit and stay on command, so the focus of these photo sessions is all about the *other* species and getting them in and out of the frame quickly.

The most common type of noncanine friend is a cat, and if your dog is the cat's BFF, trust us, you definitely want a photo of them together. To get the photo, follow these steps, and make sure you do everything slowly and steadily so you don't startle either animal:

1. **Get the dog in place first because he's more likely to stay put when told.**

2. **Have an assistant wrangle the cat and attempt to comfort and calm her down in his arms.**

3. **Have the assistant sit next to the dog, with enough room between them for the cat to be placed.**

 The assistant can place the cat down next to the dog while continuing to comfort and pet the cat.

4. **Have the assistant slowly inch his body out of the frame.**

 If the cat appears to be comfortable enough to stay in place, your assistant can slowly let go of her. If the cat seems apprehensive, she's probably going to bolt the second your handler lets go, so instead, have him keep his hand on the cat's back end so she continues to feel that secure touch. You can always remove the assistant's hand in postprocessing, just like you remove a leash.

This technique is for dogs and cats that already know each other and get along. Never force a dog and cat together if they're not comfortable with it!

Inevitably, you'll come across a group of animals (whether it's a mixture of species or a dogs-only group) that simply *won't* look at the camera at the

same time. One dog will look at you, only for the other to look away. It's actually quite comical and can sometimes seem as if the animals are doing it on purpose.

If you're having trouble in this department, remember to shoot multiple photos from the same distance, angle, exposure, and focal length. If you can at least get a photo of each animal looking at you one at a time, you may be able to fix things in postprocessing. In many group photos, like the one in Figure 16-8, Kim has actually had to take the head of a dog from one frame and superimpose it onto its own body in another image just so every animal is looking at the camera at once!

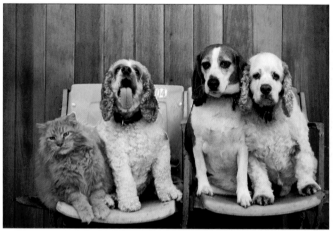

24mm, 1/80 sec., f/4.5, 250

Figure 16-8: This group shot is actually a combination of three different images merged together in postprocessing.

Sizing Up the Challenge of Giant Breeds

Giant breeds like the Great Dane, Saint Bernard, and mastiff pose unique challenges that are *not* behavior-related for a change! These breeds are actually a challenge to photograph because of their sheer size.

- ✔ Full-body photos of your giant breed dog may require unique angles or a very wide-angle lens to get the shot. We took Figure 16-9 with a focal length of 34mm, which still wasn't wide enough to capture Duncan's whole body without physically backing up.

- ✔ Headshots may require more depth of field than you're used to using in portraits because the distance between the dog's features (like the tip of his nose to his eyes) can be so great.

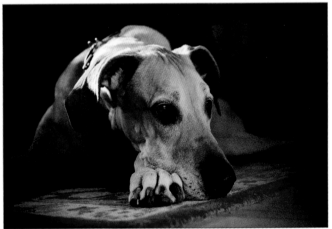

34mm, 1/125 sec., f/2.8, 250

Figure 16-9: Even at a fairly wide angle, getting the entire body of a giant breed dog in the frame can still be challenging!

Handling Stressed-Out Humans

If you're photographing for someone else, having a stressed-out human hovering over her dog can make an already stressful situation even worse. Dogs have a way of soaking up the energy of a room, so if you're tense or the dog's human is tense, the dog will be tense, too. Because the goal here is to keep things as stress-free as possible, use these techniques to head off any uncomfortable moments at the pass:

- ✔ Whenever possible, explain to the human what to expect during the photo session *before* you begin and reiterate how important it is for everyone to stay calm.

- ✔ Let her know that the photo session will follow the lead of the dog and that you'll take as many breaks as the pup needs. If the dog doesn't respond to a command, let her know that you won't force him — he's probably in need of a breather.

- ✔ If you sense a particular human may be unable to give stress-free commands, be sure to have an assistant on hand to help you out. The best way to avoid a stressed-out human is not to have the person assist you in the first place. The human can feel free to sit back, observe, and enjoy, because your assistant is there to do the treating!

Pro-Bone-O: More than Ten Tips for Giving Back

*N*ow that you're a superhero dog photographer, it's time to discuss using your newfound powers for good. The shelter systems and rescue groups across the country have *so* many dogs just waiting for someone like you to come along and adopt them. Many shelter dogs don't have much time, either; sadly, many shelters hold dogs for only *three days* before they're "red-listed" because the shelter doesn't have space for them. If a dog isn't adopted or pulled by a rescue organization, the chances of him making it out of the shelter system alive are slim.

Overcrowded shelters are forced to play a sheer numbers game, but the more volunteers they have photographing and networking adoptable animals, the more likely it is that those animals will find a home! Keep reading to see how you can help.

Identifying Local Shelters and Rescues

No matter where you live, we can pretty much guarantee that an animal shelter is nearby. If you're lucky, you may live in an area that boasts a no-kill shelter, but they're few and far between. The first step to helping out

in your own community is figuring out which shelters serve your area, where they're located, and how you can go about volunteering for them. Most shelters have a volunteer coordinator for you to speak with about offering your photography services free of charge for their animals.

Volunteering at a kill-shelter isn't for everyone — we get that. Know your own limitations and assess whether you can connect with these animals that may or may not make it out of there alive. Some people don't have the capacity to walk into a shelter without bursting into tears and/or leaving with an animal that's about to be euthanized, and that's okay. If you fall into that category, you can still help in other ways.

Many adoptable animals are pulled from the shelter system by various nonprofit rescue organizations that assume the cost of caring for these animals and that make sure they have a safe environment to live in until they find a permanent home. These organizations are the reason half of the animals that do end up in the shelter system make it out alive. Most rescue organizations have weekend adoption days that take place in public areas like an outdoor park or a local pet supply store. Contact them directly to find out how your photography services may be of use!

Making the Best of the Shelter Setting

Not every dog makes it to the shelter's adoption days, so if you're up for actually photographing *at* the shelter, here are a few things to keep in mind so that you can get the best photos possible:

- ✔ Start by talking with the shelter staff about which dogs are in most need of photos. You may want to start with the ones in the most danger of being euthanized.

- ✔ Shelter kennels may be indoors, outdoors, or a combination of both. More often than not, you'll come across rows and rows of concrete kennels void of bedding, toys, or the comforts of home. The concrete environment makes for a very loud and stressful home for these dogs, so if you can find any way to take them out of that environment — even if it's just to the front lawn of the shelter facility or a quieter meet-and-greet area, like in Figure 17-1 — you'll have a much better chance of getting decent photos.

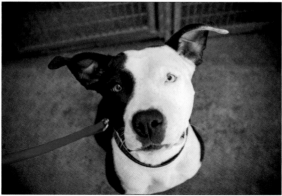

24mm, 1/320 sec., f/2.8, 320

Figure 17-1: A shelter volunteer brought Delilah out to the meet-and-greet area so we could photograph her in a calmer environment.

✔ Shelters have very strict operating and handling guidelines, so don't expect to walk in there and pull a dog out of a kennel on your own. The shelter will likely pair you up with a shelter volunteer who can safely handle the dogs you intend to photograph. If you plan on being a regular fixture at the shelter, consider becoming an official volunteer so you have more clearance to freely access the animals. Most shelters have a volunteer training program you must pass in order to be with the animals unsupervised.

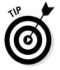

✔ If you absolutely can't remove the dogs you're photographing from their kennel environment, try to shoot through the kennel bars by using the selective focusing technique we discuss in Chapter 4. The goal is to be sure your camera focuses on the dog and not on the kennel bars. The bars become blurred in the foreground of the image, but you'll still be able to get an okay shot of the dog.

Offering Your Help without Creating Extra Work for the Rescue

When working with local rescue organizations, keep in mind that they usually run solely on volunteer power and through the efforts of some very dedicated founders who more than likely have a day job on top of running a nonprofit organization. A select few national rescue organizations have the funds for full-time employees, but the local rescues you come across probably don't.

With that in mind, try to make your services as efficient for them as possible. Meet with the founder to determine exactly what type of photography services the organization needs from you and the most helpful way for you to deliver those photos. The organization may want you to photograph its available animals or be the event photographer for its next big fundraising event. Depending on how large the operation is, it may also have a protocol for file specifications — should your photos be low-resolution and web-ready or high-resolution and printable? Should the images have the rescue's logo embedded in the bottom corner or the animal's name in the file name? These are all questions you want to ask ahead of time so that you don't create more work for an organization with limited resources.

Making the Most of Adoption Day Shoots

If a rescue organization does ask you to come out to an adoption day, be prepared to photograph *a lot* of animals and have the founder point out any animals that are in particular need of great photos — likely the shyer dogs or black-coated dogs that are difficult to photograph. Spend some time with each animal (and his handler), getting to know a little about the dog. Let the dog sniff you and introduce himself before shoving a camera in his face. You are a stranger, after all, so this may not be as easy as photographing your own dog.

24mm, 1/100 sec., f/2.8, 400

Figure 17-2: Run for the shade if you're shooting at a midday outdoor adoption event.

Find out in advance if the adoption event will be held outdoors or indoors and plan accordingly. If it's outdoors, you probably won't have the luxury of shooting during your favorite times of day (early morning/late afternoon), unless the adoption event happens to fall during those times, so be prepared to scout out the best shady locale, like we did in Figure 17-2, or use your fill flash technique if there's no shade to

be had (see Chapter 3 for more on fill flash). If you find a bit of shade, take advantage of it; the pups will look less stressed from the heat, and you'll get much softer light to work with.

Being Aware of Rescue Animals' Special Needs

Not all rescue animals are created equal. Some may walk right up to you and act like your best bud, and others may cower behind their foster parent in fear or even snap at you if you go in for a pet too soon! Always use caution and err on the side of safety when photographing a dog you don't know. If he's been out of the shelter for a while, his foster parent will likely clue you in on his personality and any potential negative triggers, but if he's fairly new to the rescue, the employees and volunteers may still be learning about him.

The best technique with any unfamiliar animal is to adopt a slow and steady mentality. Be patient and take your time getting to know the dog, and understand that this may be a very new (and scary) experience for him.

Many dogs pulled from the shelter system suffer from temporary or long-term physical limitations. If you suspect the dog you're about to photograph has any medical issues, be sure to ask whether there's anything he *can't* do during your mini photo session, such as sit, lie down, or even stand for prolonged periods of time. Coming across dogs recuperating from recent surgery isn't uncommon — everything from minor surgeries like being spayed or neutered to more intrusive surgeries like having an infected eye removed, a broken hip repaired, or even a leg amputated. The sad reality is that pet owners often dump their sick and injured pets at shelters when they can't afford the medical bills. And until those dogs are either adopted directly from the shelter or pulled by a rescue organization, they generally don't receive extensive medical care.

Spreading the Word about Adoptable Animals through Social Media

If you're as addicted to Facebook as we are, consider becoming a social media animal networker. Your local rescue organizations and shelters may already have their own web pages where they post adoptable animals, but if they don't, why not help start one? You can network adoptable animals by sharing their photos and details on your own Facebook wall. You never know who may be looking to adopt a new friend.

We once found a home for a Los Angeles shelter pup (see Figure 17-3) all the way across the country in North Carolina! After watching the pup's owners drop her off at the shelter, we decided to start networking her on Facebook. One thing led to another, and a close friend of ours reposted Callie's plea on her own wall. When our friend's aunt in North Carolina saw Callie's photos, she knew right away that she wanted to save this dog. We pulled Callie from the shelter system and we transported her to Chicago, where her new family drove up to meet us! Granted, that's a long-distance rescue story, but it just goes to show how powerful social media networking can be!

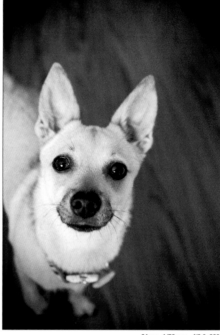

24mm, 1/50 sec., f/2.8, 320

Figure 17-3: Callie found a forever home on the other side of the country, thanks to social media networking.

Donating a Portion of Your Session Fees as a Fundraiser

If you do decide to turn your budding dog photography passion into a full-fledged business, another easy way to give back is by donating a portion of your session fees to designated local rescues. You may even consider offering a special mini session from which you donate back 100 percent of your proceeds! You may not have hundreds of dollars of your own money to donate, but you *do* have a skill that people are interested in. Sure, you'll have to donate your time, but often that's more feasible than donating your own moola.

From time to time, we like to partner with local pet supply stores to offer 20-minute mini sessions with all the proceeds going to a rescue. Doing so is an easy way to support our favorite rescues without breaking the bank. Most pet supply stores have an ample dog-loving customer base, so be sure to promote your fundraiser with in-store signage.

Donating Packages for Silent Auctions

Another popular way for rescue organizations to raise money is through special fundraising events, which may include a silent auction component. The nonprofit secures donations of goods or services from various businesses and then auctions them off to raise money. Perhaps the quickest and easiest way for you to give back is by donating a dog photography photo session package to your favorite organization's silent auction. The rescue organization immediately benefits from it, your name and business are on display throughout the event, and you meet tons of other animal lovers if you actually attend the event!

Don't be afraid to say no to charities soliciting donations! Although it's good to make donations to help rescue animals, giving too much can wind up putting you in the hole. Share your generosity wisely. And don't feel bad about it; charities ask a lot of businesses expecting that some won't be in a position to donate.

Hosting Special Events as a Fundraiser

If you're more of a party planner yourself, you can even develop your very own fundraising event as a way to give back! The possibilities are endless here, but be forewarned that these events take *lots* of planning and coordination, so be sure to focus on activities you enjoy. For example, if you're an avid runner, consider putting together a pet-friendly fun run to raise funds for your favorite rescue. Coordinate with your local pet boutique and use its store as the finish line so the pup-participants have a place to mingle after the event. Or, if you're more of a fancy socialite, team up with a local wine bar or restaurant to host a pet-friendly "yappy hour," with proceeds going back to the rescue.

Using Your Own Website to Help Rescues

Do you have your own website now that you've turned dog photography into a business? Consider using it to help raise awareness of the local rescue organizations you support. You can

✔ Devote a section of your website to adoptable pets from your favorite rescue or shelter, like in Figure 17-4.

✔ Include a resources section with links to the various shelters and rescue groups that people in your area can adopt from.

✔ Support special fundraising efforts by adding a "Donate Now" button to your home page that links to a rescue group's special plea.

Figure 17-4: Our website has a section that features animals in need of homes.

Using Adoptable Animals in Your Promo Materials

Finally, if you're working as a professional dog photographer at this point, you probably use marketing and promotional material. Try to use photos of available rescue or shelter dogs whenever you can; the more people who actually see these adoptable dogs, the better! Whenever we display our hard-copy portfolio, we try to include images of adoptable dogs and somehow tag them as such. As people flip through the portfolio, they often start inquiring about the adoptable dogs. If you always have available animals in the back of your mind, you can usually find a way to work them into your business and get them some much-needed exposure.

18

Ten Ways to Promote Your New Business Endeavor

In This Chapter

▷ Using the Internet to market your business

▷ Establishing relationships with other businesses

▷ Exchanging your services to benefit yourself and others

*W*ell, you've taken the plunge, gotten your business license, set up a bank account, and it's official — you're a professional dog photographer. Congratulations! So now what? Calling yourself a dog photographer and taking the necessary legal steps to set up a business is one thing. Getting people to pay you to take photos of their dog is another! How successful you are at attracting customers is a direct result of how well you promote your fledgling business. In this chapter we go over ten ways you can start promoting your dog photography business. Most of these ideas cost very little (if any) money to implement, because let's face it — most small businesses don't even have a budget to promote themselves.

Creating a Website

First and foremost, you *need* a website . . . immediately! If you're not exactly web-savvy, setting up a website can be a daunting task, but in reality, solutions are available for everyone. You don't need to know what html is or how Flash works; you simply need to navigate through a tool (be it a software program or a web application) that creates a website for you. Check out these options and play around with them to see which feels right for you:

- ✔ **Blogging sites:** These types of sites are free but can be a bit finicky when it comes to working with the templates. Simply type "free blogging website" into any search engine and start exploring your options. If you have the time to tinker around and like the free aspect, this may be the perfect route for you.

- ✔ **Lightroom web gallery:** If you use Adobe Lightroom, explore its web gallery features to create a simple portfolio page. See Chapter 13 for step-by-step instructions on how to publish a Lightroom web gallery. If you're not scared off by the prospect of buying a domain name and a hosting plan, and if the letters FTP actually mean something to you, you'll likely find this method pretty straightforward.

- ✔ **Online portfolio management services:** For a small monthly fee (usually around $12 to $30), these online services provide user-friendly interfaces to upload and manage your work without the hassle of buying a domain name or a hosting plan separately. Check out `www.carbonmade.com` or `www.viewbook.com`; they're similar, but each has its own style, so see which one best fits your needs.

Getting Found by Search Engines

Getting your website live is half the battle. Getting *found* online is the other half. Today, most people use a search engine like Google to track down what they're looking for, so understanding how search engines catalog and rank websites is important. Each search engine has its own proprietary way of doing things, but essentially, the search engines "crawl" the web looking for new content to catalog and add to their databases. Most people look through the first, second, and *maybe* third page of search results before they type something else into the search box, so if your site doesn't show up toward the top of the list, people won't find you.

So *how* do you get to the top of the search results? Doing so on your own takes time and work, but trust us — it *can* be done. Despite being hounded by search engine optimization companies that wanted us to pay them to get our site to the top of search engine results, we stuck to our guns and simply worked within the search engine's guidelines and suggestions. For instance, Google has a site (`www.google.com/support/webmasters/bin/answer.py?answer=35769&hl=en`) dedicated to helping you get the most out of your website. Visit the site to understand how Google really works.

Search engine optimization may sound like a fancy schmancy term, but really it just boils down to getting your site found by implementing the best practices set up by the search engine. Search engines are dedicated to providing the most relevant and accurate results, so they don't take kindly to

any sort of trickery to get your website to the top of the list. Hundreds of factors determine how relevant your page is, but these are a few of the most important:

✔ **Page rank:** Your page rank is determined by how influential you are on the web and is measured by how many other websites link to your website. The more linkage you have going on, the better your page rank. Page rank also considers the influential factor of *who* links to you. For instance, if a small-time blogger links to your website, that's good, but if you happen to get press in a national newspaper and it links to you, that's much better!

✔ **Site submission:** Take the bull by the horns and *submit* your site so search engines know it's out there and ready to be indexed. Don't sit back and wait for them to do it. To submit your website to Google, visit `www.google.com/addurl.html`.

✔ **Guideline adherence:** Follow the design, content, and technical guidelines set forth by the search engine. These best practices are there for a reason — use them! For instance, use only keywords that are appropriate for your site; don't add the celebrity of the moment's name to your keywords simply because her name is being searched constantly. Your page isn't considered relevant to that topic, and that type of practice only hurts you in the long run.

✔ **Web presence:** Establish your presence on the web by having *more* than one website dedicated to your business. For example, create a Facebook page for your business, a Twitter account, a Yelp business page, a separate blog, and so on. The more your business is out there on the web, the more likely a search engine will think highly of you.

 Be wary of solicitors who claim that they can get you ranked number one in search engine results; no one can guarantee that! Proper SEO companies are upfront about how you can increase your page rank and are transparent about the process. This isn't to say you should never pay for SEO help, because some legitimate firms exist; just be sure to do your homework first.

Talking Up Your Business

One of the best ways to drum up business is simply by being vocal about what you do and being prepared with a business card so prospective clients can get in touch with you. We admit it — in the beginning we weren't the best at remembering to carry our business cards. Now, we're sure to always have a stash in our back pocket, and we also keep a supply in our cars because you never know when you'll run out!

It's also time to quit being shy. Again, this one took practice for us. Walking up to a complete stranger, introducing yourself, and somehow slipping the person a business card by conversation's end can be a sweat-inducing task for many. Luckily, in this business, you usually have an icebreaker — a furry, friendly, happy icebreaker! Break the ice by asking if you can say hello to a parkgoer's dog, and later on in the conversation, let the person know what you do. Most people with dogs will even ask if you have a business card on you, so get out there and start socializing!

Building Relationships with Local Pet Care Businesses

Talking up dog photography is a heck of a lot easier if you do it in the right places. Do some research to map out all the pet care businesses in your area, including pet boutiques, groomers, dog walking services, and even doggie daycares. All these businesses have the same clients in mind — dog lovers! Begin by targeting a few businesses you like and try to build a mutually beneficial relationship with them. Most local small businesses are receptive to cross-promotional relationships as long as you have something good they can offer to their clients (and obviously, your photography is much more than *good* by this point or you wouldn't have started this business in the first place).

Trading Services Wisely

When it comes to helping others in your community, don't be stingy. Consider trading your photography services for promotional opportunities for your own business. For instance, approach that brand-new doggie daycare and offer to photograph its facility free of charge if it agrees to hand out your business card to new clients. Get your business name and logo on your local pet boutique's monthly "Yappy Hour" promotional material by offering to be the event photographer. Have your web designer friend build your fancy new site in exchange for photographing his dogs. The possibilities are endless; you have a valuable skill that can help others, so use that to everybody's advantage!

Volunteering with Local Rescue Groups

If you're into animal rescue like we are, you probably already photograph adoptable animals for your local rescue groups, but be sure to offer your support in other ways as well. Consider donating a gift certificate to a rescue group's next silent auction fundraiser or hold a studio session day in which all proceeds benefit your rescue of choice. These actions are a fantastic way to give back to the community while also meeting other dog lovers (who may one day become a client).

Attending Pet-Related Events

Keep your eyes open for local pet-related events that you can get involved with. Perhaps your favorite pet boutique is holding a "Howl-o-ween Extravaganza" you can be the official photographer for or maybe there's a yearly "Bark in the Park" charity event where you can set up a display table. Los Angeles has no shortage of pet festivals, expos, and adoption fairs, and most major cities across the country are following suit. Break out the newspaper, scour your city blogs, or visit your local pet boutiques to find out which events all the cool canines go to.

Visiting the Dog Park

Chances are you have a dog of your own if you're reading this book and you've started a dog photography business, so why not put Sasquatch to work as well? Take him for an outing to your favorite dog park and let *him* break the ice. Anyone who cares about his dog enough to socialize with him at the park is a great candidate for a doggie photo session. Consider bringing your camera as well to take some "practice" shots. If you start photographing other dogs at the park, their humans may even inquire as to how they can get a copy of the photos. Feel free to give one or two away in hopes of securing a full-on photo session with them later, or try selling them as one-off packages. Either way, you've made a contact and quite possibly a sale.

Building Press Instead of Advertising

Want to know the secret to advertising when you have *zero* budget for it? Get press instead! In our opinion, a story about you and/or your business holds a lot more weight than an advertisement you pay to place. Start small with online niche websites or blogs that may be interested in featuring a story

about a pet photographer. Figure out what sets you apart and approach your media outlets with ideas that appeal to their already established reader base. Decide which websites, magazines, and newspapers you'd be a good fit for and contact their editors or writers by dropping them a note to introduce yourself and then following up with them once a month or so. If you're persistent without being pesky, sooner or later that editor or writer will think of you when a story comes up that you may be a good source or topic for. Just like you build relationships with local businesses and even perfect strangers at the dog park, this one is about relationships as well. It is called public *relations* after all!

Staying Connected with Past Clients

One of the easiest ways to promote yourself is simply by doing your job well. Nothing's more powerful than a word-of-mouth referral in this business, or in this case, the sharing of a photo. Every single photo you take for a client is a potential calling card that may land itself in front of that client's family, friends, and co-workers. Create something eye-catching enough and people will surely stop to ask, "Wow, who took that?!"

Use your social media outlets to stay connected with clients as well. Ask your clients to "like" your Facebook business page and share it with their friends. Also, consider starting a monthly newsletter as a way to interact and connect with your past (and future) clients.

Index

• D •

• E •

Apple & Macs

iPad For Dummies
978-0-470-58027-1

iPhone For Dummies,
4th Edition
978-0-470-87870-5

MacBook For Dummies, 3rd
Edition
978-0-470-76918-8

Mac OS X Snow Leopard For
Dummies
978-0-470-43543-4

Business

Bookkeeping For Dummies
978-0-7645-9848-7

Job Interviews
For Dummies,
3rd Edition
978-0-470-17748-8

Resumes For Dummies,
5th Edition
978-0-470-08037-5

Starting an
Online Business
For Dummies,
5th Edition
978-0-470-60210-2

Stock Investing
For Dummies,
3rd Edition
978-0-470-40114-9

Successful
Time Management
For Dummies
978-0-470-29034-7

Computer Hardware

BlackBerry
For Dummies,
4th Edition
978-0-470-60700-8

Computers For Seniors
For Dummies,
2nd Edition
978-0-470-53483-0

PCs For Dummies, Windows
7 Edition
978-0-470-46542-4

Laptops For Dummies,
4th Edition
978-0-470-57829-2

Cooking & Entertaining

Cooking Basics
For Dummies,
3rd Edition
978-0-7645-7206-7

Wine For Dummies,
4th Edition
978-0-470-04579-4

Diet & Nutrition

Dieting For Dummies,
2nd Edition
978-0-7645-4149-0

Nutrition For Dummies,
4th Edition
978-0-471-79868-2

Weight Training
For Dummies,
3rd Edition
978-0-471-76845-6

Digital Photography

Digital SLR Cameras &
Photography For Dummies,
3rd Edition
978-0-470-46606-3

Photoshop Elements 8
For Dummies
978-0-470-52967-6

Gardening

Gardening Basics
For Dummies
978-0-470-03749-2

Organic Gardening
For Dummies,
2nd Edition
978-0-470-43067-5

Green/Sustainable

Raising Chickens
For Dummies
978-0-470-46544-8

Green Cleaning
For Dummies
978-0-470-39106-8

Health

Diabetes For Dummies,
3rd Edition
978-0-470-27086-8

Food Allergies
For Dummies
978-0-470-09584-3

Living Gluten-Free
For Dummies,
2nd Edition
978-0-470-58589-4

Hobbies/General

Chess For Dummies,
2nd Edition
978-0-7645-8404-6

Drawing
Cartoons & Comics
For Dummies
978-0-470-42683-8

Knitting For Dummies,
2nd Edition
978-0-470-28747-7

Organizing
For Dummies
978-0-7645-5300-4

Su Doku For Dummies
978-0-470-01892-7

Home Improvement

Home Maintenance
For Dummies,
2nd Edition
978-0-470-43063-7

Home Theater
For Dummies,
3rd Edition
978-0-470-41189-6

Living the
Country Lifestyle
All-in-One
For Dummies
978-0-470-43061-3

Solar Power Your Home
For Dummies,
2nd Edition
978-0-470-59678-4

Available wherever books are sold. For more information or to order direct: U.S. customers visit www.dummies.com or call 1-877-762-2974.
U.K. customers visit www.wileyeurope.com or call (0) 1243 843291. Canadian customers visit www.wiley.ca or call 1-800-567-4797.

Internet

Blogging For Dummies,
3rd Edition
978-0-470-61996-4

eBay For Dummies,
6th Edition
978-0-470-49741-8

Facebook For Dummies, 3rd
Edition
978-0-470-87804-0

Web Marketing
For Dummies,
2nd Edition
978-0-470-37181-7

WordPress
For Dummies,
3rd Edition
978-0-470-59274-8

Language & Foreign Language

French For Dummies
978-0-7645-5193-2

Italian Phrases
For Dummies
978-0-7645-7203-6

Spanish For Dummies,
2nd Edition
978-0-470-87855-2

Spanish For Dummies,
Audio Set
978-0-470-09585-0

Math & Science

Algebra I For Dummies,
2nd Edition
978-0-470-55964-2

Biology For Dummies,
2nd Edition
978-0-470-59875-7

Calculus For Dummies
978-0-7645-2498-1

Chemistry For Dummies
978-0-7645-5430-8

Microsoft Office

Excel 2010 For Dummies
978-0-470-48953-6

Office 2010 All-in-One
For Dummies
978-0-470-49748-7

Office 2010 For Dummies,
Book + DVD Bundle
978-0-470-62698-6

Word 2010 For Dummies
978-0-470-48772-3

Music

Guitar For Dummies,
2nd Edition
978-0-7645-9904-0

iPod & iTunes
For Dummies,
8th Edition
978-0-470-87871-2

Piano Exercises
For Dummies
978-0-470-38765-8

Parenting & Education

Parenting For Dummies,
2nd Edition
978-0-7645-5418-6

Type 1 Diabetes
For Dummies
978-0-470-17811-9

Pets

Cats For Dummies,
2nd Edition
978-0-7645-5275-5

Dog Training For Dummies,
3rd Edition
978-0-470-60029-0

Puppies For Dummies,
2nd Edition
978-0-470-03717-1

Religion & Inspiration

The Bible For Dummies
978-0-7645-5296-0

Catholicism For Dummies
978-0-7645-5391-2

Women in the Bible
For Dummies
978-0-7645-8475-6

Self-Help & Relationship

Anger Management
For Dummies
978-0-470-03715-7

Overcoming Anxiety
For Dummies,
2nd Edition
978-0-470-57441-6

Sports

Baseball
For Dummies,
3rd Edition
978-0-7645-7537-2

Basketball
For Dummies,
2nd Edition
978-0-7645-5248-9

Golf For Dummies,
3rd Edition
978-0-471-76871-5

Web Development

Web Design
All-in-One
For Dummies
978-0-470-41796-6

Web Sites
Do-It-Yourself
For Dummies,
2nd Edition
978-0-470-56520-9

Windows 7

Windows 7
For Dummies
978-0-470-49743-2

Windows 7
For Dummies,
Book + DVD Bundle
978-0-470-52398-8

Windows 7 All-in-One
For Dummies
978-0-470-48763-1